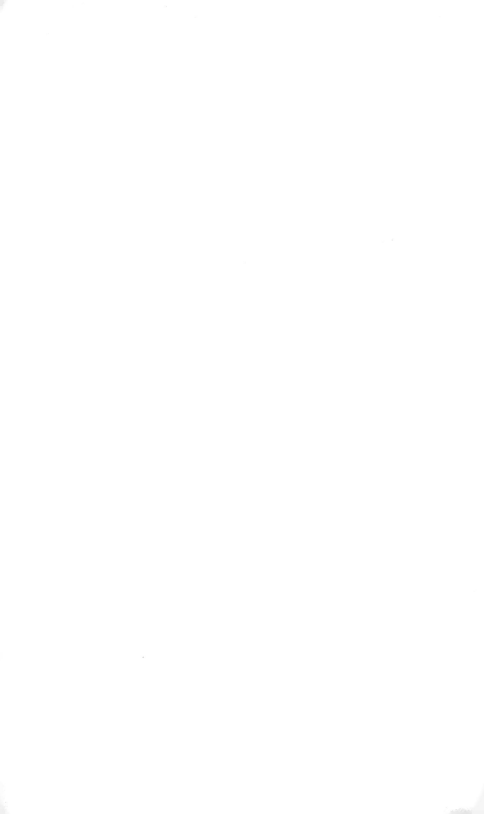

THE INSCRIPTION

Δ Mettini

Fort Ross •

At the
South
Water

Kostromitinov •
Ranch

Russian River

(Santa Rosa)

Napa

River

(Occidental)

Salmon Cr. Δ Pakahuwe
 Δ (Freestone)

Bodega Bay

Khlebinikov Ranch

Sonoma
•

N
W E
S

Estero Americano

Sonoma Creek

(Petaluma) •

San Antonio Creek

Petaluma River

Tomales Bay

Olompali

San Pablo
Bay

Drake's
Bay

San Δ
Rafael •

(Sausalito) •

San Francisco Bay

San
Francisco

The Sonoma Coast Country and Vicinity
in the late 1820s and '30s

• Russian and Mexican settlements
() Later establishments
Δ Amerind villages

The Inscription

RICHARD HUGO GATCHEL

FITHIAN PRESS
SANTA BARBARA
1992

To Professor Clifford Drury, *in memoriam*

Copyright ©1992 by Richard Hugo Gatchel
All rights reserved
Printed in the United States of America

Design and typography by Jim Cook

LIBRARY OF CONGRESS CATALOGING-IN-PUBLICATION DATA
Gatchel, Richard H., 1926–
 The inscription: a novel / Richard H. Gatchel.
 p. cm.
 ISBN 1-56474-002-1
 I. Title.
PS3557.A855I57 1992 91-26468
813'.54—dc 20 CIP

ACKNOWLEDGEMENTS

No one writes alone. True, in one sense, writing *is* a singularly solitary business, and as I pursue the craft I must ultimately take full responsibility for whatever from within myself I release to be shared with (or thrust upon) family and friends or a broader readership. Nonetheless, one cannot sit down to write without being surrounded by a great host of contributors, inspirers, kibitzers, critics, midwives, and well-wishers, both from the past and from the present.

Among the host when *The Inscription* was in the making were those who brought California's Russian presence alive for me, especially John McKenzie, Stephen Watrous, and Diane Spencer-Hancock. Harry Lapham and Gene Walker rendered like service for local history and color in and about Occidental and Freestone. Works of Robert S. Smilie, Myrtle M. McKittrick, Edith Buckland Webb, Rupert and Jeanette Henry Costo, and Burt W. and Ethel G. Aginsky were indispensable sources of information on the Sonoma Mission, Mariano Vallejo, and, more broadly, the life and world of California's Amerinds. Helpful staffs at the Bancroft Library in Berkeley and at the mission archives in Santa Barbara gave me access to treasuries of Russian and Hispanic primary sources unfrequented by the general public. And, as the reader will discover, there was Prof. Clifford Drury who long ago supplied the crucial seed crystal to "get me going."

Above all, egging me on and devoting untold, unsung hours to transforming my work into readable form were my dear friends Elizabeth Berryhill and Eden Nicholas and my wife (also dear) Beth.

1

Our friend, Nicholas, had often told us that we would *never* appreciate Italian cooking until we had worked our way through a full seven-course repast at one of the old family restaurants in Occidental. Occidental is a little town tucked away up in the redwoods of the Coast Range between Santa Rosa and the Sonoma Coast, some seventy miles north of San Francisco. Its thriving existence apparently depends principally upon Bay Area folk who insist that their occasional escapes from the megalopolis include a touch of the "old country" at the end of a narrow, winding mountain road. In addition to its dining establishments, the town's main street presently boasts a gas station, a couple of modern motels, souvenir and art shops, two or three churches, and an up-to-date grocery store. Most of the homes are all but hidden from view in the woods that rise abruptly from the village center. But when my wife and I pulled into town one cool fall evening a number of years ago, I do not recall having noticed much of anything other than the Italian family restaurants. One of them occupied most of the first floor of an old, 1880s-looking hotel,

where warm lights glowed, and rich aromas and strains of "O Sole Mio" wafted their way out to us through an inviting open doorway.

Selecting the hotel as the setting for our gastronomic indulgence and overnight accommodations, Andie and I mounted the plank steps, crossed the white spindle-railed veranda, and were ushered into an aging but pleasant dining room. Once seated at one of its checkered oilcloth-covered tables, we were left to contemplate our fellow patrons or walls bedecked with Italian memorabilia until our towel-over-the-arm, tray-on-the-shoulder waiter made the first of numerous appearances. For an hour and a half we moved with determination, if in increasing oblivion, through an entire menu of hors d'oeuvres, minestrone, salad, ravioli, spaghetti, spumoni, and fruit, not to mention a loaf of Italian sourdough bread and ample quantities of red wine. The concluding touch was a cup of strong—*very* strong—Italian coffee.

Nicholas had been right. Clearly his credentials were not only those of a distinguished cultural anthropologist and linguist. Indeed, as we had become respectfully, if painfully, aware, they were those of a connoisseur of Italian cuisine as well. There was no doubt in either of our minds that we had now lived—Italiano. At last we could identify with a Michelangelo, a Verdi, a Caruso. In our conditions it seemed that even a Mussolini could not have been all bad. From under heavy lids, Andie and I peered at one another across the table of empty dishes. My blurred gaze revealed no hint of the half smile that normally complemented her lively blue eyes and crinkled the graceful arch of her slender nose. I could also imagine that the face which appeared to her through the mist of surfeit bore little resemblance to that of the dignified academician she thought she had married. The sated, bespectacled, balding, wrinkled raisin of a man whom she was dully contemplating at the moment could only have roused additional feelings of discomfort.

We had lived together long enough to recognize our moods without benefit of verbal confirmation. One glance and we knew the present mood was definitely not for a starlit stroll through town to "walk it off." Only sleep could begin to deal with this one. As we pushed back from the table, a reflexive jerk in reaction to the grating chairs convinced us that we had made a prudent decision. Even more convincing was the labored lumbering up the long flight of creaking stairs.

Clutching the weathered redwood bannister, we literally pulled our way up to the modest but inviting room that awaited us. Not having pre-tested the double bed, our one remaining hope was for a firm mattress. Post-gourmet throbbings from within simply would not tolerate our being thrust together center stage on sagging springs.

Alas, as might have been expected on such aging premises, the mattress was anything but firm. It appeared that our miscreant stomachs were sentenced to time together in one padded cell. But fortunately, as I was about to try the floor on my own, Andie made a brilliant discovery. By changing hands occasionally to ease the strain, one could hold onto the edge of the mattress and preserve the much needed open space between us. Only later were we reminded by other guests that we had overlooked the older and less strenuous rolled-up-blanket-down-the-middle technique.

As we clung to our respective outside edges, I tried a little tension-easing humor by singing "Climb Every Mountain." Andie began to chuckle quietly, but, to my chagrin, what tickled her was not my brilliant vocal selection.

"You know, Greg," she said, "you really did look funny out there this afternoon."

"Out where?" I retorted, unamused.

"Oh, come on, you know," she replied. "I mean when you lost your grip on that boulder by the creek and fell flat on your back in the middle of the berry bushes."

All I could come back with was, "Ha, ha, very funny. Remind me not to come knocking on *your* door when I need some sympathy.

But, really, she was right. I must have looked pretty silly lying there in the midst of that tangle of thorny vines. Beside having the wind knocked out of me from the fall, I was looking sheepishly up at Andie, trying to protect my dignity by assuring us both that it did not hurt. What a laugh! That bramble must have been waiting a long time for a victim. Still, there were a couple of consoling factors. One was that it was a berry bush rather than a clump of poison oak that held me prisoner. The other—well, the other had to do with what prompted the present narrative. I am a California history buff of sorts, and at the time of my slight slip I was enveloped not only in a berry bramble but also in an intriguing bit of historical research. Since the subject matter

of the research bears directly on that afternoon fiasco, a bit of bridge-work should prove helpful at this juncture.

Long, long ago, as an eager young theological student at a Bay Area seminary, I was roused from near slumber one morning in church history by a statement from the course's esteemed professor, Dr. Clifford Drury. "Ladies and gentlemen"—actually, there was only one young woman who had braved that male-dominated classroom, and only a handful in the whole institution—"Ladies and gentlemen," he announced in his somewhat gravelly but spirited voice, "note well that it was right here in the state of California that the institutional church, having come from east and west, encircled the earth and met."

His reference was to the fact that Roman Catholics, having sailed west across the Atlantic, had made their way through the Mexican mainland to Baja and, ultimately, to Alta California. In an intrepid eastward march the Russian Orthodox had traversed the entire length of Siberia, sailed via the Aleutian Islands to Sitka, and continued southeast until they, too, had established themselves in the Golden State.

For some reason unbeknownst to me, other members of the class were only mildly interested, but I recall waving my hand wildly to ask: "Professor Drury, just *where* in California did they meet, and *what* did they have to say to each other?" For the "where" the good Doctor had ample historical data at hand. In 1812 the Russians had constructed Fort Ross, a formidable stockade for those days, on one of the head-lands of the Sonoma coast some seventy miles north of the Golden Gate. At Bodega Bay, twenty miles south of the fort, they secured for themselves an all-weather port and warehouses.

As for the Hispanics, by 1824 the successors to Fr. Junípero Serra, founder of the first nine links in California's Franciscan mission chain, had extended the enterprise to its eventual northernmost point, Mission San Francisco Solano at Sonoma, which lay in an oak-studded valley about ten miles above San Pablo Bay and less than fifty miles from the Sonoma coast. So there they were, the Russian Orthodox and Roman Catholics, each thousands of miles from home base and yet presumably hobnobbing with each other on the Califor-nia frontier. But were they?

Official correspondence between the national sponsors of the two

settlements was discouraging. Government documents, with a bit of paraphrasing, ran somewhat as follows.

Mexicans to Russians: "Get the hell out of here, or we'll run you into the Pacific!"

Russians to Mexicans: "Try it, if you think you're big enough!"

Mexicans to Russians: "California's our turf! Go back to Sitka, where you came from!"

Russians to Mexicans: "Who says it's your turf? It belongs to the Indians, and *we* at least have a signed treaty with them!" Clearly the official relationship was not characterized by particularly amicable attitudes. The twain had met, but under somewhat trying circumstances.

Still, I wanted to know what the Russians and Mexicans in California were saying to each other *unofficially*. Professor Drury responded in excellent, if predictable, academic style by suggesting that it might be well for me to do some digging on my own. That was forty years ago. From one year to the next, various impediments, such as continuing professional study, marriage, numerous offspring, a career, and dwindling momentum, conspired to delay serious action on the professor's advice. Then, one day I learned that our beloved mentor had died. The event, reminding me as it did that I, too, was mortal, roused me to a flurry of scholarly activity. After seeing my way through innumerable dusty tomes tucked away in private and public archives, I was able to begin to piece together something of the unofficial contact that existed between California's Mexicans and Russians in the 1820s and 1830s.

Indeed, all kinds of fascinating exchanges between the two constituencies had taken place during those years. The Mexican Californios needed boats. The Russian entrepreneurs saw that they got them. The Russians needed wheat. The Californios responded in kind. The Californios wanted hardware, household goods, guns and ammunition. The Russians traded as much as they could spare. The Russians wanted beef, hides, tallow, wine. The Californios were only too happy to oblige from their bountiful inventory. Not to be outdone, men of the cloth contributed to the unofficial amity. In 1824, the dedication of the Sonoma Mission's Catholic sanctuary was enhanced by the presence of altar cloths, vestments, goblets, and frames for sacred paintings, many of the items being gifts from the Russian fort, where

an Orthodox chapel had been constructed that year. Somewhat over a decade later, mission padres at San Rafael, San Jose, and Santa Clara had occasion to return the favor as they hosted a visiting Orthodox priest, Fr. Ioann Veniaminov, who was to become a bishop and, ultimately, Metropolitan of Moscow.

While much, if not most of the practical, day-to-day trafficking between the Russians and Californios was officially illicit, there was little need for it to be *sub rosa*. St. Petersburg, Mexico City, and, as an increasingly weaker seat of authority, Madrid, were simply in no position to lay down the law. Then, too, as a consequence of practical exchange, folks began to get acquainted socially, even romantically. The Russian-Spanish language barrier undoubtedly presented a major problem, but there was a will and, hence, a way to surmount the difficulty. Attesting to the fact were some of the get-togethers at the Vasily Khlebnikov ranch, which was situated a few miles inland from Bodega Bay. A particularly gala event occurred there in the summer of 1840, when both Russians and Mexican rancheros gathered for a two-day celebration of Elena Rotcheva's birthday. Diverse tongues proved to be no obstacle on the dance floor, where, as always, the music had a language all of its own. In addition, the confluence of vodka and wine no doubt contributed to mutual understanding even where none had been expected. Most helpful, however, were the host and hostess themselves. Mme. Rotcheva, descended from a princely Muscovite family, was the wife of the fort's commandant, Alexander Gavrilovich Rotchev, who was not only a very able administrator, but a gentleman of letters and patron of the arts and sciences as well. I believe it would be safe to venture that by the end of the party's second day Alexander's linguistic versatility, together with Elena's beauty and grace, left no guest feeling like an outsider.

The Khlebnikov ranch, I learned, was but the second of three subsidiary farms under the aegis of Fort Ross. The first, established in 1833 by Peter S. Kostromitinov, was near the mouth of the Russian River, where the Russians maintained a ferry service for overland traffic along the coast. The precise location of the third ranch I have yet to determine. According to one reliable source, it was situated in the Upper Salmon Creek Valley, near the present little town of Freestone. Established in 1836 by Egor Chernykh, an able Moscow-trained agronomist, the farm must have borne some of the markings of a

present-day experimental station. Motives which led the Russians to conduct such an experiment are readily discernible.

For almost four decades the Russian American Company's headquarters at Sitka had been searching desperately for an adequate supply source of wheat. Indeed, the company, with the tacit approval of the tsar, had founded Fort Ross not only to secure its continuing sea otter trade along the California coast, but also to get some wheat planted. The results had been disappointing. Either gophers and field mice had their fill from beneath or coastal fog rotted the crops from above. Then came Egor Chernykh to have a look at the problem. It did not take long to discover what the locals already knew, namely, that over the hills to the east, under clearer, warmer skies, the Mexican rancheros were making out much better. A move farther inland made good sense scientifically, too, not to mention the political advantage of such a Russian establishment. Hence the assumption that Chernykh developed his farm in the Upper Salmon Creek Valley sounded quite plausible. A Russian presence there might be a threat to Mexican officialdom, but who was to say whose dreams of empire were the more legitimate? Who but the Amerinds had any real claim to the land, and who *really* cared about the Amerinds? ("Amerind" is an anthropological term, coined to distinguish American Indians from Asian Indians.)

It was a sketch of the Chernykh ranch that captured my imagination and focused my attention on that little plot of earth. The sketch was done in 1841 by Il'ia Gavrilovich Voznesensky, a well-known scientist and graphic artist whose stay at the fort that year included not only a trek to the Chernykh ranch but a climb to the top of Mount St. Helena as well. His sketch portrays a man on horseback approaching a couple of livestock pens, behind which lie well-tended, fenced fields, some planted in vegetables and others, presumably, in grain. A substantial barn and other buildings are situated to the rear, where pine, bay laurel, madrone, and redwood trees finger their way to the edge of the fields from the dense woods of the surrounding hills. In a pasture to the right lies a contented longhorn steer. Close by is a *carreta,* or wooden-wheeled cart of Spanish design. Back near the barn, holding a rake or hoe—it is hard to tell which—stands a farmhand, who appears to be looking with interest toward the approaching horseman.

I am not sure quite why that particular sketch held me with such mesmerizing effect. Perhaps it was because, to my knowledge, there was no other picture of any of those Russian farms. Perhaps it was because it promised to unfold a scene in California's past that I longed to enter. In any event, I simply *had* to locate the valley and, if possible, the very spot where Il'ia Voznesensky had stood so long ago when he sketched that landscape.

My first sortie to the area ended in utter failure. It was late on a cold, rainy afternoon in January when I pulled up in front of Freestone's old general store. The proprietor was a pleasant woman of indeterminable age who seemed to have a remarkable command over her local customers as well as the store's crowded shelves. After doing duty as postmistress for an oldtimer and ringing up some kids' Cokes and candy bars, she turned to me with a "and what can I do for you, stranger?" I explained that I was trying to locate the old Chernykh ranch. She had heard of it, but had no idea of where it might have been. I must have looked terribly despondent as I stood there with rain-matted hair and slicker dripping water on the floor, because she thought very hard for a moment and then said, "Let's see, you might try the folks at the plant nursery just a block down the road. They've been around here quite awhile and know most of the old landmarks."

I thanked her for the help, bought a cup of hot coffee to go, and sloshed my way back out to the car. It was raining really hard now, and the few shops in town were already beginning to close for the day. By the time I arrived at the nursery, the only life in evidence was a soggy, gray cat that quickly disappeared into a yard full of potted evergreens. Behind the evergreens was a house that was obviously the residence of the nursery folks, but there was no car in the driveway or any light inside. In fact, as I looked around, it was as though the whole town had suddenly closed down and the townspeople had vanished. My guess was that Saturday nights were reserved for a big time over the hills in Santa Rosa.

It was not until the following fall that I finally had another opportunity to pursue what by then had become almost an obsession. Although bits and snatches of reading research in the interim had not unearthed anything new on the Chernykh ranch, I was returning to the scene of my earlier disappointment with greater determination—

and with Andie for company on a "night out." It will come as no surprise that this was the day of my—how shall I put it—minor mishap, and that a few miles through the redwoods up Salmon Creek from Freestone awaited the night of our discontent in Occidental. Still, although the berry bush incident that Andie was chuckling about has already been noted in the bedroom scene, no mention has yet been made concerning the highly animated conversation we had at the dinner table beforehand. Hence it may be well to note that we were talking with such excitement and the content was so unusual that patrons at the tables around us were straining to pick it up above the din of the equally lively Italian music and dining room clatter. The conversation had to do with the events of our day near Freestone.

In retrospect it is difficult to think of that day as anything short of a fantastic dream. On the other hand, given the findings of my subsequent research, it was anything *but* a dream. Upon arriving in Freestone we had gone at once to the nursery. The used Chevy pickup we had bought with the present outing in mind was functioning beautifully. And this time, instead of a cold rain, it was cheery sunlight that poured out over the premises. Steller jays were flitting about and scolding from the surrounding redwood trees. Planting pots were alive with brilliant blossoms. A congenial nurseryman greeted us. Everything was so right that as I mentioned the name of Egor Chernykh I *knew* there would be an expression of immediate recognition on the man's face. Alas, it was not to be. Still, as on the previous visit, a referral was readily forthcoming.

"See George at his realty office over there in that yellow house across the street," the gentleman suggested, doing his best to be helpful. "George has a real flair for the history of these parts. If anybody knows where that Russian ranch was, George is the one."

Apparently nobody knew, because George did not. He was keenly interested and wonderfully accommodating, though. As a matter of fact, George—big, congenial George, with bone-crushing handshake to match—impressed us as being every bit as much interested in talking about "the history of these parts" as he was in talking about real estate. After rummaging through some of his old copies of the Sonoma County Historical Society's *Journal*, he came across the article he was hoping to find. Among other fascinating bits of local history, the article made reference to Rancho Cañada de Joniva, a

rancho of thousands of acres that had been granted by the governor of Mexican California in the early 1840s. By the close of the decade the Rancho, along with considerable other acreage (or "leagueage") had wound up in the hands of one Jasper O'Farrell. Although he later lost most of his vast land holdings in imprudent business ventures, he was a tireless public servant and the O'Farrell ranch was always a refuge for trail-worn and often nearly destitute newcomers to the area. The "area" included the very ground upon which George and we were standing.

Of even greater importance, our newly-found mentor knew precisely where the old O'Farrell adobe ranch house had stood. We stepped outside, and he pointed to the spot, which was marked by a double row of tall Lombardy poplars less than half a mile up a rise and off to the left of the road east to Sebastopol. Logically, he surmised that (1) if the Chernykh ranch had been located here in the Upper Salmon Creek Valley and (2) if the O'Farrell ranch had been established only a few years after the Russian exodus in December of 1841, then the O'Farrells might simply have added their own structures to what the former occupants had left. In addition, the lay of the land was so similar to the terrain in the Voznesensky sketch that I could hardly wait to take off my shoes and tread reverently upon that holy ground. If I had been more confident that George would understand, I would have given him a big bear hug.

Fifteen minutes later, having walked up the road, surmounted a couple of barbed wire fences, and reassured a barking but tail-wagging Labrador, Andie and I stood quietly beneath the poplars. Jasper O'Farrell and, if we were on the right rack, Egor Chernykh before him had chosen well. Aesthetically the site could not have been more satisfying. As we faced westward looking down to the foot of gently undulating fields, we could follow the alder and oak-lined course of Salmon Creek, as it ran across our view from northern headwaters and then turned in a westerly direction to make its descent toward the ocean. On either side of the stream, farmland continued down the valley for some distance, but the creek itself was soon hidden behind the shoulders of encroaching forested slopes. We promised ourselves a return visit to view this vista at sunset.

Looked at with the critical eye of a rancher, the site had other merit. An ample water supply was available from Salmon Creek and

nearby springs as well as from reservoirs along the creek's seasonal tributaries. The valley land was well drained and, being ten miles or so from the ocean, was free from much of the dense coastal fog that tended to destroy grain and make for poor viticulture. Given the labor supply obtainable from local Amerind communities (whether voluntary or coerced seemed to be a moot point), the potential for agricultural development must have appeared bright indeed.

As we poked about in the withered grass beneath the poplars we could make out bits and pieces of crumbled adobe, no doubt the weathered remains of bricks that had formed the O'Farrell ranch house. Since so few pieces were left, whole adobe bricks must have been toted off long ago for use in other frontier enterprises. There seemed to be little hope of happening upon remnants of the earlier wooden-frame structures of the Chernykh ranch, even if this had been its location.

We were about to return to town when Andie drew my attention to a rather curious ground depression that entered the poplar grove from the north. Stepping out from under the trees for a better look, we could see that it followed the contours of the hills, descending very gradually from the direction of an arroyo some distance to the northeast. Except for Andie's discerning eye, I would have passed off the trough as just another cow path, albeit a somewhat wider and deeper one than usual. On closer inspection it became clear that not only bovine hooves, but human hands, had fashioned it.

"I'll bet it's what's left of an old aqueduct," Andie ventured.

"Agreed," I replied. "How about following it to its source?"

"I'm game," she said, and so rather than heading back down into the village, we made for the hills.

With the channel's circuitous route and our occasional difficulty in picking it up again after totally eroded segments, the walk to the little arroyo took us longer than we had anticipated. Still, it was only twenty minutes or so before we stood on the precipitous bank of a nearly-dry but densely-thicketed creek bed. Tracing its green path down to the southwest we could just about see where, in season, the stream made its contribution to Salmon Creek. Rising more rapidly to the east, then north, beyond the cleared hillsides, the arroyo was soon lost under a cover of dense woods.

From prints deeply embedded in crusted mud near the arroyo's

remaining trickle of water, it was clear that an occasional cow, deer, or rodent had been the only recent visitors to the spot where we stood. Just below us a considerable amount of rock rubble clung to both banks of the stream bed, indicating that there had once been a small dam reaching to a level slightly higher than where the aqueduct left the arroyo. But it looked as though the flood waters of many winters had washed most of the barrier downstream, leaving the brook to pursue its wonted course. Above the tumbled-down dam the breadth of the stream bed, together with banks reinforced by natural outcroppings of sandstone boulders and overhung with a variety of vegetation, suggested that this must once have been a beautifully shaded, poolside hideaway.

As we picked our way carefully down through the remains of the dam to the creek bed, Andie commented, "Too bad, isn't it, that nobody bothered to rebuild the old dam again and clear out the aqueduct. It must have been a lovely spot."

"Yes, change is not always progress," I pontificated.

Then, as we were about to scramble back up the bank and retrace our steps to the poplars, eagle-eyed Andie once more found cause for reconsideration.

"What's that shiny thing up there?" she asked.

"I don't see it."

"Oh, come on," she chided, "look a little harder . . . up there on the left . . . on that boulder just upstream from where the old pool must have reached."

"Now I see it . . . probably an old beer can," I responded, sensing that she was about to coax me into working my way through a lot of brush and up a ten- or twelve-foot escarpment for nothing.

"I don't think so," she persisted. "It's too big for a beer can. Why don't you mosey up and have a look?"

"Mosey" was not the word I would have chosen to describe what it would take to cover the distance that lay between me and that beer can. A machete would have come in handy to make it up the creek bed, then some rope and belaying pins for scaling the monolith. However, my own curiosity having now been piqued and I being somewhat stoical about such ordeals, I bowed to the inevitable and began my assault on bramble and boulder.

The first leg of the trek went more smoothly than I had expected.

By getting down on all fours I was able to maneuver through most of the thorny vines and under the beautifully red overhanging poison oak. Having arrived at the base of the rock (still on hands and knees but with only a few flesh wounds and one small three-cornered rip in my—my *new*—Pendleton jacket), I was delighted to find that, by exercising some care, I could once more assume an upright position. From downstream came Andie's cheery encouragements: "Good going!" "You've got it made!" "Hang in there!" (as though I were not sufficiently strung up already), and other such irritating nonsense.

The task of scaling the miniature El Capitan posed no small problem. Only the foolhardy or immune would have attempted its left facade, which was shrouded in poison oak, while its right face was a mass of slippery moss. Undaunted, I edged my way up and to the right and, like Hillary before me, began probing to locate hidden chinks for hand and foot. Once again I was gratified to find the going easier than I had anticipated. The needed fissures were there waiting, one after the other, to right and left. In no time at all the arroyo lay far, far— well, eight or nine feet—below me. A moment later I could feel the vertical surface beginning to round off toward the summit. Another powerful surge and I was just high enough to make out and almost touch the gleaming prize atop the sandstone giant. It was a beer can, all right. In utter disgust, and momentarily unmindful of my somewhat precarious position, I lunged out to seize the abominable flow can, intending to heave it and a few derisive epithets back toward Andie. Alas, that emotive moment was the cause of my undoing, or, more generously, of my minor mishap. Suddenly the solid purchase that had secured my footing evaporated. Where only a split second ago I had been rigidly erect, I was now perfectly supine—quite laid back, you might say—falling fast, and dragging a tangle of berry bushes with me to meet the equally fast-rising mud flat below. The impact was stunning, as though I had been dealt a brickbat blow to the solar plexus—from behind. Only after a considerable period of agonized gasping, did a bit of air begin to find its way into the deflated recesses of my lungs. Then, mercifully, full consciousness faded into a tranquil blur.

When my eyes began to function again, they focused heavenward on a rather curious scene. Filtered sunlight penetrated here and there, first through leaves and branches high above and then, lower down,

through a lattice of vines. The only troubling aspect of the scene was a turkey vulture, which came into view intermittently as it circled over the labyrinth. Then, all at once, I was jolted wide awake as a worried face appeared directly above, sticking out over the massif.

"Are you okay, honey?" Andie called down anxiously.

"Sure, fine, just fine," I wheezed, trying to smile bravely but only managing a grimace. "How in heaven's name did you get up *there?*"

"Oh, I just climbed out of the wash on the opposite side from where we entered and ran up the open field alongside it until I got to where this boulder sticks up through the bushes." Her reply was much too smugly matter-of-fact. "You were right. It was a beer can. Sorry."

"It's all right. I was curious, too," I admitted, "but be careful up there. As they say, that sandstone is free falling. Just give me a minute to check for broken bones, and I'll crawl back to where we started. See you there."

"Okay, but take it easy," she cautioned, and her head flipped back out of sight.

Alone once more, I tried to rise to the occasion but found that I was wedged in between the undercut base of the boulder and a bundle of brambles. The least bit of movement was painful, both from without and from within. I was beginning to despair of figuring out any way to stand up, turn around, and get headed in the right direction for the downstream crawl. But above my head, barely within reach, was a rock protrusion that I had at first discounted as too feeble to support my weight. Now, as a last resort, I reached up, grasped it with both hands, and gave it a few trial tugs. Unbelievably, it remained firmly affixed to the parent stone. Slowly, but with mounting confidence, I entrusted my body to its safekeeping and hoisted myself to a standing position.

Ah, I had made it. Briars were working on my posterior, and the helpful outcropping had now turned on me and was poking me in the stomach. But there I stood, face to face with the base of the silent but cunning culprit that had done me in. There was much that I could have said to that big, ugly, lichen-covered hunk of sandstone, but never in the world could I have imagined that it had something—something of great moment—to say to me.

Maybe I had been too close to appreciate the fact at once, or perhaps it was the irregularities presented by the lichen encrustation.

In any event, I now stood amazed at the remarkably flat stone surface before me. In particular, an area about two-thirds of a meter wide and somewhat over a meter vertically resembled more the smooth face of a marble monument than the rough side of an unhewn rock. Using a twig from a dead branch beside me, I scratched tentatively into some of the lichen cover in an attempt to determine the cause of its irregularities. It soon became apparent that depressions in the lichen cover were the result of cracks or grooves in the stone surface beneath. A bit more scratching and the *whole* truth began to surface. These were not just your run-of-the-mill cracks and grooves. They were letters, letters routed out long ago by some human hand!

Completely forgetting the rendezvous with Andie and oblivious to the smarting fore and aft, I fished around in my jeans for my pocket-knife. Using the twig would be much too tedious if the groove clearing were to become a major undertaking. Damn! I had tossed the knife into our day pack after coring a couple of apples at lunch, and the day pack was back at the dam site with Andie. Frustrated but much too excited to stop now, I continued with the twig, replacing it with another and still others as each broke under the strain. After several minutes of feverish twig work, it became obvious that a more efficient tool was essential. A little help would be welcome, too.

Once again it was Andie who recalled me to the present. Her voice came wafting its way sweetly up to me from downstream: "You all right, honey? It's taking you an awfully long time to crawl back."

"Good grief, how could I have been so distracted—and dimwitted?" I wondered. She must be practically next to the pack."

"All's well," I called back, trying to keep too much excitement from spilling over into my voice. "I just ran into something kind of interesting up here. Do you think you could bring the day pack and come back to where you were on top the boulder? I'll explain when you get here."

Her response was not exactly enthusiastic, but it was affirmative. In a moment her face, plus an arm with the day pack in hand, again appeared over the edge of El Capitan.

"Want me to drop it down to you?" she asked. "What are you doing down there, anyway? I thought you were crawling back to the dam."

"No, just get my knife out and drop it," I replied in response to question number one. "The bag is likely to get caught in the berries

halfway down. I found some old writing in the sandstone down here, but it's mostly covered over with moss and lichen. I could use some help scratching the stuff off. Want to try coming down?"

"No, thanks. I'll just stand by up here and wait for your progress reports," she answered. "Here's your knife."

Fortunately, the knife hit my shoulder rather than my upturned face, and I was able to retrieve it without undue torment. As anticipated, the lichen removal went much faster now, but care had to be exercised in order to avoid further defacement of the soft stone façade. It was fifteen minutes before I called my first report up to Andie.

"In one section we have an '*es nuestro*,' and so we're going to have to brush up on our Spanish. Curious, though, because in another section I'm finding letters from the Cyrillic alphabet. I think the words are going to turn out to be Russian."

Andie may have said something in response, but I was unaware of it as I continued the gutting operation. Suddenly there was a thunderous landslide and a cloud of choking dust. Andie, wrapped in brambles but apparently without injury, was sitting at my feet.

"Your first report was so fascinating," she sputtered, "I decided I'd have to have a look."

I helped her to her feet, noting that, indeed, she had somehow managed the descent without destroying herself. She also had had the foresight to grab a spoon from our pack before making the plunge. As eager as I and with make-do tool in hand, she joined me in the frontal attack.

It was fully three hours later, by then late afternoon, when we completed our task. Before us, now free of moss and lichen and etched deeply in the smooth sandstone face, were four eight-line paragraphs, arranged neatly in a square. Below each paragraph was a name, and below the four paragraphs and names, at the bottom of the artistically bordered square, was a date.

The paragraph, or inscription, at the upper left was in Spanish. It was signed, "Maria." The inscription at the upper right, also using the Roman alphabet, was in a language unfamiliar to either of us. The only clue we had to its identity lay in our all too modest acquaintance with A. L. Kroeber's works on the languages of the Amerinds of California's northern coast. With what little we could remember of his phonetic listing of Amerind words and their English meaning, it

seemed that the inscription might be in a dialect of the Coast Miwok people, whose homeland extended from Sonoma on the east to Bodega and Tomales bays on the Pacific. A later return to Professor Kroeber's work confirmed our assumption but provided no clue to the meaning of the Miwok's signature, which was "Paca."

The inscription at the lower left made use of the Cyrillic alphabet but, here too, was a language unfamiliar to us. Once more it was Kroeber to the rescue, in that a phonetic reading of the paragraph reminded us of words we had encountered in his ethnological research on the Kashayas, that tribelet of the Pomo nation whose communities encompassed Fort Ross and extended for some thirty miles along and a number of miles inland from the coast. Here a return to the professor's work also established the meaning of the Kashaya name below the inscription: *Lekida*, or in English, *Glad*.

The fourth paragraph, at the lower right and also employing the Cyrillic alphabet, was in Russian. It was very useful to us for two reasons. Most importantly, it supplied a second written language to compare with the Spanish at the upper left. The other significant element concerning the Russian text was its signature, *Grigory*. Clearly the lettering of all four texts, as well as the date and border, had been fashioned by the same hand—the hand of a professional. There was no reason to doubt the authenticity of the signatures, for three of the four were the works of amateurs and as different from each other as from the hand of the master calligrapher. Grigory's was the master's hand. Never without pencil and notebook, I was able to copy the inscriptions in their entirety.

It was with reluctance and considerable physical difficulty that Andie and I tore—literally tore—ourselves from the sandstone façade and began to inch our way beneath the arroyo cover in the direction of the dam site. But the return trek, while as demanding as my upstream struggle, was abetted by the strong magnetic pull of what we both knew lay waiting for us in our Chevy pickup, abandoned hours— it seemed ages—earlier in Freestone's little picnic ground. In the truck's glove compartment were our Spanish-English and Russian-English dictionaries, tools without which we could expect to make little progress in the resolution of our textual tribulation.

Having mercifully been spared excessive torment in attaining the dam site, Andie volunteered to retrieve the day pack from the top of

the boulder and then catch up with me as I limped slowly back toward the poplars. Somehow, though, the ordeal of our return to Freestone was less painful than I had anticipated. We paused briefly by the poplar grove to enjoy the sunset we had promised ourselves, once again reassured the barking, tail-wagging Labrador, cautiously wiggled between the strands of barbed wire, and, in due time, at last eased ourselves onto the bench of the picnic table beside which we had left the pickup.

In a moment, however, Andie was on her feet again. She disappeared briefly into the truck cab and then returned to the table—dictionaries, cups, and thermos of coffee in hand. Immediately we set about comparing several key words in the Spanish and Russian texts of the inscription. What we found was that words with the same or similar meaning in both tongues appeared in approximately the same places in the texts. For example, *refugio* and *pr'i-yoot*, meaning refuge, shelter, or home, appeared in the first sentence of both texts, as did *valle* and *da-l'ena*, that is, valley or dale.

The obvious inference was that the two paragraphs said the same thing in different languages. It was but a small step to the further inference that the phonetic renderings of the Amerind tongues were repetitions as well. Later we consulted our friend Nicholas, who was not only fluent in Russian, but also well-versed in the Amerind languages of northern California. We were pleased to hear that our assumptions had not been presumptuous. In fact, it was as though we had discovered another Rosetta Stone, only ours was a "Freestone" with four rather than three linguistic constructions.

But before these speculations had been confirmed, we were engrossed in the tantalizing task of translation. With daylight fast fading on our picnic table under the redwoods, we had gone to work on the more manageable Spanish renditions of the text. After interminable discussion—haggling might be the more accurate term—over numerous English synonyms, we ultimately agreed that a reasonably respectable English version would read as follows:

> This valley is our home;
> We are one with her and she with us.
> We breathe of her air,
> We drink of her streams,

We eat of her plants and trees and creatures,
We sleep under her sky,
We rejoice in her beauty;
She belongs to no man or nation,
Nor do we.

Oh, yes, and the date: The new moon of October, 1839.

2

It was one of those strange, totally disoriented returns to morning consciousness. First, a happy-sounding "Good morning, Grigory" worked its way into my fuzzy brain. Then through eyes that would not quite focus properly, I could make out shafts of sunlight entering the room through the somewhat tattered lace of a curtained window. Finally a blurred face appeared directly over mine and the happy sound started to make sense.

"Gre-e-e-gory [titter] . . . Honey, are you awake?" Andie's query was accompanied by an affectionate peck on my forehead. "It's almost a quarter to ten," she said worriedly. "We were hoping to get up to Fort Ross by ten o'clock."

In our thirty-seven years of life together, Andie had never called me anything but Greg or, infrequently, when protocol (or exasperation) demanded, Gregory. What was this "Grigory" business all about? Aha! The inscription's Russian signatory! Suddenly I was wide awake, and, imbecilicly, overwhelmed by a sense of brilliance for having penetrated the cause of Andie's unusual greeting. But when I reflexively jerked to a sitting position all I could utter was, "Damn!"

"It's okay, honey," Andie responded. "We don't have to be there by ten. I just didn't want to waste any of this bee-yoo-tee-ful day."

Actually, my "Damn!" had not been occasioned by a concern for lost time. Apparently, the previous day's fall, followed by a night on listless bedsprings, had contrived to do me in. First, I tried to move my legs out over the edge of the mattress; then, gingerly, to lie down again. My back would have none of either course of action.

"Andie," I informed her dejectedly, "I think we're stuck here for a while. I can't move."

Andie mumbled something sweet and reassuring as she quickly plumped up our pillows and arranged them so as to provide me with a little back support. (The routine was nothing new to her. She had gone through it off and on ever since I had popped a couple of discs years previously.) Then she disappeared out the door and into the hall, throwing a "back in a minute" over her shoulder as she left.

She returned twenty-five minutes later, a coffee pot in one hand and a couple of cups dangling from the fingers of the other.

"Not much stirring down in the kitchen," she reported, "but the manager's an obliging old fellow . . . has a bad back himself. He brewed us up this pot of espresso. While he and I were waiting for the pot to work up steam, we chatted about the Chernykh ranch. He knows about the location problem. In fact, he says he's had a California history professor from Sonoma State overnight here at the hotel several times looking for the same thing . . . oh, yes, and another one from some college down near Santa Cruz. The profs are as frustrated as you are, Greg. It seems that the one remaining possibility of finding an accurate description of the Chernykh site lies in getting access to untranslated Russian manuscripts in archives somewhere in the Soviet Union. Not very encouraging, huh?"

Andie proceeded to fill the cups with that delightfully aromatic brew, rummaged in her purse for a moment and then turned to me again.

"Here, have a couple of aspirin with your espresso," she said. They just may find their way through that messed up back of yours and calm down the spasms."

"Thanks, sweet," I mumbled halfheartedly, unsure as to whether I was pleased to have the help or threatened by her being so darned efficient. Also, there was one thing Andie had not mentioned, and it really had me worried.

"You didn't say anything to the manager about the inscription, did you?"

"Not a peep," she smiled.

"Thank heavens!' I replied, relieved. "I take it you remembered what Nicholas told us about archaeological finds."

" 'Never breathe a word about what you've found or where you found it, especially if it's pre-'49, unless, of course, you want another gawdawful gold rush on site.' Right?"

Andie's smartalecky smile was justified. Not only had she quoted him verbatim, but she even looked and sounded like Nicholas as she intoned his warning of many years ago. As she did so, a wave of apprehension flicked on every visceral switch in my anatomy. Last night at dinner, in our excitement, we had talked pretty fast and freely about our discovery. We could well have been presumptuous in thinking that the decibel level of *Rigoletto* issuing from the dining room speakers was high enough to prevent anyone from eavesdropping.

I was thinking in particular of the fellow eating alone at the next table. He appeared to be innocent enough, even lost in some little world of his own. But, with no one to talk to, might he have been feigning that innocuous look in order to get in on a bit of excitement from *our* little world? Surely Andie's and my exuberance would have encouraged the effort. We have never been inclined to play our cards close to our respective chests, but we would have to be more careful now. It occurred to me that we had not yet even photographed the inscription, let alone plotted a plan to identify its signatories and reconstruct the historical situation that had occasioned such a vibrant outpouring of feeling and intent. Come to think of it, we had not yet even identified the present rancher on whose property we had trespassed.

Both the espresso and the aspirin were doing their work. With a brain that was functioning more clearly and a back that did not rebel at every little movement, I was able to make a few intelligent suggestions concerning a possible agenda for the day.

"Andie," I began, "your recall on Nicholas's warning was word perfect. What troubles me is that I think we may have unwittingly broken the rule already. Do you remember that fellow eating alone at the table next to us last night—forty-ish, tall, lanky, long straight black hair, somewhat piercing, deeply set eyes?"

"You mean the one in Levis, work shoes, and a black and red plaid lumber jacket?" she responded.

"I don't remember everything he had on, but, yes, I think he *was* wearing a jacket like that." Recovering from being momentarily distracted again by her detailed recall, I continued, "Did you get the feeling that he might have been more interested in our conversation than he let on?"

She poured the rest of the coffee into our cups, perhaps to give herself a moment to recapture the scene and mood of the previous evening, then responded thoughtfully, "What struck me was that he was definitely a local, not one of us outsiders. But unless he had exceptionally good ears, I don't think he could have heard more than snatches of what we were saying. The music was simply too loud."

"Well, maybe I'm being unduly cautious," I said, "but I wonder if it might not be a good idea for us to get back up to the creek today and take a few snapshots of the inscription. I'd hate to have someone messing around that stone who had little or no appreciation for its historic value, especially after all we went through to expose the lettering."

"Greg, you're insane! You know you're in no condition to go anywhere today," Andie protested.

She was right, of course, but the apprehensive feeling still nagged at me. I thought of asking if she thought she might be able to manage it on her own, but could not quite bring myself to bait her into what had all the makings of another ordeal.

We were mulling over a few alternative, less insane possibilities for the day, when a discreet, almost apologetic knock sounded at the door. From my bedded-down position I had to strain several resisting muscles in order to see past Andie to the visitor, who did not budge from the hallway as she opened the door and welcomed him in. The man stood no taller than she (and it is questionable whether Andie's avowed five feet four inches were attainable with any less muscle strain than that which I was suffering at the moment). Still, with commanding brown eyes and full but neatly trimmed, graying mustache and decked out in fresh white shirt, black tie, and well-pressed black suit, the gentleman presented a very impressive figure. In his hands was a linen-covered tray, and he was gesturing to Andie with it toward my bed. The two of them had a lively, if half-whispered

exchange, after which Andie turned to me to say, "Greg, the manager is here with a tray of Italian sourdough toast, cheese, fruit, and another pot of coffee . . . on the house . . . but for the life of me I can't get him to come in."

It was only after considerable effort that we were able to persuade our genial host that his presence, far from being an intrusion, was most welcome. It became clear that he was taking personal responsibility for the hotel's failing bedsprings which, he assumed, were the sole cause of my present unhappy condition. Once convinced of his welcome, there was no turning back. He and Andie pulled up chairs to the sides of the old, walnut-headed bedstead, the tray was uncovered and placed at my feet, another cup appeared from somewhere, and, in a moment, toast crumbs were tumbling down three sides of the white-covered slopes around my knees as the manager warmed up to our questions.

Giulio Bettini, into his seventies but still dapper and delightfully gregarious, had just enough Italian in his English to make it sound authentically Mediterranean. His father, we learned, had been among the early Italian immigrants to Occidental, or Howard's as the town was known in the 1880s and for many years thereafter. While still in his late teens the elder Bettini had gained passage to New York with other adventurers from Tuscany, found work with road gangs on the new transcontinental railroad, and gradually worked his way west. Arriving in San Francisco with two years and three thousand miles of railroading behind him, it was only natural that he should have found employment with another new and developing business venture, ultimately incorporated as the Northwestern Pacific Railroad Company.

Sausalito, lying just north of the Golden Gate and accessible by ferry from San Francisco, was the southern embarkation point for the NWP's narrow-gauge track. Over high trestles and through long, deep-cut tunnels, it wound its tortured but magnificent way through the hills, along the coast, and in and out of the redwood forests of Marin and Sonoma counties, arriving finally on the wooded banks of the Russian River. Both redwood lumber and vacation-bound passengers were the NWP's money-makers. But when Giulio's father found himself assigned to the company kitchen in Occidental, it was only the railroad crews, lumberjacks, and sawmill hands that the

kitchen served. In those early years, vacationing passengers might have got out to stretch at the Occidental stop, but their destination was the river.

Such was the situation when the elder Bettini and a few of his friends from Italy recognized in Occidental and its surrounding terrain a remarkable resemblance to their old haunts in the hills of Tuscany. Together with a number of Anglos and Hispanics who had settled the area before them and had equally sufficient industry and ingenuity to secure themselves in the Sonoma Coast wilderness, the Carlo, Antonio, and Giuseppe come-latelies were determined to stay. Somehow they managed to amass enough savings to purchase land and ship passage, and they sent for sweethearts, wives, and family to come and join them in their new Eden.

Giulio's father had always enjoyed the culinary art. Hence, rather than simply limit himself to work in the company kitchen as one might weather a period of indentured servitude, he had seized upon the long hours in that railroad cookhouse as an apprenticeship preparatory to the development of a full-blown family business. By the time Giulio's mother had made her way safely across the Atlantic and the North American continent, his father was already well on his way toward converting local tastes from flapjacks and potatoes to fried zucchini and spaghetti. By the early nineties, when Giulio arrived on the scene—fourth in line and first boy in a series of seven new Bettinis —the future of the family business appeared to be well secured. Still serving the railroad crews but no longer a company employee, Signor Bettini had become the proud builder, proprietor and owner of the town's newest establishment, a two-story structure with restaurant and family quarters on the ground floor and rooms for local working men above. It was positioned across and down the unpaved main street from the depot, and a large redwood placard, lettered in bright green and suspended by two heavy chains over the front veranda, proclaimed it "The Arno," after the beautiful river which flows through the heart of Tuscany.

Giulio was born in the family quarters of The Arno, grew up in its Italian microcosm and was waiting tables before he was ten. He had a command of the hotel and restaurant business by the time he was seventeen, and at twenty, he had married his childhood sweetheart, daughter of the proprietor of a neighboring Italian grocery store.

(Hence it is understandable that the mother tongue remained almost exclusively the language of the house.) Upon his father's demise shortly thereafter, he had assumed oversight of the family business.

While The Arno had emerged relatively unscathed from the great earthquake of April 18, 1906, it did not escape the ravaging flames of the fire that swept through town in the fall of 1923. Giulio's recollection of the inferno was vivid, as was his recounting of the community's struggle to build anew on old foundations. The heyday of redwood logging, so remunerative in the 1870s, 1880s, and 1890s was long gone, and the nation was soon to experience the financial disaster of October, 1929, with its ensuing decade of depression. But in the memory of old-time locals, the date of greatest immediate moment was that day in the spring of 1930, when old engine No. 90 picked up the NWP's last load of freight, mail and passengers in Occidental. Abandoned by the railroad and stripped of livable income from farm and fruit produce, the Bettinis' Eden should logically have slipped by default into the oblivion of Dante's Inferno.

Had the Bettinis and their compatriots been of less self-sufficient, less tenacious stock, oblivion might well have characterized the little community's future. But the close-knit and hospitable, if affectionately bickering, band had apparently long since developed an immunity against the depressing effect of poverty. Giulio had been among the first to rebuild after the fire, holding closely to the materials and design of his father before him. And somewhere deep within that uncanny brain of his had come the conviction that a new age lay ahead, the age of the automobile, and that the automobile would bring city folk to the country for a breath of fresh air, and that when they came they would be hungry, and that if they were served generously and well they would return, and if they returned they would want to stay over.

Giulio's wife had died three years before our visit, but their eldest son, his wife and their two teenagers had already assumed most of the operational end of the business. Giulio continued to do what he liked best, namely, to see to it that guests experienced personable Italian hospitality and, second, to kibitz in the kitchen, praising or doing battle with the cook, depending on the quality of the day's minestrone seasoning.

There was no local whom Giulio did not know personally, and

there was very little in the area, past or present, with which he was unfamiliar. Although he had no ready resolution of the Chernykh ranch enigma, he was not without his opinion concerning its location. "Signore," he concluded after we had discussed the mystery at length, "I'm a know how a you feel, but I'm a think you just have a to be patient until the professors, they find a the right book in Russia." Then in hush-hush tones, he added, "I'm a tell a you, though, I'm a think the Russian signore's picture, he must a be over in a the Coleman Valley when a he make it." Giulio's opinion was only a hunch, but it was the hunch of a man who was intimately familiar with the terrain and history of those hills and valleys.

He was rising to leave when it occurred to me to ask about last night's solitary diner—but in such a way as not to divulge the reason for our interest in the man. My lagging brain was desperately searching for some obtuse approach to the subject when Andie, with her ready-at-hand sixth sense working smoothly, inquired innocently, "Mr. Bettini, you no doubt know that gentleman in the red and black plaid jacket who had dinner at the hotel last evening. He impressed us as being one of the local residents, and Greg and I are anxious to talk with as many folks as possible here in town who might help us in our search."

"Sì, sì, Signora," Giulio responded, his eyes drifting off obliquely, "the signore, he's a very strange a fellow. He's a here all a the life, like a me, but he's a got a no wife or bambinos. His people are here a long a time before my people, they come a to this country."

Andie and I listened, entranced, as Giulio's biographical sketch unfolded. The man's name, we learned, was Peter Castro. Giulio and Peter's father, Ivan, had been fast friends. The two had been drawn instinctively together when, as fifth-graders in the community's little one-room schoolhouse, Ivan had come to Giulio's rescue. The teacher, Mrs. White, a dour young woman newly arrived from one of San Francisco's normal schools, was apparently a total misfit for the backwoods or, for that matter, any pedagogy. It was she who had occasioned Ivan's simple but endearing gesture.

One morning exasperated beyond endurance by Giulio's garrulousness, the schoolmarm had sentenced him to one month of hard labor chopping wood for the schoolroom's potbellied stove, adding in her anger, "You Italians! All you do is talk, talk, talk!" Without a word,

Ivan simply got up from his desk, walked to the stove, lifted the lid, and withdrew a partially burning log. The classroom was electrified, but no one moved. Mrs. White stood transfixed as Ivan, holding the log by its unburned end, proceeded methodically to her desk and carefully placed the torch on the paper-strewn desk top. Pandemonium suddenly burst forth, along with the flames, as other students rushed outside for pails of water to douse the fire. Each with an arm around the other's shoulder, Giulio and Ivan also moved toward the outside, but never to return. It was the last day of their formal education.

During the years which followed the boys became inseparable— inseparable at least in heart and during those moments of leisure granted them in otherwise long and, especially for Ivan, exhausting working days. While Giulio was helping mornings in the hotel kitchen and waiting tables in the evening, Ivan's lot was cast with his father and older brothers in the surrounding forest. Occasionally they worked as lumberjacks for a San Francisco company which had extensive redwood holdings in the area. Ivan's official employment, at fifty cents a day, was as water boy for the tree fellers. Most often, however, his work began at 5:30 A.M. with rounds through town for the family business. The Castros were the major firewood suppliers for Occidental's businesses and for a number of its family residences. Ivan's task was to make sure that each establishment had a pile of smaller split wood by the back stoop—neatly stacked and sufficient for the day.

Arriving at the kitchen door behind The Arno, Ivan knew that Giulio would already have the wood in place and the fire in the kitchen stove underway so that the two of them could have a few minutes to themselves without fear of serious repercussions. They would select a couple of cups from the dish drainer, pour themselves some hot chocolate, pull up stools to either side of the cutting block, and then plot their next heroic move to save their former, less audacious classmates from the tyranny that had continued to prevail under Mrs. White. The day's golden moment usually terminated when the chef, blurry-eyed, stretching and yawning, made his appearance in the kitchen. With a devilish grin, he would walk to the cutlery rack, remove one of the lethal-looking meat cleavers hanging there, and then with a deft flourish, sink it into the cutting block between the two boys.

Sundays also brought Giulio and Ivan together. There was no Catholic priest in residence, but Giulio's father had insisted that one

of the priests in Sebastopol, over the hills and through the woods some ten miles to the east, be assigned to celebrate Sunday mass for Occidental's predominantly Catholic community. Through the years a succession of priests, some begrudgingly, some welcoming the diversion, had covered the distance astride horse or mule on Saturday afternoon, heard confessions Saturday evening and lodged overnight in one of The Arno's rooms—Andie's and mine, Giulio told us. (We had wondered about a crucifix still hanging on the wall above the bed.)

Bright and early Sunday morning the hotel's comfortable parlor was transformed into a chapel. Chairs were carefully spaced, with a cushion on the polished hardwood floor in front of each for kneeling. A magnificent antique oak table served as altar and was covered with a snowy white linen cloth. The chalice, paten, tabernacle, candles and other accouterments were removed from their weekday display in the glass-doored parlor cabinet and reverently placed upon the altar. Behind it, on the mantel above the crackling hearth, a small, handcarved crucifix stood in its accustomed place.

In all of the arrangements, the priest was assisted by two very willing, if distracted, young aides, Giulio and Ivan. While Ivan was dressed simply in his Sunday best, Giulio was bedecked with the usual black cassock and white cotta of an altar boy. As the town's faithful and some of the hotel's Catholic guests began to filter in, Ivan would quietly move to one of the less conspicuous chairs at the side of the room where he could observe unobserved.

Our biographer, noting Andie's and my quizzical look, apologized for his anecdotal wanderings. "I know, I'm a take a too long a to get to Peter."

"No, no, Mr. Bettini," I assured him, "please don't apologize. We're fascinated. Besides, I think what Andie and I are wondering about is why you and Ivan weren't *both* altar boys."

"You call a me Giulio, sì?" he requested, smiling. "Okay, I'm a think I understand. With a name a like Castro, you think a Ivan, he's a be Catholic, too, eh?"

We nodded affirmatively, and Giulio explained. He had learned from Ivan that the family name was shortened to the Hispanic "Castro" in his great-grandfather's time—shortened from the Russian "Kostromitinov." As Giulio had anticipated, Andie and I looked at one another wide-eyed. In the 1830s a Peter S. Kostromitinov had

been the commandant of Fort Ross. To my knowledge, however, there was no record of the Commandant's having left any progeny in the Golden State after his transfer to San Francisco and ultimate return to Russia. In fact, I was unaware even of any suspicion that he had. The possibility that Ivan was descended from the fort's commandant seemed implausible for another reason. Unlike many others, the Russian colonists, perhaps because of pressures stemming from deeply ingrained Orthodox tradition, held it a moral duty to persuade their native bred and born families to return with them when recalled to their home country. Still, "Kostromitinov" was not exactly a common name in California.

Giulio continued to explain that he was not at all certain whether or not Ivan's great-grandfather was the commandant's son, although he, too, was inclined to believe not. The great-grandfather was born in Siberia, and, as Giulio concluded, "Maybe the Russians, they have a much Kostromitinovs . . . like a you have a the Smiths. But *now,*" he said explosively, "I'm a tell a you about a Peter!"

The broad smile which momentarily creased his already-wrinkled face quickly faded as he pondered how to introduce a couple of outsiders to a world that was at once painful to him and foreign to us. After a moment of silence and somewhat haltingly he began, "You see, Peter, his a papa, like a me, he's a take charge of a the family business not a long after he's a get marry. He's a marry a nice a Indian signora. But Ivan, when Peter's a be born, he's a get kill a when a beeg a redwood tree falls on a him a one day."

It was clear from Giulio's hesitancy and difficulty in finding the right words that he had seldom spoken about the death of his good friend. In such a small community, to have found, enjoyed, and then been denied intimate friendship must undoubtedly have left a deep void and yearning. Perhaps his continuing conviviality was in part impelled by the hope that some day another Ivan would appear in Occidental, and Giulio was not about to let him pass through town unnoticed. But if hope sprang eternal in Giulio, Ivan's tragic death affected his son, Peter, in quite a different way.

Peter, we learned, had also been very effervescent as a child. As he grew older, however, a strange melancholy began to displace the earlier spontaneity. Most of the folks who were acquainted with the Castros concurred in attributing the change to Peter's having become

old enough to understand his own implication in his father's death. According to Giulio's painful reconstruction of the tragedy, it had occurred on a blustery morning late one spring after a winter of very heavy rain. About a mile from town, down Salmon Creek, where the Castro cabin was situated, the duff-covered forest floor was even spongier than usual. Peter's mother was out behind the house hanging up the wash, the towels and sheets flapping and snapping in the wind as soon as they were pinned to the line. Ivan was close-by splitting firewood. Peter, still in a cradle, lay asleep within the cabin.

Suddenly, rising above the howl of the wind, a piercing, wrenching sound began to mount. It was a sound with which Ivan was only too familiar. Instinctively, judging the source of the sound and direction of the wind, he frantically waved Peter's mother away from the imminent danger as he himself leaped toward it. A towering redwood from which the eerie cry emanated, stood just upwind from the cabin and was already beginning to list noticeably toward it. From her refuge well to the side of the danger, Peter's mother watched aghast as Ivan disappeared into the cabin. The giant was well along on its terrorizing descent, when Ivan, babe in arms, appeared at the back door. One momentary glance skyward and he raced down the steps in the direction that promised least disaster. Save for one outstretched limb that seemed determined to destroy both father and son, he would have outdistanced his pursuer. But even as the immense limb caught Ivan and thrust him face-forward to the ground, little Peter flew from his arms beyond its grasp.

The earth trembled from the impact of the fallen monarch, and the noise of splintering cabin and breaking branches was deafening. Then all was quiet. Even the wind subsided to a reverent whisper as Peter's mother, holding the child close to her, bent over the lifeless form of her husband.

As though unburdened of a horror too long confined within him, Giulio sighed heavily. Then more relaxed, he continued: "Peter's mama, she's a quick a come here with the little papoose on a her back and a she's a tell us. The signoras here, they take a care of them; and a the signori, we drive a to the cabin to cut a the tree off a my friend and do what we have a to do." Giulio employed Peter's mother at The Arno, and she and little Peter became part of the Bettini household. It was all that he could do for Ivan.

For years the old Castro cabin lay in shambles, victim of the monstrous redwood that still appeared to be devouring it. Then one day when Peter was thirteen or fourteen years old, the lad abruptly announced to Giulio: "I'm going to fix up the cabin for Mama and me."

Giulio was somewhat taken aback by this matter-of-fact statement, but he was also impressed by the serious, determined expression on Peter's face. Smiling at his young protege, whose eyes were already almost on a level with his own, Giulio responded, "And who's a to wait table for me if a you run off a to the woods?"

"Don't worry, Papa Bettini, I'll come back every night and do my job." Again, Peter's reply came simply as a statement of fact.

Giulio had considerable misgivings about the boy's having any energy left for evenings in the dining room following days of backbreaking labor, first on the tree and then on the restoration of the cabin—and all of this in addition to Peter's youth and inexperience. Still, more than any other, he understood Peter's need to break away. Despite the Bettinis' genuine effort to count Peter and his mother as part of the family, the two of them knew they were not. The feelings lodged deeply within Giulio from his long experience of open, intimate friendship with Ivan, a half-breed, were not of a kind that could easily be projected into the viscera of others in the Bettini household. Try as she might, Mama Bettini found it all but impossible to express herself naturally when Peter or, especially, his mother was present. Something in the deeply-set, piercing eyes and unfathomable quietude of Peter's mother arrested Mama Bettini's usual easygoing banter. Even when simply assigning chores for the hotel's daily routine, she had to struggle to repress the self-consciousness and patronizing tones that inevitably surfaced. Giulio recalled one night when he and Mama Bettini were readying themselves for bed. Harking back to Giulio's boyhood experience and perhaps more impatient with herself than with Peter's mother, she had burst out: "If all we Italians do is talk, talk, talk, then all those Indians do is think, think, think! The spirit to bridge the hiatus between the two of them, indeed, willing, but fleshing it out apparently required a sort of constructive engineering that was beyond her.

Peter had timed his announcement well. In another two weeks he would be out of school for the summer and free to pursue his plan to restore his family's former residence. Rather than try to dissuade him

from the undertaking, Giulio had determined to confront Peter with the project's practical problems, which were formidable, and to help him organize his efforts. Giulio, of course, had sufficient experience from his own construction days to enable him to anticipate Peter's forthcoming frustrations. Hence, they devoted many after-school hours to on-site visits, long discussions and detailed note taking. There were the tools that for years had been locked away in the old Castro shed, the only structure that had survived the disaster. The tools would have to be repaired, oiled and sharpened. There were three times enough lumber in the fallen redwood to build a new cabin, but the tree would first have to be brushed out, its trunk trimmed, stripped and crosscut so that the logs could be trucked the eight miles down to Bodega for milling. The cost for trucking and milling should come to about half the value of the lumber produced. Hence, according to Giulio's and Peter's estimates, there would be not only sufficient lumber for Peter's needs but also enough cash to purchase the nails, roofing, plumbing, glass, wiring, hardware and other items essential to the completion of the abode.

Giulio's enthusiasm had its ups and downs during the two weeks of planning, waxing when he envisioned the new structure rising phoenix-like from the wreckage of the old, waning when he stood at the site contemplating the splintered devastation that must be removed. Peter's feelings, at least insofar as Giulio could assess them, ran a steadier, almost stoic course. His infrequent remarks or queries never reflected excitement about the completed project but only concern for its immediate, first steps. Indeed, Giulio was surprised to learn that, only a few days into their planning, Peter had already quietly obtained from his mother the key to the old shed, located the essential tools, and, with successive wheelbarrow loads, trudged the mile to town to deliver them into the hands of a classmate's father for repair and sharpening. Peter's only comment to Giulio was, "I'm going to give him some of the lumber to pay for it."

A few days later, still before summer vacation, the two of them were again at the site together. Giulio blinked unbelieving at the scene before him. A large brush pile was positioned for burning in the old clothesline clearing. Cut and stacked neatly by the shed for firewood, rose close to a half cord of unusable cabin siding. It was only a start, but it was an impressive one. Giulio took Peter's hands in his and turned the

palms upward. They were deeply cut, embedded with splinters and blistered. Exasperated and horrified, Giulio scolded, "Pietro, Pietro, why you don't a tell me? Just a you tell me and we give a you the gloves."

"It's okay, Papa Bettini, they don't hurt much," Peter lied.

With increased hotel patronage during the summer months, Giulio rarely found a moment to drive down the winding, wooded road to check on Peter's progress. On those few occasions when he did, however, the contrast between the bustling hotel lobby and the serenity of the Castros' brook-side hideaway provided a relished respite. Although the homestead was only a long, dirt driveway's distance down from the road, the redwood, oak, bay laurel, and shrubs and fern made its seclusion almost complete. Because the fallen tree lay between the driveway and the near side of the cabin, Peter was at first usually lost to view. Then, hearing a car approaching and curious to see who the visitor might be, he would emerge at some point along the top of the 170-foot stretch of horizontal trunk. Giulio remembered laughing and crying at the same time upon seeing Peter appear, a little David atop a slain Goliath. As Peter stood there, dirt-stained perspiration streaking down his cheeks, half the tail of a multi-torn shirt protruding from his baggy dungarees, an axe, bucksaw or one-man crosscut hanging from his listless hand (now gloved), Giulio found that his own cheeks, too, were wet.

Because of Peter's tenacity, it came as less of a surprise than earlier to Giulio when, toward midsummer, he arrived at the site to find the massive trunk departed. Peter had been obliged to make three crosscuts in order to reduce the tree to manageable lengths for the logging truck, but the deed was now done and lumber was in the making. In addition, only a small amount of debris remained where the cabin had stood. Giulio did not at first see Peter, who was sitting on the steps of the shed, off to the side of the clearing. A small strongbox, the lid open, rested on the step at his feet. In his hands he held what appeared to be a photograph, one in which he was so absorbed that he had not heard the approaching car. Not until Giulio hailed him did the lad look up, startled, and try furtively, if futilely, to return the object to the box unnoticed. Pretending not to have seen Peter's embarrassed effort, Giulio approached him, gave him a solid slap on the back, and happily proclaimed the obvious, "Well a, Pietro, you a do it! I'm a not know how a you do it, but a you do it! Tonight a we celebrate! You sit! I'm a serve you!"

Peter, still self-conscious but with the wisp of a smile making a rare breakthrough, obviously appreciated the congratulations—and the prospect of a night off from waiting tables.

"Thank you, Papa Bettini," he replied, and then with at least some semblance of continuing enthusiasm, "Look, I found the box that my papa kept important stuff in. Mama told me to look for it when I got the tree off what's left of the fireplace. It was in a secret place behind the stones by the hearth."

As they walked over to the rubble of the old stone fireplace to inspect Ivan's craftily concealed vault, Giulio thought to himself, "Ah, the patience in a the Indian." Soon after the catastrophe, he and others, to Mama Castro's apparent satisfaction, salvaged all of the household items that were accessible. She had not breathed a word about the strongbox but, instead, had waited quietly for thirteen years until the propitious moment arrived. It was as though she knew all along that one day Peter, as the man of the house, would be the one to tend to such official papers as the box might contain.

"So now, Pietro, you build a things up, not a tear things down, eh?" Giulio asked, breaking the silence.

"Well, both, Papa Bettini," was Peter's curious reply, but he explained, "I'm going to build a hogan, one that's partly sunk in the ground, and so I'll have to dig down before I build up."

Giulio was not quite certain about how he wanted to respond. An Indian dwelling was the last thing he could have envisioned rising to supplant the old Castro cabin. If it was the recovery of roots the boy was after, he was surely going about it with considerable ingenuity. But Peter had increasingly distinguished himself as a loner, and living with his mother down from town in the woods in a hogan was not going to endear him to the hearts of classmates or townsfolk.

Guessing what was running through Papa Bettini's head, and before he could conjure up the words to express it, Peter quickly continued: "But it won't be a regular hogan. It's going to have a cement floor and cinder blocks up above the ground a little and then eight redwood sides with windows and a roof that slopes up to a round dome on top, like the one in the picture Mama showed me of the little church at Fort Ross. And it's going to have a sink and a bathroom and electric lights and a fireplace in the middle and . . . "

"Just a one minute, Pietro," Giulio interrupted. It had been years

since he had heard Peter say so much all at once or speak with such complete abandon. Obviously, his young ward had gone beyond his earlier, almost exclusive preoccupation with immediate problems so that now, at least in his mind's eye, he saw standing before him the completed project—and this in extensive detail. Not that the immediate was no longer of concern to him. In fact, Peter's vivid description of the new dwelling helped Giulio to understand the significance of a comment that one of his carpenter friends had made only the previous day. Peter, he was told, had been stopping by to watch the workers who were constructing a new house. While asking only a few questions, the boy seemed to be observing every detail of the work with great intensity. Peter, as Giulio could now appreciate more fully, was determined that no hogan, especially an "irregular" one and a good one, would begin to be dug out and raised until he had learned some rudiments from master craftsmen.

"Just a one minute," Giulio repeated, "you think a you get the Russian and Indian in a one a place together, eh?"

"Well," said Peter thoughtfully after reflecting for a moment, "I hadn't thought about it quite like that, but, yes, I guess you're right."

Then, reaching into the strongbox, which he had carried with him to where they stood by the remains of the fireplace, Peter withdrew the photograph he had been studying upon Giulio's arrival. He turned it so that both of them could see.

"Look, it's a picture of Mama all dressed up with some other Indians in front of a hogan. She told me she lived in that kind of house when she and my father first met. I'll bet my father took the picture and the hogan is where she lived and the Indians are her family. I'd like our new place to look something like that so she'll feel at home. But she said my father went to Fort Ross with grandfather one time when some Russian Orth . . . Ortha . . . "

"Orthodox?" Giulio suggested.

"Yeah, when some Russian Orthodox priest came over from San Francisco to have a big celebration in the little church in the corner of the fort. I think it'd just been fixed up again—kind of like we're doing with our house. Anyway, Mama said my father really liked the little church and wanted to build a house someday that would look sort of the same, only with a fireplace in the middle with a chimney that

would go right through the dome or . . . what do they call it . . . the . . . "

"The cupola?" Giulio helped again.

"Yeah, the cupola. So you see, Papa Bettini, I thought maybe I could put Mama's hogan and my father's little church together, like you said, in one place."

It had been years since Giulio had seen Peter so animated, and never had he seen him so exhausted from talking. He smiled inwardly, not only because of Peter's unanticipated effusion but also because his visualization of Peter's dream house seemed to be such a curious and hopelessly irreconcilable admixture of styles. What would they call the new art form, indigeno-Orthodox? Or how about Russo-rustic? Still, what the boy was contemplating reflected a very beautiful intent. Giulio had not the heart to discourage him from the undertaking, no matter how *un*orthodox the plan. Besides, with Peter, he could hardly wait to hear the tap-tap-tap of a trowel positioning the last chimney stone in mortar atop the cupola. How could he know how he would like it until he saw it?

Perhaps it was my shifting to a more comfortable position on the bed or Andie's reaching for the coffee pot and pouring us another round. Whatever it was, Giulio suddenly fell silent and blinked, as though awakening from that decades-old moment with Peter and wondering what on earth he was doing here in this room with two strangers. Then, recovering, he said, "You forgive a me, my friends. I'm a take too much a time a to tell you about one little thing. I'm a not know what's a get into me this morning."

Andie and I looked at each other—dismally. The spell was broken, and nothing short of Ally Oop's time machine was going to transport Giulio back to that scene at the old Castro place. It was almost noon, and Giulio's attention was now diverted to the need for his presence downstairs with the guests in the dining room. He had already gathered up the cups, brushed crumbs from the bed onto the tray, and was rising apologetically to make his exit when Andie made a desperate last stand to hold him a moment longer.

"Giulio, thank you *so* much for bringing us breakfast and taking time to tell us about Mr. Castro. We couldn't have imagined that you

and he were so close. Do you think he would be willing to talk with us about the old Chernykh ranch?"

"Well a, my friends, I'm a don't know," he replied. Then, more hopefully, he added, "He's a stay pretty much in himself, but I'm a talk to him today and a we see."

He was almost to the door when I chimed in: "Giulio, assuming that I'm sensible and stay in bed this afternoon, I should be in shape to get down to the dining room for dinner. If Andie and I were to come down fairly late, would you have time to join us and maybe complete your rendition of 'Peter's Progress'? You've completely captivated us, you know."

Giulio did not catch the attempted pun—I probably should have worked up something from Machiavelli rather than Bunyan—but he smiled and, making his exit backward with a well-practiced bow, said, "It's a my pleasure. Dinner at a nine." The man was an incorrigible storyteller—and an uncured ham.

3

As the door clicked shut the room was suddenly very still. It was as though in that instant Andie and I had been transported from a busy city street into the hushed silence of a cathedral, then left there to contemplate earth's tumult. For some time neither of us disturbed the quietude. Finally, in a kind of reverent whisper, Andie said, "I can't believe it. We come up here to get a few clues to the location of an old Russian ranch and what happens? You go traipsing off after an old beer can and stumble onto . . . onto I don't know what, but it must be something terribly important. And I go trucking down to a hotel kitchen to get us some coffee and stumble onto a living legend. What's happening to us, Greg?"

Andie, of course, was not waiting expectantly for an answer to her question, but I wondered, too. The only thing of which I was certain was my impatience to hear the rest of "Peter's Progress" and, even more, to know if the man would allow us to penetrate his private world. Gentle repose, although sensible, promised to be a difficult regimen for the long afternoon hours. It occurred to me, however, that

Andie was bound by no such restrictions and that she could use the afternoon to resolve one question about which she was no doubt as curious as I.

"What is happening to us, my dear," I began, "is the inevitable consequence of a morning's walk through a century of Occidental history, not to mention occasional detours into the Russians' Oriental Siberia. We are hyperactive mentally and emotionally. In addition, we are physically famished. Lunch would provide a constructive cure for the latter condition. As for the former, to quell at least a portion of our quickened curiosity, I have a little errand for you to run this afternoon."

"Like for what?" Andie retorted, her reverential air having given way to a perceptibly suspicious tone.

"How would you like to take a little drive or, if it be your wont, a stroll down the road a piece in order to do a bit of undercover investigation for us?"

"Like for what?" she persisted.

"I assume that you are as vexed as I to be left wondering whether or not young Peter Castro ever completed his ecclesiastical wigwam. Our distress could be assuaged in a moment, were you but to mosey on down and have a peek."

"Oh no you don't," Andie flashed back. "You're not going to get me involved in snooping around that man's property. Besides, he probably has NO TRESPASSING signs posted all over the place."

"Only if his Orthodoxy should require them as reminders of his moral obligations."

She tried to keep a straight face, but I was sure that I detected a wisp of a smile. There was also a telltale conspiratorial tone in her voice as she said, "I'll bring up some cheese and crackers from the car for you. I'm not hungry, but I *am* feeling awfully cooped up after a whole morning in this hotel room. If you're okay, I think I'll get out for a walk around town while you nap."

Hooked!

A few minutes later Andie had delivered my lunch, such as it was, and then set out on the alleged walk around town. Getting painfully to my feet and edging to the window, I caught a glimpse of her on the street below as she paused momentarily to get her bearings before turning confidently toward the road that led to the old Castro place.

Having followed her as far as the window frame permitted, I eased my way back onto the bed and turned to the stack of books which Andie had thoughtfully left beside my pillow. Among them were several English translations of Russian works, which we had included in our mini-mobile library because of their power to create an appropriate mood for our adventure.

The title that caught my attention was A Journey To Arzrum, a first-hand account of one of Russia's military campaigns against Turkey in the 1820s. Its author was the celebrated Alexander Sergeyevich Pushkin. Just letting that name roll off one's tongue a few times was a mood maker in itself, but it was for another reason that I pulled Pushkin's little volume from the stack. The author, not quite thirty-eight, had died in the winter of 1837, victim of a pistol duel. Ever since I had first read of it I had agonized over the occasioning of Pushkin's death. In one of his captivating stories, "The Captain's Daughter," he, himself, had made such a point of the idiocy of personal duels. But, rather than the occasion for it, it was the date of his death that now held me. Pushkin had died only two years before Grigory, Maria, Paca, and Lekida had carved their names into that sandstone surface near Freestone.

As my eyes grew heavy and I stretched out full-length (gingerly) on the bed, I wondered whether Grigory might have possessed a copy of A Journey To Arzrum. Might he, as I, have been sickened by the futility of Pushkin's death? Might he, translating from the original, have read A Journey to the other three as they sat by a hearth, or simply a fire, somewhere in their valley? I wondered if they, as I, had pondered the senselessness of that slaughter in the Caucasus which Pushkin recounted, or the horror of the same sort of genocide half way 'round the world in their own California a decade later. The four of them were already becoming my friends, and they lingered with me as consciousness surrendered to dream.

Andie should have known better. I could hardly believe that she would pull her "Gree-gor-ree" gag on me again. My nap, filled as it was with fantasies of the four, while effecting a marvelous restoration relative to my lumbar area, had left me emotionally very tender in relation to any kidding about Grigory. Ignoring the crude, if unwittingly rude awakening, I turned toward the window and surmised from

its fading light that I had slept much longer than I had intended. Then my eyes slowly worked their way back to where Andie was sitting at the foot of the bed. She had taken off her coat and tossed it over my knees, close enough so that the scent of forest bay laurel engulfed me.

"Welcome back, snoopy. I didn't realize this town had enough in it to keep you nosing around for four or five hours."

"Oh, come off it, Greg," she protested. "You know very well where I've been. How's your back?"

"Sufficiently better for me to keep our dinner date," I replied. To prove the point to our mutual satisfaction I rolled slowly to my side, moved my legs out over the edge of the bed, and carefully pushed myself to a sitting position. Ah! No complaints from the lumbar region—and no more of the bedpan that Giulio had so discreetly placed by the bed earlier in the day.

Returning from the bathroom, I demanded, "Okay, out with it. What did you find?"

"You wouldn't believe it, Greg. I couldn't at first. Well, to begin with, there *are* KEEP OUT signs all over the property and a cable across the driveway . . . not too different from a lot of other places in the woods around here. Either these people don't like people or they've been pestered to death by folks who think they have a right to go tearing around and shooting up the territory."

"I can believe that," I replied testily. "Probably some of both. But what about the *house?*"

"Well, that's what you wouldn't believe . . . and don't get pushy. I didn't just walk right in and introduce myself. KEEP OUT signs make me nervous. It took me a while to find a spot where they were far enough apart so I could convince myself—or him—that I hadn't seen them."

"You devil," I interrupted. "If it'll help any to ease your conscience in retrospect, you weren't exactly planning to tear around and shoot up the territory, you know."

"Yes, I know that, but I was being awfully sneaky. Anyway, I finally did find a point of entry where I couldn't see any signs at all, but it was down pretty close to the creek. The willows and ferns were so thick and lush that I could hardly make my way up through them. It was kind of spooky, too. I don't mean just because I was trespassing, but

because it was so musty and dusky down there. There it was, the middle of a sunny day, and it seemed like twilight.

"Well, I'd gone through the really dense part of the foliage and up to where the ground started to level off a little, and I leaned against what I thought was a big redwood tree . . . and this you *really* won't believe . . . "

"Try me," I cut in smartly.

She stuck out her tongue at me, then continued, "Well, I *thought* it was a redwood I was leaning against. Actually it was a house—to be more precise, Peter's house! Peter finished it all right, and he must have finished it way back when, because it looks like it's been there forever. The sides are so weathered and moss-covered, and the trees and bushes have grown up so close to it that you just don't realize it's not part of the woods . . . until you lean on it and feel water dripping on your tennies and look down and see it's coming from a spigot projecting from the wall."

I noted that the only hideaway I had was the crawl space in our attic, but then inquired, "Does the house itself look anything like what Giulio described?"

"Exactly, and it's beautiful. Everything seems to be so—how can I put it?—so proportionally pleasing . . . like the Parthenon. Well, maybe that's stretching it, but it's hard to imagine that a kid of thirteen or fourteen not only dreamed up, but actually built, the place. It must have taken him years if he did it all on his own. And the inside is absolutely . . . "

"The *inside?*" I asked, alarmed. "You saw the *inside?*" At that instant I wanted nothing more than to be a true disbeliever. "What in heaven's name were you . . . ?"

"It's okay, Greg," she said, trying to head me off.

But it was not okay. From the neck up she had turned bright red, and she was beginning, nervously and unsuccessfully, to pick lint out of the bedspread.

"It's just that everything happened so quickly."

"Every *what* kind of thing?"

"Well, his coming up behind me."

"Who's coming up behind you?"

"Peter."

"You mean Mr. Castro?"

"Yes, Peter Castro, but by the time I left he was calling me Andie—or Andrea—and I was calling him Peter.

"And just precisely how long was it before you left?" (I could hardly believe I had asked the question. I sounded like the Grand Inquisitor.)

"Where the hell do you think I've been most of the afternoon, shopping in Sebastopol?" (Andie detests inquisitions.)

It was merely a little lovers' quarrel, but it seemed the better course of wisdom for me to be generous and back off a bit.

"Sorry, but you scared the living daylights out of me," I said soothingly.

"Well, for Pete's . . . for heaven's sake, Greg, I'm here and I obviously haven't been raped or manhandled or anything." Apparently she was satisfied that I really was sorry—and I was, kind of—and so she picked up where she had left off.

"I honestly *was* starting up the path toward the driveway when a voice behind me said, 'May I help you?' To say it scared the living daylights out of *me* would be a gross understatement. My first instinct was to run like crazy. Then I felt embarrassed. Then I got courageous, mustered up the sweetest smile I could, and turned around.

"And there stood Peter, in the same red and black plaid lumber jacket he had on last night with the same blank expression on his face. The door was open behind him, and so he must have seen me from inside. He just stood there, figuring, I guess, that *I'd* eventually figure out what to say if I had something to say. I was feeling terribly self-conscious, of course, but I think I finally introduced myself and told him about our obsession with the mystery of the Chernykh ranch, and about your back, and Giulio, and our just *having* to meet him—Peter, that is—and see his house.

"But, you know, Greg, he just went on standing there without a word. I had the uneasy feeling that I'd left something out that he was waiting to hear, and then it dawned on me that I hadn't apologized for coming unannounced. So I apologized. I hoped to heaven he hadn't heard me sneaking through the bushes from the back, but I don't think he could have seen me until I was up front on the path. If he'd heard me, he didn't let on. But he still didn't say a word, just went on standing there.

"I was about to tell him how nice it was to have met him, and to have seen his lovely house and then make a quick exit, when bango, a

burst of insight! He hadn't said anything because I hadn't asked for any help . . . and he had asked if he might help me! Well, I got really gutsy and asked for what I wanted most, which naturally was to see the inside of his house—if it wasn't an inconvenience. Presto! His lips were unsealed, and he said very matter-of-factly, 'It's no inconvenience. Please come in, and I'll tell my mother we have a visitor.' I can understand now what Giulio meant when he said that Peter is a 'very strange-a fellow.' "

"You really *are* a devil," I broke in. "But his mother . . . somehow I expected that she would have been dead by now."

"I'll tell you about her in a minute," Andie hurried on, "but let me tell you about the house first. There's a little veranda in front, level with the ground, and it's just wide enough for a chair on either side of the door. Peter carved the chairs out of solid redwood logs, and they're exquisite. They have full backs and armrests, and I know at least one of them is *very* comfortable—and so smoo-o-o-th. We sat out front and talked for a while after we'd been inside. And the veranda railings and posts still have the bark on them, and there's so much fallen stuff on the overhang that it's hard to tell where the woods leaf off (ha, ha) and the house begins. But it's the *inside* that's really unbelievable, Greg."

"Try me again," I encouraged her.

"Well, this rough, heavy-looking redwood door—just high enough for me, but not for you without ducking—this door opens into a half-round, stone landing, and then steps fan out and down to the main floor level. The first thing you see . . . oh, darn, I forgot to ask Peter about the design he'd worked into the landing. It looks kind of Indian."

"Amerind," I insisted.

"Okay, Amerind," she dutifully acquiesced. "Well, the first thing that draws your attention is the stone fireplace and its stone chimney that disappears up into the cupola. The whole thing is right splank in the middle and dominates the entire interior, and the fireplace opens out in all directions. I guess it's supported by pieces of train rail or some kind of metal posts that look awfully strong, and then the hearth projects outward with its edge following the octagonal line of the walls. A fire was crackling away, and it made the place feel and look so comfy with its warmth and soft light."

At that moment in our hotel room, neither Andie nor I could have anticipated the fascinating, if often strange hours we would be spending by the hearth as guests of Peter and his mother. Nor, at the time, could I fully appreciate all that Andie was feeling as she continued.

"Peter asked me to wait on the landing while he went to tell his mother I was there, and then disappeared somewhere back behind the fireplace. The moment alone gave me a chance to take in the rest of the room—and it does seem like one big, beautiful room, although there's an enclosed area on the far side of the fireplace—for a bathroom and a bedroom would be my guess—and an open stairway that leads up to a kind of curtained balcony above it. Each side has a window just above the ground, and so all you see of the outdoors are ferns and bushes and an occasional gray squirrel or jay—like those natural history displays you see in museums. Under one window on the back left there's a sink with cabinets on either side, but I couldn't see any stove. I'll bet they use the fireplace for cooking. And the furniture, Greg! It's all redwood and handmade and beautiful: a table, chairs, couch, a desk, lamps, everything. And the floor is redwood, too—redwood planking, I guess you'd call it—with hooked scatter rugs here and there.

"But it's the walls and the fireplace mantel, or what's *on* them, that provide the finishing touch. I've never seen such gorgeous Indian—oops Amerind—artcraft: baskets, beadwork, dolls, bows, blankets. You name it; it's there. And last but far from least, on two sides and reaching from the floor to where the ceiling beams start angling up, there are bookshelves *loaded* with books. I couldn't quite make out any titles from where I stood on the landing, but the volumes looked old and heavy. I found out that Peter's the reader, and he must be a *big* reader."

Andie took a deep breath and then, remembering my inquiry about Peter's mother, plunged ahead.

"Well, after two or three minutes, Peter reappeared from behind the fireplace and invited me in, assuring me that his mother was not disturbed by my having arrived unannounced. In fact, she wanted to meet me! Honey, I don't recall ever being quite so nervous and self-conscious, unless it was when you took me up to the bar at the Top of the Mark and proposed to me. Peter didn't ask if *I* wanted to meet *her*. I think he's very proud and protective of his mother and assumed that

anyone would consider it an honor to be granted an audience. And you know, I had the feeling that I was the first person who had visited that house for a long time, except for maybe Giulio.

"Anyway, he escorted me down the steps and across the room to the great fireplace and paused there, noticing that I was distracted by a couple of photographs on the mantel—the *redwood* mantelpiece, of course, and smooth as silk. The photos face so that you don't see them from the landing. But they're very handsomely framed and behind glass, and one of them is the photo that Giulio said Peter was looking at on the shed steps that day. I told Peter that Giulio had described it to us, and Peter blushed a little. I think he's still embarrassed by the incident—after all these years. The other photo is of his mother and father and his father's folks, taken before Peter was born. They're all standing on the front steps of the old house, and Peter pointed out the huge redwood tree that fell later. How a young teenager managed to saw through that thing I just don't know. I should mention, too, that Peter is the spit and image of his grandfather, and . . . "

I was beginning to sympathize with Peter's mother, wondering if Andie and Peter were ever going to move on around the fireplace to wherever it was that she was waiting.

"Come on, Andie," I said in exasperation, "what about Peter's mother?"

"You'll never believe . . . "

"Yes, I will!"

"Don't rush me. I'm trying to think of how to describe her."

"Let me help you. She's eighty-four and she's in bed in the back bedroom—reading Tolstoy."

"No, Peter thinks she's eighty—there's no birth certificate, of course—and she's, or she was, sitting in another of Peter's hollowed-out log chairs by the fire, in the cozy little nook behind the fireplace. She had a shawl around her shoulders and a blanket over her lap. The shawl and the blanket were . . . terrific." (Andie was making a valiant effort to bring her descriptive detail under control.) "And, no, she wasn't reading Tolstoy. She's about blind. Peter tried to get her to learn braille when her eyes started to go a few years ago, but it was too late. The will and energy just weren't there anymore. But I'll bet she *has* read Tolstoy. She's the one who made a reader of Peter. Later, on the veranda, he told me: 'Mother read to me every night when I was a

little boy and we lived at The Arno. When I was older and had learned to read myself, she got books for me from my teachers and from the priest and a few from her own people up north. Some of the books were about Russia or by Russian authors; others were about religion and about Indian lore."

"Note well, dear stickler, that he said 'Indian,' not 'Amerind' or 'Native American' but just plain 'Indian.' If it's okay for him, it's okay for me."

" 'Amerind' is a fairly recent term," I persisted obstinately. "Once he gets acquainted with the word, I'm sure he'll prefer it."

This time it was Andie who brought us back on track. Semantics are not really her "thing," and she had no intention of getting sucked further into linguistic combat.

"Mother Castro was simply sitting there, quietly thinking her own thoughts and enveloped in a world of her own. She must have heard our approach, but the expression on her face remained unchanged. Still, I had the feeling that she could see me—no, that she could see through me. Her eyes are like the eyes in those 1890s black-and-white photos of older Indian women, but not quite so piercing. Her face has all of the deeply-rutted wrinkles that you'd expect, distributed as you'd expect. The prominent, high cheek bones are there and the kind of tucked-in mouth and bent-over nose. Her skin is reddish-brown, but not so leathery because she's been inside more. But those eyes, Greg! They may not work very well anymore, but I don't think I could hide anything from them."

Andie was beginning to lose control again, then recovered and continued: "Peter didn't give me any cues, and so I just said 'Good afternoon, Mother Castro. I'm so pleased to be in your home and have this opportunity to talk with you and your son.' Calling her 'Mother Castro' must have been the right choice, because the trace of a smile momentarily crossed that otherwise passive face of hers, and she slowly reached out with a very bony, quavering hand. I put my hand in hers—reflexively, I guess—and we just stayed that way for what must have been at least a minute. Geez, talk about energy flow! It was as though I was suddenly in touch with antiquity—eternity even.

"Then she slowly withdrew her hand from mine and reached up to touch my face. Whango! More energy flow. She seemed to be satisfied with what she felt, and then, at last, she spoke. Her voice is sort of

halting and cackly, but there was certainly no evidence of senility in what she had to say, which began: 'You are most welcome to be in our humble house, Andrea.' It was very formal, very correct, very matter-of-fact, but somehow quite uncontrived and genuine, too, as though she always talked that way. The 'Andrea' threw me at first, until I remembered having told Peter the same. There was another minute of silence, which I was fast finding bothered Peter not at all. Then, strangely, I was spared putting my foot in it. I was about to ask her about herself—you know, her Indian name, where she'd grown up and all—when she spoke again: 'You are also welcome to inquire of Peter concerning our family heritage. He is much freer than I to speak of such things, because he was reared in your culture.' End quote, end of interview. Mother Castro's eyes were closed. She had obviously returned to that less disturbing world of her own, and I was stuck with Peter."

Again, Andie should have known better. In one of her rare lapses of memory she had forgotten one of Nicholas's injunctions: "Never ask an Amerind his name, at least not in your part of the state. To do so is a serious breach of etiquette. Were he to respond, his people and earth's spirits would consider him lacking in humility. Self-effacement is a virtue. Ask someone else about him." I assumed that the protocol applied to "her" as well as "him."

"So how did it go with Peter?" I asked.

"Well," Andie replied, "first I had to get used to the difference between talking with him and talking with Giulio. Peter is not just a horse of a different color, he's a wholly different breed. Give Giulio a little rein and he'll give you the ride of your life. Give Peter the rein and nothing happens. You have to get off his back and gently lead him along until he noses something of interest up ahead."

"A very apt and vivid analogy," I complimented her. "I hadn't realized you were so experienced in the equestrian art."

"Well, it was just like that. I prodded and prodded to get him to say something about himself, but didn't get much response—a few one-liners were about all. Yes, he did build the house, but not all by himself. Yes, it took several years but he should have spent more time on it. Yes, he made the furniture, but it's not very original. Yes, he reads a lot, but he's not *well* read. I was beginning to think he didn't feel any freer to talk about himself than Mother Castro about herself. Maybe she was just passing the buck."

Andie chortled, obviously pleased with her little pun. I did, too, despite myself.

"I was afraid your visit would steal Giulio's thunder tonight," I interjected, "but it would appear that there's no danger of his being upstaged."

"Well, I *did* finally get Peter cantering, even galloping, on one subject, which, of course, was his mother. I had remarked on what a gracious lady she was and on how she had entranced me with those fathomless eyes of hers, and then asked if she had always had such personal power or whether it was a distinguishing characteristic that had matured with her many rich and varied years of experience." (When Andie asks a question she really asks a question.)

"And his reply?" I urged.

"I thought Peter would take a moment—a *long* moment—to reflect on the matter, but to my surprise his response was immediate. 'I've never known her to be any different,' he said without hesitation. 'I don't know how much Papa Bettini has told you about us, but before she and father were married, she had been groomed to assume very important responsibilities in her people's part of the Pomo nation. Her father was one of the most respected Kuksu doctors among the Pomo. You and your husband would probably call such doctors shamans.'

"Well, Peter really got going on his Kuksu grandfather, and some of the details he got into made it clear that he knew his grandfather through long and intimate personal contact, not just through what he'd learned about him from his mother. For instance, he talked about the sound of his grandfather's voice—high-pitched and otherworldly—as he chanted songs, each one carefully selected from a seemingly endless repertoire which he used in treating one particular ailment or another. You know, Greg, if I'd had the nerve to ask him, I'll bet Peter would have sung one of those songs for me."

I thought to myself, "You should have worked up the nerve, dear girl. After my lousy rendition of 'Climb Every Mountain' last night you could use some good Pomo programming." But I was also wondering about how such a prominent figure as Peter's grandfather could have allowed his daughter, particularly a daughter with Mother Castro's charm and potential, to be released to the world of the paleface. The good Kuksu doctor's days had spanned that sad period in California history during which we Yankees completed what our Spanish and

Mexican predecessors had begun, namely, a ruthless, if rationalized, process of almost total disintegration and near extermination of the state's Amerind peoples. Ivan must have been *some* statesman—and a real charmer.

I half turned from the window where I had been standing listening to Andie, and asked her about the enigma. She was still sitting on the bed, but resting back on her elbows now. "I wondered, too," she replied, "and I asked Peter about it. It turns out that Ivan, because of the Indian-Russian mix in his parentage, was drawn toward his mother's people, especially when it came time to be looking for a spouse. His mother was a Kashaya, from over near Fort Ross on the coast, and she and Ivan's father were good friends of the Kuksu doctor and his wife— Mother Castro's folks—who were Southern Pomo and living then not too far from Guerneville, up along the Russian River, about ten miles north of here. With me so far?"

I nodded affirmatively, if somewhat doubtfully, and she continued. "How the two couples came to know each other Peter didn't tell me, but obviously their kids grew up knowing one another. Also obvious, once you know that, is the fact that Mother Castro's father wasn't exactly turning his daughter over to the enemy, nor was she abandoning her own people. Given the magnetism in Mother Castro at eighty, it's little wonder that Ivan found her irresistible when they were young. But it wasn't only his love for her that convinced the Kuksu doctor to give his consent to their marriage. According to Peter— which, of course, is actually according to what his mother has told him—Ivan became more and more steeped in Kuksu tradition. He and one of Mother Castro's brothers came to be bosom buddies (much as were he and Giulio)—what the Pomo call *awihinawas*—and so Ivan learned a lot of their songs and dances and ritual. In fact, it was at one of the Pomo confabs—Peter called it the 'Big Time,' where they get together and talk and eat and trade and do the Ghost Dances and everything—it was at one of those that Ivan asked Mother Castro's father for his daughter's hand in marriage."

Andie had mentioned Giulio's name again, and I was jolted back into the present. "Good grief, what time is it?" I asked. (I never wear a watch, my rejection of the practice stemming from the conviction that rebellion against our time-regimented culture is long overdue. However, I am not above asking others for help occasionally.) She

looked at her watch and, as shocked as I, rejoined me in the present.

"I can't believe it," she said incredulously.

"I can," I responded, "and I'll bet it's 8:54." (Because of my self-imposed watchlessness, I pride myself in having developed a highly accurate sense of time.)

"No," she said triumphantly, "it's only 8:51 . . . and forty-eight seconds," then added with less enthusiasm, "but my watch is slow. I wish you wouldn't do that, Greg. It's kind of uncanny, and uncanny things make me feel uncomfortable." At that moment she must have felt terribly uncomfortable, not just because it was 8:54, but because the last two days had been infused with more of the preternatural than we had ever experienced in so short a period.

Giulio, all smiles, was waiting for us when we entered the dining room at 9:07. I hastily tucked in the shirttail that I felt projecting when pulling down my sweater, then looked down dejectedly at a shoelace that was flapping around untied. Andie, struggling with similar problems from our quick change, was equally self-conscious, especially as the eyes of other late diners followed our ungainly procession to the little table for three where Giulio seated us and then sat down between us. I was about to apologize for our tardiness, but he beat me to the opener.

"How's a the back, my friend?"

"Much better, thanks to your solicitous attention," I replied, genuinely grateful.

"That's a good, and don't a you worry about a the bed tonight. When a you get a back upstairs, you find a she's a all fix up."

Andie and I threw a questioning glance at each other, but Giulio, who was obviously enjoying our perplexity, wasn't about to spoil his little surprise by explaining.

The loudspeakers, toned down this night, were giving forth with the overture to Rossini's "Barber of Seville" as one of Giulio's grandsons arrived with the hors d'oeuvres and a tureen of minestrone. Remembering the previous night's ordeal, a sudden feeling of panic flashed through me, but Giulio soon had me distracted from visceral concerns. In words that occur only to proud grandfathers he introduced us to the handsome, up-and-coming young man. Introductions completed, our blushing waiter backed away and Giulio turned to

Andie. "Peter, he's a tell me you and he have a good a talk a today." There was nothing accusatory in the statement, but one could detect just a pinch of the conspiratorial.

Andie is seldom caught off guard, and in this case she replied simply and honestly, "Yes, Giulio, we really enjoyed getting acquainted. With Greg confined to quarters and I finding myself with time on my hands, I'm afraid I let my curiosity take over. It's a world apart where Peter and Mother Castro live in the woods down there by the creek, isn't it?"

Breaking in, I said protectively, "And I'm afraid I egged her into going down there, Giulio. I hope I wasn't too out of line by jumping the gun and sending her off unannounced."

"No, no, my friends, no offense a. I'm a glad you get acquainted. Now you understand better what I'm a tell you about those a two. But better you ask a me what a you want to know, now a you meet them."

Andie did a masterful job of summarizing for Giulio what she had told me before our descent to dinner. Then, for both of us, she said, "Peter isn't so adamant as his mother in refusing to talk in the first person, but he's still pretty reticent about it. He told me a great deal about his father's interest in his wife's people, but we're wondering how Peter, himself, made out with them . . . and what he and his mother have been doing in that house for three decades or better.

Giulio's response, which was interrupted only by occasional questions from us, spanned the remaining courses of our second and much more relaxed encounter with the hotel's culinary productions. Peter had, indeed, made out well with his Pomo in-laws, having developed the same interest in and respect for their tradition as had Ivan. In one respect, he had advanced far beyond Ivan in the relationship, not only because of his longer and more intense tutelage under his mother and Kuksu grandfather, but also because of his own inherent tendency toward the mystical. Peter's was a world which Giulio could not fully enter or appreciate, a world which was at once filled with strange fears and profound spiritual resources. Still, the two men had remained very close through the years, held together perhaps by the unseen presence of Ivan.

But the story of Peter, although its principal was still alive and well, was no less tragic than that of his father. As Ivan, so had Peter fallen deeply in love (or risen to its heights) with a very charming young

woman from among the Pomo. They, too, had played together as children when Peter and his mother had attended the Big Time. But it was not until after a number of years' separation that they happened upon each other one day in the library of Sacramento State College, where both were seniors. The attraction was mutual and the romance blossomed. Arrangements for their wedding, which was to take place shortly after graduation, were already under way when the accident occurred. She had driven home to the Russian River to be with her family for the weekend. Upon entering the house she found her father, drunken and enraged, threatening her mother with a shotgun. She rushed to protect her mother, was shot, and fell to the floor dead.

Peter never completely recovered from his loss. For several years even his mother did not know his whereabouts or if he, himself, were alive or dead. Then one night he appeared at their home, begged her forgiveness for what he had put her through, and the two of them settled into life together in that largely unfrequented world of theirs. Peter devoted much of his time to reading but, over the years, also developed his skill in woodcraft to the extent that it had long been the source of a modest but comfortable income for them. Giulio noted that on rare occasions Peter would accept his invitation to drive with him to Santa Rosa and that, once there, Peter would disappear into the county library, where he would remain until Giulio had completed his business and was ready to return. When asked about his reading, Peter's reply was invariably in general terms having to do with his interest in the history of the area. That we had encountered him in the dining room the previous evening was unusual, in that his appearances in town were infrequent and primarily for the purpose of paying his respects to Papa Bettini.

The story ended as we were sipping the last of our strong—*very* strong—Italian coffee. In response to a call for assistance from one of the dining room attendants, Giulio excused himself. Andie and I remained at the table for a moment longer, reflecting on the travail of a fellow human being, which Giulio had rendered so vividly for us. Then, as we, too, rose to go, I reflexively reached over to snuff out the little candle that had cast soft light on our table. Somehow it seemed appropriate.

Giulio was absorbed in conversation with the cashier when we made our exit. His back was turned toward us, and so he did not

notice as we passed behind him. But we were close enough to over-hear him speaking—in *perfect* English! The rascal! He was not only a ham, he was an old fraud!

Although we were again weary and once more had been sumptu-ously wined and dined, the pull of the stairs was less arduous than the night before. Now all that lay between us and a peaceful closure to a most memorable day were the usual evening ablutions and changing for bed. Later, not only having completed the ritual preparations but also having forgotten Giulio's promise, we lay back on the old double bed. Then, abruptly, we both sat up on the "new" double bed. It was firm, all right—like a rock. I climbed out to inspect. Sure enough, following Giulio's instructions, room service had inserted a thick sheet of plywood between springs and mattress. I climbed back in and, once more, lay down—gently.

4

leep came quickly and easily to Andie. Her afternoon with
Peter, followed immediately by her report to me, a frantic
change for dinner, and an additional half-century of Peter, had left her
exhausted. My day had been more leisurely. As welcome as it was to
be stretched out on those sagless springs, I knew that sleep, too, would
approach at a more leisurely pace. A thousand thoughts crowded my
mind, and it was going to take a while to sort them out and assign a
few priorities before letting go.

One thought claimed my attention for several minutes, perhaps
because it was so comforting. It centered in the growing conviction
that there really was something to be said for retirement, a state of
being which was quite novel for me at the time. A partial vacuum still
remained from having relinquished the daily give and take with
students in my philosophy classes. But immediate experience of the
larger human drama, such as that in which Andie and I were presently
and seemingly inextricably immersed, was fast filling the void. In
addition, we were now free to pursue the experience more fully and at

tempos appropriate to the moods of the moment. No more discussions that must commence precisely on the hour and terminate promptly at "ten minutes to." Our intention had been to devote the weekend to an on-site investigation. Here it was, Sunday night, and it looked as though we could well become long-term residents of this little village near the headwaters of Salmon Creek.

Another thought followed closely on the heels of the first: Where to go from here in our inquiry? The adventure had issued from a broad, rather nebulous curiosity about Russian Orthodox and Hispanic Catholic relations a century and a half ago along the well-beaten path between Fort Ross and Sonoma. It had narrowed to fascination with the Chernykh ranch mystery. Then, totally unanticipated, the pursuit had come to focus on the identification of four people who had scratched their names and claim into a chunk of ancient sandstone. Now, again without reason aforethought, two other unknowns had appeared in the woods, unknowns who, even if unwittingly, just might provide the keystone that would firmly fix the precarious pieces of a neglected past in meaningful relationship.

Ah, Peter and Mother Castro! How I wanted to know what must surely be tucked away somewhere in those well-guarded heads of theirs. Or was it the spirit, at the core and more heavily guarded still, that really attracted me? I was uncertain. Perhaps the light of a new day would be sufficient to penetrate further the cluttered maze of my own probing spirit. But of one thing I was certain, and I smiled as it came to mind: Andie, doing what came naturally for her, had behaved admirably in that crucial initial contact with Peter and his mother. Her interest had not been to exploit but, rather, to enjoy them. There would be no need to mend fences on the morrow.

Andrea Maria (alias Andie) was still asleep when I awoke. Could it be that the perfect moment had arrived so soon—the moment, that is to say, at which I would wreak my revenge on Andrea Maria for her "Gree-gor-ee" the previous day? If I was to be identified with the inscription's Grigory, then, by golly, an early morning reminder that she and another of the rock's signatories also had a name in common seemed only fair. And what better mode for my little reminder than a heart-rending rendition of Bernstein's hit song from "West Side Story"? Turning toward my beloved and propping myself on one

elbow, I drew in a deep breath and let loose with the plaintive strains of "Maria." Over and over and with increasing intensity the name bellowed from my off-key voice: "Mar-ree-ya, Mar-ree-ya, Mar-ree-ya!" Suddenly from the other side of the wall came a thunderous pounding, followed by an equally thunderous voice: "Try to control yourself, fella; it's only 6:00 A.M.!" Overwhelmed with embarrassment I immediately desisted and called a weak "Sorry" through the wall to our unappreciative neighbor. Looking down at Andrea Maria, I found her with still-closed eyes but with a grin stretching from ear to ear.

It was not the best beginning for an otherwise magnificent, clear and bracing fall day. Not until we were seated for breakfast at Occidental's one thriving coffee shop, did Andie finally take note of the morning's abortive concert. I had retrieved a copy of the *San Francisco Chronicle* from the vacated table next to us and was hiding behind it when Andie said, "What do you say we call a truce and let Grigory and Maria rest in peace? If we start fooling around with those Indian names on the inscription, this thing could go on forever."

I let the newspaper crumple in my lap, much relieved that she did not intend to get further mileage from "Maria."

"Deal," I said, stretching my hand across the table to shake on it. "Besides, I have a great idea. How do you think Peter would react if we were to invite him to drive with us to Fort Ross today . . . after we photograph the inscription? If he's as interested in his Russian roots as he is in his Pomo past, he might go for it. If he did, I'd have a chance to catch up with you two in getting acquainted."

"I don't know, Greg, but it's certainly worth a try. Why don't we stop by his place on our way down to Freestone? If he's interested in going, I'll get a few things at the Freestone store for a picnic lunch before we return to pick him up."

As we finished our coffee we mulled over alternative routes to the fort, but the discussion was less a needed review than it was a distraction from letting our hopes mount too high. Aside from the problem of his possible reticence, our arrival at Peter's would again be unannounced. In addition, he might well have already made plans for the day. Nonetheless, we forged ahead, returning briefly to our hotel room to collect ourselves and our gear for the day's outing and then setting out on the one-mile drive down to Peter's.

Remembering the wire cable, which Andie had described as being

stretched across the drive leading down to the Castro residence, I had intended to park by the road. Upon our arrival, however, we found the wire removed from one of its posts and lying coiled at the foot of the other. Both of us had the same thought, but Andie was first to voice it.

"Do you think maybe, *somehow,* he knew we were coming?"

"Ridiculous!" I replied, doing my best to maintain at least a facade of scientific respectability. "I seriously doubt that the open drive has anything to do with clairvoyance, and I'm even less convinced that it has anything to do with us. There'll no doubt be a logical explanation awaiting us when we talk with Peter."

I eased our pickup into the driveway, and we followed its tree-tunneled route down to a little turnaround from which a path led to the house. As Andie had indicated, the structure itself was completely hidden. Not until we had parked and proceeded halfway along the overgrown path, did the contour of Peter's hideaway become distinguishable from the surrounding redwoods and madrones. Despite Andie's excellent word picture, that first glimpse held me spellbound. There was the inviting front veranda, and there were the ground level windows, which reflected the ferns and other greens of the forest floor. There was the octagonal shake roof, steeply pitched in its ascent to the cupola and chimney top. Yes, all of the parts did, indeed, converge in a proportionally pleasing whole. Even the wisps of smoke issuing from the chimney seemed to belong to the oneness of design, rising as they did to join the infinity that spread itself above the forest canopy.

Perhaps it was my impatience with her descriptive detail or perhaps it was that the door had been standing open when she had entered the day before. Whatever the reason, Andie had not mentioned the elaborately carved wood knocker which confronted us as we stepped onto the veranda and approached the door. Only the sturdy striker ring itself and its striker plate were of hard oak. The rest was an intricately detailed floral wreath fashioned from redwood. At the top, interspersed among the wreath's carved branches, were Cyrillic letters which formed the Russian word *privajet.* (The word suggests "private" but actually means "Welcome!") Hence, we took the knocker as confirmation of Peter's continuing interest in his Russian roots.

The oaken ring arced perfectly to accommodate three fingers and felt silken to the touch. When I rapped, the sound was mellow but

quite audible. As we waited, shoulder to shoulder, somewhat nervous and staring blankly at the knocker, we heard a slight rustle from somewhere far within. Then, after what seemed an interminable interim of silence, we could hear the padded shuffle of footsteps mounting to the inside landing. The door remained closed, but a tentative "Yes?" reached us from its other side. Andie threw one quick, agonized look at me, then turned back to face the door.

"Good morning, Mother Castro," she said cheerily, addressing the barrier between them. "It's Andrea, and I have my husband, Greg, along. We were wondering if we could speak with you and Peter for just a minute."

"Andrea?" The quavering voice from within was still hesitant, but almost immediately, fully composed and cognizant, it continued: "Andrea! Good morning, my dear! Of course, of course. But you will have to be patient with me. I have never been able to master Peter's instructions for unlocking this door."

"Please take your time, Mother Castro," Andie reassured her. "There's no need to hurry."

We smiled at each other as we listened to the rattle and clanking of chain and the fussing with an obstinate dead bolt. Eventually the din of battle subsided, and the door swung inward to reveal the powerful presence of that remarkable woman. She was wearing a turquoise-colored gown of Amerind design, and a beautifully knit, black shawl was gathered about her arms and shoulders. White hair, swept back and braided, was held tightly in a bun by a bone comb. Although only of average height, her erect posture gave the impression of greater stature. But, as Andie had indicated, it was Mother Castro's dark penetrating eyes which, while actually seeing very little, seemed to transfix all before them. As she offered her hand, first to Andie and then, in turn, to me, I wondered whether the energy flow I experienced was genuine or merely induced by Andie's earlier remarks. Having received the impression of a little old lady, blanketed and huddled by the fire, I was unprepared for the woman who stood before us, obviously ambulatory, almost spry. (It appeared that Andie was as surprised as I.) Without further ado she escorted us through the main room and past the fireplace to the enclosure at the rear, explaining on the way that Peter was engaged in his usual morning routine of study and writing and adding that his afternoons and, occasionally, evenings

were devoted to woodcraft. Her welcome was unreserved, but one could also sense a certain protectiveness when it came to Peter.

Arriving at the rear enclosure, she rapped gently on the door, then opened it sufficiently so that we could see her son, who, back toward us, was seated at a massive old oak roll-top desk. On one of its pull-out writing boards several open books were stacked, one upon the other. A confusion of papers and pamphlet covered the desk top. Book-filled shelves, floor to ceiling as in the main room, bordered the desk to left and right. As elsewhere, a window opened out onto the fern-covered forest floor.

Peter apparently had heard neither our knocking nor his mother's. Not until she spoke his name did he turn from the desk and, taken aback, rise quickly to greet his visitors. The reception, while cordial, was accompanied by the lackluster expression I had come to expect. Almost immediately, and also anticipated, an embarrassing silence began to set in—embarrassing at least for Andie and me. No doubt Peter was simply waiting for us to tell him how he could help us. Andie was, for some reason, disinclined to intercede, and so the initiative was left to me. I found it difficult to repress an almost uncontrollable desire to inquire into the nature of Peter's research. I also wanted to ask him about the open driveway, but, surmounting the urge, I managed to direct my remarks to the reason for our visit. The only problem was that it now seemed inappropriate to exclude Mother Castro from our invitation.

"Mr. Castro . . . or, if I may, Peter . . . and Mother Castro," I began haltingly, "Andrea I are planning to drive to Fort Ross today. If you are interested and free to go, we should be delighted to have you join us."

Silence. Perhaps I had broken some rule of Pomo etiquette. Maybe I had put the invitation too abruptly or formally. It may have been taken as an insensitive intrusion into their well-planned day. Whatever the reason for their reticence in responding, I hastened to elaborate on the reason for our presence and, if possible, ameliorate what appeared to be a most unfortunate impasse.

"You see, Andie and I . . . "

"Please," Peter interrupted quietly. "Please try to understand our need to take a moment to consider your thoughtful invitation. Actually, Mother and I find it flattering and, because of our conversation

with Andrea yesterday, most welcome. Although I normally hold to a daily regimen of study and craft, our days are, in the final analysis, our own. There is no problem there. Rather, the problem issues from our experience in response to a similar invitation some years ago, one in which the day turned out quite badly."

Peter did not name names nor did he recount the incident in great detail, but it was clear that he and his mother had been used for what information could be extracted from them, and then dropped. Their host had had no time for or interest in the immediate human encounter but only for and in historical data. Later they learned that even the data provided had been misquoted and that impressions freely expressed had, by insinuation or innuendo, been used primarily for the purpose of marketing a story, not for disseminating truth.

Peter's explanation was very straightforward, and it was clear that he intended no offense. The earlier incident, which may have been but one from among others had simply confirmed them in their inclination toward the solitary life. Andie and I, despite the favorable first impression she had engendered, were still relatively unknown qualities. Our enthusiasm had prompted us to move much too fast, to take too much for granted. We were about to exit, as gracefully as possible, when we found ourselves again misled by our own presumptuousness. Mother and son had reached a consensus. No word had passed between them, and I had obviously missed the knowing glance that had. They had decided to risk another bad day. Peter's Russian roots *did* run deep after all, and his mother was not about to be left behind to tend the fire.

Since neither Andie nor I had mentioned our intended Freestone errand, the Castros assumed that we were ready to go—now. Fearing that their interest in the day's outing might wane if we were to suggest a delay, we reorganized our thoughts for immediate embarkation. Their preparations were eminently simple. Peter, pen still in hand, laid it on the desk and donned the old red and black plaid jacket, which had been draped over the back of his desk chair. Mother Castro pulled the shawl more tightly around her shoulders, and the four of us moved toward the front door. The house check consisted of Peter's pausing momentarily to swing back the iron bar which held a blackened teakettle over the fire. As he was securing the front door, my attention was again drawn toward the knocker, and I complimented him on its intricate detail.

"The oak ring and striker block are from the original, which was crafted by my great-grandfather," he confessed. "The wreath and lettering were destroyed by the tree fall, of which Giulio has no doubt told you. I pieced them together so as to provide a model for their re-creation, but my work is only an approximation of the old." I waited expectantly, thinking he would surely say something more about his great-grandfather, but he made no further comment. The urge to press for that ancestral name was overwhelming, but such probing would have to bide its time. I did not intend to be held responsible for another "bad day."

The ladies had proceeded us on up the path, Andie steadying her aged companion as they walked slowly toward the turnaround. Once there, a second consensus was reached, this time by the four of us. Peter and Andie would endure the confining jumpseats behind while Mother Castro would sit with me up front. (Andie had little interest in getting behind the wheel, remembering only too well the narrow, winding, not to mention precipitous, road to the fort.) As we approached the head of the driveway, Peter asked me to stop so that he could get out and replace the cable, commenting that he had removed it earlier in the morning to accommodate the electric meter reader who had now come and gone. I felt it hardly necessary to burden Andie with a smug smile. In fact, I found the mundane explanation disappointing. Some good solid evidence for the occult would have been much more dramatic.

Since the selection from among several alternative routes to the fort proved to be of indifference to the Castros and Andie, I decided to try the old Coleman Valley Road. It was a little-used back road which began in Occidental, wound its way west for eleven or twelve miles through mountain meadows and wooded glens, along high, open ridges and, finally, down steep headlands to the Pacific. Reaching the fort would require another eighteen- or nineteen-mile drive north, much of it climbing and descending on a road that clung perilously to cliffs rising from a pounding surf. I had been told, however, that views from the Coleman Valley Road were unparalleled.

Now that we were under way, I was suddenly struck by the curious convergence of humanity crammed into our little pickup cab. Here on the seat beside me (and obviously relishing the adventure) was a woman whose people had, until the last century, roamed this territory

relatively undisturbed for two or three thousand years. Behind her was a man who shared not only in his mother's heritage but in that of the *promyshlenniki*, those Russian pioneering entrepreneurs who had fished and farmed in these parts over a century and a half ago. The remaining two of us were, by contrast, pale-faced newcomers whose forebears had arrived upon the scene via distinctively different routes and cultures. Andie was descended from that contingent of Welsh extraction which, in canvas-covered wagons, had plied its way west with Brigham Young from Illinois to the Great Salt Lake and later, on their own, to the Golden Gate. My folks hailed from German Lutheran and English Baptist stock that had settled in the farmlands of New York and Ohio. But it was not until the Roarin' Twenties that Mother and Dad pulled up stakes, climbed into their Model-T, and set out for California. No one could deny that the four of us comprised a uniquely authentic All American team, albeit sans rooting section.

The grade up and out of Occidental led through dense redwood, but after a couple of miles the hills rounded off and we passed through land which had been cleared for farming. We saw a decaying barn, an old frame farmhouse, and a picturesque little one-room schoolhouse. There were moss- and lichen-covered fences, some almost hidden under wild roses and sweet peas, all of which bespoke their long-lived presence. I asked Peter how long they had been here. His matter-of-fact reply could not conceal a genuine interest in the subject.

"The farm we just passed dates from the 1840s, only a few years after the Russians abandoned their holdings in the area. In fact, it could be the site on which Egor Chernykh developed his experimental farm in 1836, but of that I am not yet certain. Original sources concerning the location of the site are very meager and leave much to conjecture."

Without my having to ask, Peter had revealed at least part of the focus of his study. He had spoken as a competent historian and his antiquarian interests clearly included considerable concern with the Russian period of Sonoma Coast history. Recalling Giulio's earlier comment on the Coleman Valley site, it was also clear that he looked to Peter's judgment in matters historical. The only problem was that Peter's studied appraisal shattered my growing confidence in the authenticity of the Chernykh ranch's Freestone location. Surprisingly, however, I found myself untroubled by the problem. The mystery of

the inscription had simply relegated the ranch to the dubious status of peripheral concern.

We had reached the open ridge now, where grazing sheep and an occasional ranch house were the only intrusions into an otherwise wholly primeval earthscape. At a promontory, I pulled the pickup off to the side of the road, and the four of us got out to enjoy the view. I wondered if Mother Castro, because of the intense sun, was able to see more here than in the subdued light of their forest home. Perhaps she had got out to join us simply to feel the warmth of the sun on her face and to breathe in the scents of autumn, each of which she must have been able to identify from long and intimate experience. The sun had not yet dispatched the billowy layer of fog which hugged the coast and penetrated into San Francisco Bay through the Golden Gate, but most of the landmark peaks were visible above it. The more prominent ones were familiar to Andie and me, but Peter acquainted us with many others. Their names attested to the diverse traditions of those who had dwelt here before us. To the south, rising between us and the Golden Gate, was Tamalpais, the Amerinds' supine pregnant woman. To the southeast, sentinel both to the bay and to the great delta and interior valleys, rose Diablo, the Spaniards' devil mountain. Northeast was St. Helena, whose first recorded ascent was made by Chernykh, the Rotchevs, Vozensensky, and others from the Russian fort; and to the north towered Lassen, named for the Yankee who blazed the Old Lassen Trail.

It was not until we had descended the headlands and driven north along the coast past the Russian River-crossing that Peter volunteered further comment. Although Andie and I had asked few questions, he knew full well that we were restraining ourselves. Perhaps it was his own need to share what was of vital interest to himself, that and the fact that he had finally found a couple of people who appeared to be mutually interested and relatively unthreatening. Whatever the reason, he began to sound like a tour guide—with a touch of the guru.

"Just ahead and down to the left there you see the Russian River as it relinquishes its identity and is absorbed into the anonymity of the vast Pacific. Farther upstream the river flows through the land of my mother's people, the Southern Pomo. Here, near its mouth, it flows within the bounds of my father's mother's people, the Kashaya Pomo. Her village was situated near the river, close to the present little fish-

ing community of Jenner, which we are approaching. Her village was called 'At the south water,' because the river crosses their coastal territory near its southern boundary."

I could not help but take note that Peter's repeated references to his people's territory were stated in the present tense. His grandmother's and other villages may have disappeared long ago, but, to his mind, the identity of his people with the land remained inviolate. Except for a pitifully inadequate, forty-acre federal grant to them, few Kashaya Pomo now possessed recognized deeds to any considerable part of the land which for so many centuries had been respected as theirs. Those who survived the decimating scourge of smallpox in the late 1830s and the debilitating intrusions on their hunting grounds then and later had been obliged to hire themselves out as day laborers, living for the most part from hand to mouth. The story was not new, but it was, nonetheless, very sad. Peter and his mother could not be characterized as morose, but neither could they be fully understood apart from that sadness.

As we continued north, the coastal fog gradually gave way to a determined sun. By late morning, when the fort came into view, the day had become brilliant, giving the seaside setting of the restored stockade the picturesque quality that Voznesensky had captured so well in his 1841 watercolor. Our tour guide again sprang to life, but he directed our attention not to the fort but to a pleasant, partially forested area somewhat farther from the shore.

"It was over there, in the village of Mettini, that my great-grandfather was born. His mother, a resident of Mettini, had been but a child herself when Ivan Alexandrovich Kuskov came with other Russians and Aleuts to make a treaty with the Kashaya and build the fort. She grew up with the Russians and Aleuts as well as with her own people and was ultimately given in marriage to one of the Russians. That was in 1823, by Kashaya rites, which were confirmed in 1836 by the Russian Orthodox when Fr. Veniaminov came down from Alaska to visit the fort and several of the Franciscan missions near San Francisco Bay." Directing our attention to the stockade now, Peter continued: "The Russian Orthodox rites were celebrated in the little chapel, the building with the two turrets that you can see in the corner of the stockade nearest us."

I wanted desperately to ask Peter the groom's first name, but, again,

patience seemed the wiser course. Besides, Peter was forging ahead with his current commentary. Keeping my mind on track required a great deal of effort, but I knew that if I did not make the effort, I should become hopelessly lost in the tangle of his family genealogy. At the moment, pulling out notebook and pencil to assist my flagging memory seemed utterly out of the question.

"If you had come just a few years ago," Peter said, "you would have found the highway turning abruptly left toward the fort here rather than continuing past it to the northeast. The old road went right through the middle of the stockade, turned sharply to the right outside the southwestern wall, and then continued its northerly course. The site is much more authentic now that the state has restored the stockade and buildings in accordance with the original plan. John McKenzie, who was Ranger-Curator here for thirty-five years, gave himself completely to the restorative work. It was a terrible disappointment to him when, shortly before the road was rerouted, the restored chapel burned completely to the ground. But, as you can see, the chapel has once again been rebuilt, this time employing construction methods and materials that are even closer to the original. John is officially retired now, but he and his wife continue to live nearby, close to the scene of his life's work."

Clearly Peter was still the master craftsman, fascinated by and curious about every detail of this strange and lonely citadel overlooking the Pacific. The historian in him showed, too, especially in his concern to pay tribute to the curator, a man with whom Peter must have shared much mutual interest. I had anticipated Peter's attraction to Ross, but not his intimate acquaintance with it.

As we pulled into the new visitor parking lot a quarter of a mile north beyond the stockade, it occurred to me that Mother Castro might have some difficulty in negotiating the wooded trail back down to the fort. Peter, likewise concerned, suggested that we continue through the lot, which connected with the old road to the fort's southwest gate. A minute later, stepping out at the road's end under a massive eucalyptus tree, we found ourselves facing George and Mercedes Call's old frame house, which, from the late 1870s to the early 1900s, had served as the bustling center of their fifteen-thousand acre ranch and ever increasing family. The house stood sparkling white behind a colorful garden and equally sparkling white picket fence. The temptation was to sit for a

while on one of the inviting garden benches and soak in the warmth from a most pleasant midday sun. It would have been the perfect spot for a picnic lunch—*if* Andie had just had a chance to make the market stop in Freestone and *if* she and Peter had not already been assisting his mother purposefully toward the stockade gate. I could not be certain whether it was historical interest or the prospect of locating the public restrooms that urged them on.

The two, big yellow school buses beside which we had parked should have been a clue, but somehow Andie's shout from up ahead at the gate came as a surprise.

"Kids, Greg! There are kids all over the place!"

Reasonably, I had envisioned our visit on a weekday in the fall as a somewhat solitary and very quiet experience, with unencumbered rangers devoting full-time to answering our many questions. But when I joined Andie at the gate, the scene was as she had described it. From the old well at the center of the stockade grounds, paths spoked out toward the buildings around the perimeter. The paths had become a kind of racecourse for a game of fox and geese. Just to our left, children were darting in and out of the old barracks. To our right, from the eight-sided blockhouse at the southeast corner, little heads appeared, then disappeared from the firing slots. As an educator I had always had the greatest respect for the instructional value of school field trips, but this was more along the order, or disorder, of a field *day*—without benefit of agenda. There must be some explanation for . . . why, of course, it was the lunch hour.

Peter and his mother had disappeared somewhere into the crowd, and so Andie and I stood there for a moment to consult the park brochure and get our bearings before becoming enveloped in the pandemonium. Assuming that we would eventually come across our companions, we decided to shoulder our way over to the commandant's house, a very authentic-looking log structure tucked up against the interior of the west wall. Peter had told us it housed not only a splendid pictorial history of the fort, but also a fine collection of books, gathered together by the Fort Ross Interpretive Association.

As we ventured into the arena, a little fellow whose head was turned in the opposite direction ran pell-mell into my midsection. He held on to me to regain his balance, looked up at me sheepishly, and then resumed his rapid progress. Glancing down at my shirt front I

detected evidence that in one hand or the other the tyke was probably still holding the remnants of a peanut butter and jelly sandwich. I thought of calling after him to see if he had any extra but, on second thought, decided to inure myself to a lunchless day. Besides, Andie was tugging on my arm now, skillfully maneuvering us through the oncoming traffic in the direction of the "new" commandant's house. (The old one, which graced the north wall, had become an armory during the last years of the Russians' residency.)

Once inside, we found ourselves in relatively hushed surroundings. Apparently the children had less interest than we in history—for the moment at least. The several rooms of the house were now given over to exhibits depicting the Amerind, Russian, and American periods of the area, but one could imagine the throb of life which had once existed in them under Commandant Rotchev and his lady, Elena. The piano at which she had entertained themselves and their guests was no longer present, but an imposing old Russian samovar impressed us with the social significance of teatime in the 1830s. A sturdy, well-crafted writing desk reminded us that, despite his demanding duties as overseer, Rotchev must have had time to pursue his scientific and literary interests. No wonder they had later looked back to their assignment at the furthest reach of the Russian empire as having embraced the best years of their lives.

Blessed with the unexpected solitude, Andie soon became absorbed in the intricacies of some nineteenth-century Russian women's apparel, which was on display in one of the showcases. On a high stone shelf above the fireplace and well above the reach of children were a few books, apparently left by the park staff for the weary visitor who might welcome an opportunity to rest and read for a bit. Although not particularly weary, I made my selection, sat down on the ancient-looking oak bench by the hearth, and was soon lost in a fascinating tome on the infamous Alexander Andreivich Baranov. Andie and I had done this sort of thing many times before and, as on more than one of those occasions, so now we were to be chagrined by our obliviousness. Andie was the first to snap back to the present. I had no idea how long she had been standing next to the bench where I was seated, lost with Baranov in New Archangel, when she asked, "Honey, do you know what time it is?" Then, before I could reply, "Oh, I know you *know*, but are you *aware* of the time?"

The truth was that we had been on location in our respective nineteenth-century worlds for well over an hour. I stood up, quickly reshelved Baranov (in accordance with the sign above the bookshelf which enjoined the reader to do precisely that), and we ran more than walked to the door. The crowd in the stockade square had thinned out considerably, but we could see Peter and Mother Castro nowhere. We checked the restrooms and several of the other buildings without success. Finally, wondering how we could have been so unimaginative, we walked hurriedly to the northeast corner and mounted the steps of the little redwood-planked chapel.

The sanctuary was unfurnished except for a very simple altar, a single icon, and a few benches placed along the walls for the infirm. Soft light entering from the cupola's tiny rose windows fell upon the altar beneath. The icon was typical, with its luminous gold background and a nimbus over the head of a solemn, beloved saint. Peter and his mother looked up from where they sat to one side in front of a sunlit window. They seemed at one with the icon's saint. We had been in our worlds, they in theirs. Somehow, though, in that mutually welcome moment of reunion, our worlds touched and began to meld.

It was not until we turned off into the Castro drive that, in a kind of desperate, last-chance move, I decided to take the risk.

"Peter," I began cautiously, "Giulio told us that 'Castro' is an appellation which local Mexican *rancheros* found both convenient and familiar as an abbreviation for 'Kostromitinov.' " I left it at that, a simple statement of fact, but one that left boundless opportunity for response—if Peter was so inclined.

We had reached the turnaround, and I had brought the pickup to a halt and turned off the ignition. The quietude of the woods was suddenly overwhelming, and we continued to sit there in that kind of stupor which sets in during a long drive. I was about to dismount to go around to open the cab door for Mother Castro when Peter spoke. "Yes, Papa Bettini is right. He learned that from my father. But I would not want you to be misled by the information. As you must know, Peter Kostromitinov was the fourth of Fort Ross's five commandants and governed there from 1830 until well into 1836, after which he was reassigned by the Russian American Company to duties in San Francisco. I know it seems logical to assume that he was my

great-great-grandfather, because he was at the fort at the time of the chapel wedding, that is, in 1836. But he was not the groom, a fact which is beyond question for two very simple reasons. Fr. Veniaminov kept excellent records of the sacramental rites at which he was celebrant, and those records have been carefully preserved. For the year 1836, during the period of the priest's visit at the fort, their is no entry confirming Peter Kostromitinov's marriage, nor is there any other historical evidence for his marriage that year. Second, there is an entry which confirms the marriage of another Kostromitinov at that time, and the bride was a Kashaya.

"I have researched numerous Russian sources, but none indicates that any relatives of the commandant lived at Ross during his tenure there. Hence, I can only surmise that the groom had no social standing, and, being but one among the many Russian workers, was of little historical interest. Further the priest's entry included no middle name for the Kostromitinov who was married. In tsarist Russia all people of position had middle names."

My question followed naturally now: "And what was the groom's *first* name, Peter?"

"Why, the name of my great-great-grandfather, of course, which was the same as yours, only in its Russian form—Grigory. His bride's name, at least the nickname which she considered safe enough to be recorded, was Laughing Woman."

5

I had no intention of informing Giulio that we had overheard him handling good old American English without the slightest difficulty. His staged Italian accent was much too delightful to discourage. But when he approached our table and lingered for a moment to chat, we did inform him of our day with the Castros. Andie remarked on Mother Castro's almost entirely silent but apparently thoroughgoing enjoyment of the outing, her vigil with Peter in the chapel, and her gracious expression of gratitude when we left them at the house. We had invited them to join us at the hotel for dinner, but it was clear that the day had left Mother Castro with little reserve energy for an evening out. Also, there was little doubt about Peter's disappointment in having to decline the offer.

Giulio was very much interested in Peter's assumption concerning the two Kostromitinovs, a logical explanation which had either escaped him or about which he had not been informed. In relating the coincidence to him I was reminded of Peter's curious comment— curious to me, at least—concerning his great-great-grandmother's

name. For the record she had used her nickname, Laughing Woman, apparently because to have revealed her real name would have exposed her to some kind of danger. I told Giulio that I did not understand.

"Well a, my friend, you have a to know the Pomo to understand a why. The old a time Pomo, they live in a much fear. I'm a think Pietro and a his mama, they still have a some fear like a that, but a not so much. You see, the . . . how a you say . . . the Kuk-a-su doctor, he's a know by a the magic the right a name for the little bambino. It's a very secret, very religious, just a for the doctor and a the bambino and a the spirits to know. If a somebody else, he's a find out, the spirits, they get a mad. And the bambino, when he's a grow up, he's a get mad if somebody knows a the secret name. Maybe he's a so mad and so afraid the spirits get mad that he's a put poison in a that somebody's food."

"Do you really think Peter and his mother still have that kind of fear, Giulio?" Andie inquired, incredulous.

"Well, not a just a like a the old a Pomo," Giulio replied. Struggling (genuinely) to express as accurately as possible his own understanding of the Castros' present state of mind, he launched into a long, somewhat circuitous explanation. Mother Castro was pure Pomo; Peter, predominantly Pomo. But Peter's great-great-grandfather was pure Russian, his great-grandfather somewhat less Russian, and so on. Perhaps it was the very fact of diminishing Russian blood that led the paternal line to preserve what it could of its Russian roots. But the effort took place in Pomo environs, and so gradual but significant changes occurred in the thinking and behavior of the fathers.

With the advent of the Russian presence on the Sonoma Coast, Pomo outlook changed, too. There was further change with the coming of the Hispanics and more still after the Yankees arrived. Everything and everyone changed some. "Maybe Pietro, he's a have a the fear like a me," Giulio concluded. "Like a the secret name, I'm a have a some secrets that just a God has a to know. Maybe I'm a get pretty mad if somebody, he's a find out. Maybe God, He's a get mad if I tell, because a God, He's a not want somebody to get hurt. You know what I'm a mean?"

I was not at all sure that I did, but he was already excusing himself and moving off to greet, philosophize with, or simply entertain a couple of new arrivals. Left to ourselves, Andie and I welcomed the

opportunity to linger over our coffee and run through the events and relationships of another remarkable day.

"Giulio may have a rather strange and jumbled way of putting it," Andie reflected, "but what he said makes a lot of sense to me."

"Oh?" I was not so convinced as she.

"Sure, isn't there a big chunk of our consciousness which remains entirely private, wholly subjective, our deepest self?" she explained. "And isn't that undisclosed self what really drives us, the part of us that we can't, maybe shouldn't, completely disclose to any other? And isn't it that which the Pomo, through their myth and magic, are trying to shape and attune to the will of the spirits, just as the Orthodox and Catholics are through *their* myths and mystical rites? Even modern-day psychotherapists do something like that when they try to help the patient clean up the mess in his subconscious so that he doesn't hurt anybody, including himself, any more than necessary?"

Andie's college major in psychology was showing, but in a sense what she and Giulio were saying did ring true for me, too. Some of the deepest, most secret longings of the human spirit *do* have terribly debilitating consequences. Such drives as greed, lust for power and just plain lust come readily to mind. And fear *is* a motive which societies have long known to be a very practicable countervailing force, and they have used it broadly, often indiscriminately, to control and reshape our deepest drives. But I was not convinced, nor, did I believe, were Andie and Giulio, that fear was the only, let alone the best, instrument available for dealing honestly and constructively with our innermost selves. If it was a conforming society you were after, then scaring the hell out of everybody from the cradle to the grave, even to the point of being afraid to let anyone know your real name, was a fast way of getting there. But I wondered if the goal of conformity justified sacrificing the human spirit's longing to be genuine and open.

I also wondered if the four who had signed that inscription down near Freestone might have done so because they were wondering, too. Perhaps Grigory and Laughing Woman had had enough of Russian and Kashaya conformity. Perhaps the motive had been the same for Paca and Maria as they struggled to extricate themselves from the suffocating effects of Miwok and Mexican demands. I could almost hear Maria shouting, "*Basta!*—Enough!—This valley belongs to no man or nation, nor do we!"

Andie was looking at me curiously from across the table. She had been tapping gently on her coffee cup with a spoon, trying to retrieve me from my musings.

"Sorry, I was thinking about what you and Giulio said just now."

"I assumed as much, but what were you thinking about it?"

"I suppose it doesn't matter . . . or maybe it's what matters most. I'm not sure. But there's something that's been bothering me ever since Peter told us about Grigory and Laughing Woman."

"You, too, huh? But don't let me stop you."

"I don't think I can hold to Nicholas's dictum." Andie threw me a knowing glance, nodded broadly and affirmatively, and I continued. "It seems to me that Peter and his mother have every bit as much right as we to know about the inscription. In fact, I think theirs is a much more profound right. We happened to make a lucky find. Peter, if my assumption is correct, has spent the greater portion of his life trying to piece together and preserve something of his father's extraordinary heritage. Undoubtedly it would mean a lot to him to know."

"To say the least," Andie shot back. She probably had misgivings about my taking so long to wake up to the fact. "So how and when are we going to pass the word along?"

"Well, what do you say to another early morning visit to the ecclesiastical wigwam?"

"I wish you wouldn't say that, Greg."

"Say what?"

"You know what I mean. The Castro house is much too beautiful to disparage by such a flippant remark." I bowed my head remorsefully. "But that sounds like a good idea to me," she went on. "They didn't seem in the least disturbed this morning, and it surely didn't take them long to get under way. I don't suppose Mother Castro would be up to the hike to the site, but my guess is that Peter would be so excited—underneath—and eager to go that he might even forget to take along that red and black plaid jacket of his."

At first I was caught up in Andie's and, presumably, Peter's enthusiasm. Then a wave of uncertainty enveloped me. For Andie and me a return visit to the inscription would be simply an adventure. For Peter the event could well be fraught with an aura of solemnity, much like a pilgrimage to a holy shrine or a visit to a cemetery.

"On second thought, Andie, I wonder if Peter might appreciate a

little more advance notice. The whole thing is going to hit him like a bombshell, you know, and he may need some time to prepare himself emotionally—or spiritually, if you will—for the actual visit."

Andie did not respond immediately, but instead sat there idly running a finger around the lip of her empty glass. Then she looked up and said thoughtfully: "I think you're right, but I'm wondering, too . . . "

"Yes?"

"Well, if it's not too late, why don't we drive down to the Castros' now, tonight, and talk with Peter about it?"

I knew it was only a little after 8:00—not too late, really, for such a call, especially if one considered its substance. Andie dug in her purse for tip money while I picked up the tab and headed for the cash register. The bill paid and no Giulio about at the moment for further conversation, we were off. Little did we realize then that the night was even younger than we thought.

By the light of the pickup headlights it was not difficult to remove the driveway guard wire, which I had so carefully replaced earlier in the evening. Our excitement was running high when, having parked in the turnaround, we neared the bend in the path which afforded the first glimpse of the house. Ah! The window to the left of the front door was in just the right place so that we could see through and down to the hearth within, where a fire was blazing away. Through the window to the right we could see a lamp glowing and, in a redwood easy chair beside it, Peter cozied up with a book. Having made our way thus far by memory along the pitch-dark path, our stumblings became less frequent with the help of the shafts of light issuing from the house.

As we stepped onto the veranda and I raised the smooth, old oak knocker to rap gently, a familiar, warm feeling of "coming home" surged through me—so different from that morning. Peter must have heard our footsteps on the veranda's plank floor before I knocked, because he was at the door almost immediately, opening it wide, and, apparently unsurprised, welcoming us in. Mother Castro, understandably, had retired considerably earlier, but Peter busied himself grouping two more chairs by his next to the hearth and fetching the drinks which had been offered and accepted. Once comfortably ensconced in our chairs by the fire, we might ordinarily have expected some one-

liner, such as "and to what do I owe the pleasure of this nocturnal visit?" But not from Peter, of course. He just sat there waiting, figuring logically that we must have something on our minds and that we would eventually get around to it if given the opportunity.

He was right. We chatted and sipped for a while, simply enjoying the reliving of what had been a great day for all of us. Occasionally Peter even assumed the air of tour guide again, detailing further for us some of what he had gleaned from his research on personages and life at Fort Ross and the nearby Kashaya settlements during the 1830s. Finally, a lull in the conversation provided the opportune moment for me to disclose our hidden agenda.

"Peter, Andie and I happened onto something day before yesterday that belongs to you more than it does to us. We didn't know it was more yours than ours until you told us about your great-great-grandfather and great-great-grandmother today."

Peter looked perplexed but made no comment, and so Andie and I proceeded to recount our adventure in some detail. Andie, of course, made a point of including my misadventure, and I am sure I detected a slight wince as Peter vicariously experienced the fall. We concluded with a joint recitation of the inscription, which by then we both knew by heart, and noted the signatories and date.

I had expected a question and discussion period to follow immediately upon our dramatic conclusion, but Peter was not one to be anticipated. Without a word or even a glance in our direction he stood up, stepped purposefully to the bookshelves behind his chair, and knelt before them. I thought at first that there must be an icon on display somewhere among the books, but Peter was not kneeling in gratitude for the newly-disclosed revelation. After he had fussed around a bit removing a couple of books, we heard a spring latch click, and the bottom section of the stack in front of him swung forward. Behind it was a small door built into the wall below ground level. It was an ingenious arrangement for a house safe depository, certainly a step beyond his father's earlier hideaway in the hearth. Peter opened the door and pulled out a metal box, larger than I visualized but what I assumed was the family strongbox Giulio had mentioned. Having opened it, he rummaged through its contents until he located what he was after and then returned to his chair.

Peter held in his hand two very yellowed, wrinkled envelopes. From

one of them he carefully extracted an equally weathered letter, slowly smoothed it out on the armrest of his chair and, without explanation, handed it to me. Andie edged her chair closer to mine so that she could see, too. The missive was in Spanish and had been penned in Sonoma on the 19th of April, 1837. It's salutation was simply "Querido Grigory." Turning to the last of its several pages I saw that it closed with "Vaya con Dios, Maria." We sat there for a moment staring blankly, almost unbelievingly, at the sheets of paper. Peter motioned with a nod and a flip of his hand, reassuring us that we had his permission to go ahead and read the letter.

Again, the Spanish was slow-going for us, but the gist of its content soon became apparent. The letter opened with greetings to Laughing Woman as well as to Grigory, indicating that it was intended for both of them. Then Maria asked whether they were still working at the fort or if, as they had planned, they were now at the Chernykh ranch. The reason for her inquiry, she explained, was to ascertain if employment might be available for Paca (presumably her husband) and herself at either location. Conditions at the Sonoma Mission had so deteriorated since its secularization that working under the aegis of its civil or, more accurately, uncivil *administrador* had become intolerable.

Also, for good reason, she feared for the life of Paca if they were to remain in Sonoma. Not only was the *administrador* an uncouth and tyrannical overseer, he was a womanizer as well. The day previous, in her own home, she had been spared rape at his hands only because Paca, normally at work at the time, had returned unexpectedly and intervened. He had beaten the intruder mercilessly, and the *administrador* had vowed revenge. Even as she wrote, Maria and Paca were preparing to gather together what little they had and depart secretly by night. Their intention was to join Fr. Quijas, formerly resident priest at Sonoma but, at his request, now reassigned to Mission San Rafael Archangel. Maria was entrusting her letter to the hands of a friend who was traveling the next day to Fort Ross, and she suggested that Grigory address his reply to them at San Rafael.

A flood of memories surfaced from readings portraying life at the Sonoma Mission and pueblo during the 1820s and 1830s. With the arrival of Fr. Altimira and the establishment of Mission San Francisco Solano de Sonoma, that area's millennia-old Amerind age had come torturously to an end. By contrast, only a single decade elapsed before

the Franciscan hegemony was stripped of all but those powers and possessions required for the functions of a parish church. By the time of Maria's writing, Amerind and Hispanic alike were firmly under the control of California's Mexican government. On its northern frontier Sonoma was the seat of that control, and General Mariano Guadalupe Vallejo was, *de facto* if not *de jure*, its provincial monarch. Only the Russians on and near the coast were in a position to resist the Mexican authority, and that for only a few years longer.

Andie and I had come primed for Peter's (presumably) inevitable questions, but now it was we who most needed some answers. Surely the Maria who had penned the letter must be the Maria of the inscription, but who *was* she and what was she doing in Sonoma? How had she and Paca come to know one another? How had they become friends with Grigory and Laughing Woman? Before we could voice a single question, Peter handed us the second letter.

It also was addressed to Grigory but dated two weeks after the first. By the beautifully delicate hand we knew at once that this letter, too, had been penned by Maria. She and Paca had made good their departure from Sonoma and were feeling much more secure under the protection of their good friend, Fr. Quijas, in San Rafael, where there was also an able and responsible *administrador*. Appreciation was expressed for Grigory's prompt and genial reply (in Spanish), encouraging them to join Laughing Woman and himself near Pacajuhue, where they had made their home. The letter closed with Maria's assurance that she and Paca would be on their way within the week.

I assumed that "Pacajuhue" was the Spanish spelling for "Pakahuwe," the English phonetic rendering for a Coast Miwok village that had been located somewhere near the present site of Freestone. If the assumption was correct, then it might well be that "Paca" was simply a nickname given to Maria's husband by the Mexicans to identify his origins. Given Grigory's and Laughing Woman's residence near Pakahuwe, there was the further suggestion that the village may have been the site of earlier contact between the two couples or, at least, between one member from each of them.

My reflections were pure speculation, of course, but they provided the satisfaction of having tied together some loose ends. It would have been helpful to have had some of Maria's and Grigory's earlier correspondence and, especially, Grigory's reply in the present exchange. But

Peter gave no indication—at the moment—that other surprises lay waiting for us in the box. The only surprise was Peter's taking the initiative to speak first. Smiling and shaking my head in utter amazement, I was returning the letters to him when he said, "Thank you for entrusting me with the information about the inscription. If you are free to take me to the site tomorrow, I should very much like to see it."

Then, without waiting for our response, he continued, "Maria was a nurse. Her maiden name was Aguilar, and her father was a military officer stationed at the San Francisco Presidio. His father and mother had been among the party of 240 immigrants under Juan Bautista de Anza that, incredibly, accomplished the overland trek from northern Mexico to California with the loss of only one of its members—a mother who died giving birth to her child. While most of the immigrants settled in Monterey, some, including the Aguilars, continued with de Anza to San Francisco Bay where he selected sites for the authorized presidio and mission. Hence, Maria was a third-generation San Franciscan, tracing her ancestry there to the city's beginnings in 1776.

"Not all of Maria's childhood and youth was bound by the confines of the presidio. Occasionally she was permitted to ride horseback with her father on his routine visits to the mission. She never forgot what she saw at Mission Dolores as a young girl. Military discipline and punishment were facts of life with which she was quite familiar, and so it was not those aspects of the mission which disturbed her so profoundly. Rather, it was the rampant sickness and death among the mission's Indian neophytes, the consequence of exposure to European diseases against which they had no immunity. In addition, many of the Indians had been brought to the mission from sunnier, more protected climes across the bay and to the south, and they could not cope with the chilling winds and dampness of the new environment.

"Maria was but twelve when in 1817, the Franciscans' Father-Prefect Sarria, with the encouragement of Governor Solá, moved to establish an *asistencia* to the north across the Golden Gate. The governor undoubtedly welcomed the opportunity to create a buffer between the San Francisco Presidio and the perceived threat of the Russian presence farther north, but the padre's purpose was to provide a warmer, drier place of convalescence for the ailing neophytes of

Mission Dolores. Maria was with her father on his first tour of inspection at the new *asistencia*, where she witnessed the dramatic change in the Indians' health under the devoted and medically knowledgeable care of Fr. Gil y Taboada. This experience was determinative in setting her on a course toward nursing or, more accurately, toward what today is called service as a physician's assistant.

"For the next five years, much to the consternation of both her father and mother, Maria could most often be found in the presidio dispensary and small convalescent ward. The tiny, dark-haired, precocious but gentle señorita devoured what was available on the medical science of the time from the few books at hand, observed such treatments as were permitted an adolescent female, and performed the menial services to patients of which the officer in charge was only too happy to rid himself. During the last of those five years she was allowed to assist the padres at Mission Dolores in their preparation of Indian patients for embarkation to the *asistencia*, which by then had been elevated to the status of a mission itself—Mission San Rafael Archangel.

"On a cold, drizzly morning in the winter of 1822–23, Maria and one of the mission padres were at the dock helping some twenty of the sick to get settled aboard the oared launch which would ferry them north over the twelve or thirteen miles of turbulent bay water to their new home. The scene was dismal enough, but Maria was alarmed when she discovered one frail young woman to be pregnant and much closer to delivery than the padre suspected. Having reassured the frightened expectant mother that her secret was safe, Maria informed the padre that several of the patients might require special attention that day and that she had her parents' permission to accompany the neophytes on their bay journey. Although dubious about Maria's veracity, the padre was concerned to see that his charges were properly attended. When her father appeared at Mission Dolores that night, inquiring after his daughter, he was told of her morning departure. Not wishing to expose either his daughter's impetuousness or his own paucity of parental authority, he simply thanked the padres and left.

"The launch had pulled away from the dock that morning with six oarsmen, twenty patients and a nurse aboard. That evening, when it approached the dock on the slough below Mission San Rafael, an

additional passenger was loudly proclaiming his presence. Mother and child were doing well and, with Maria in attendance, were the first of the boatload to be assisted up the hill to the mission by Fr. Amoros. The padre was Fr. Gil's successor as head of the mission, and that night marked the beginning of ten fruitful years during which the priest and his eager and able, if uninvited, assistant labored together ministering to the sick at San Rafael and beyond.

"But that night also marked . . . " Suddenly Peter stopped. It was as though someone had turned off a talking book. In the unexpected stillness we could hear an owl hooting somewhere out in the woods and a bursting ember on the hearth spewed a shower of tiny sparks. Peter's eyes focused momentarily on the hearth, then returned to us. "Please forgive me. I must be boring you, rattling on as I have about a lot of familiar mission history."

In part Peter was right. Some of his account was well-known to us, but in my mission research I had encountered no mention of a Maria Aguilar. Either I was unaware of some very important sources or else that Castro strongbox contained a gold mine of undisclosed correspondence. In either case, we were far from bored and we told him as much. Hoping to get him back on track, I said, "If I have my dates straight, Peter, Maria must have begun her work in San Rafael only a few months before that hot-headed friar, Fr. Altimira, stopped there overnight on his exploratory expedition from Mission Dolores into the Sonoma Valley."

"The man wasn't only hot-headed, Greg, he was paranoid—with more than a touch of megalomania!" Ah, I had struck home! Peter had some emotions after all—and in that unguarded instant he had even let that black hair of his down far enough to call me Greg. I sensed that from here on he was going to sound less like a history textbook than a fellow sleuth.

"Yes, Altimira did stop over at San Rafael in June of 1823. But you're getting ahead of me, and Maria's first night at the mission is a story all in itself."

"I'll bed'd was love at first sight for her and Father Amoros," Andie put in. I noticed that her wine glass, which Peter had filled twice, stood empty on the hearth beside her. She had also had at least two glasses of wine at dinner, which meant she had consumed *much* more than she could handle in one evening.

"No," Peter responded, "but you're warmer than you realize." She was also warmer than Peter realized. "Actually," he continued, "that night marked the beginning of her relationship with Paca. As you might expect, she was exhausted from the day's long and demanding hours—including midwifery—in the launch. She was also on strange, frontier ground, separated for the first time in her life from easy access to the amenities of the presidio. And, with time to think about it now, she was distressed by the anguish her parents must be suffering.

"She had dined simply with Fr. Amoros and the oarsmen and, finally, was being escorted by the padre along the thatch-roofed arcade to a small guest room when it happened."

"Whud'd I tell you, Greg? Here comes the good part." Peter and I smiled indulgently at Andie, and he continued.

"They had passed several doors opening onto the arcade when Maria grasped the friar's robe, signaling him to stop and listen. She thought she had heard a sound—like a moan—coming from somewhere just beyond the arcade cover and their circle of candlelight. They stood motionless but heard no sound except for the quickened pace of their own heartbeats. They were about to proceed when the faint, definitely human sound occurred again. Both heard it now. Fr. Amoros cautiously ventured a step toward it, moving from the tiled walkway into the pitch-black night. Candle in hand, he extended his arm as far into the darkness as he could reach. On the sodden earth, barely within the periphery of light, they could make out the sprawled, prone figure of a man."

I simply could not control myself any longer. "Peter," I interrupted, "you didn't get all of this from the Bancroft Library. I know. I've spent months there in the shadow of the campanile hearing bells, bells, bells while I poured over every manuscript on California's Spanish and Mexican periods that I could lay my hands on. Come on, give. Either you have a great imagination or you're playing your sources awfully close to your chest."

Andie was beginning to pout because I had broken in just as Peter was getting to the "good part," and Peter looked somewhat taken aback by my unexpected candidness. I wondered if I had committed the grand *faux pas* of the evening. Fortunately, however, our disclosure of the inscription had earned us enough confidence points so that Peter was again inclined to reciprocate.

THE INSCRIPTION

Turning to Andie he postured, "Your husband comes on pretty strong sometimes, doesn't he?" Then, toying with me, he asked: "What's your guess, Greg?"

"I'm sorry," I said, and I really was. "It's just that I've struggled with this thing so long. Maybe I get jealous when somebody else knows something about it that I don't. My guess is that you didn't need to go any farther than that box of yours to get at what you've just been telling us."

"In part you're correct," he said, "but only in part. It's true that our family archives contain information . . . historically valuable but also intimately personal information . . . known only to mother and me. I have no intention of making any of it pubic before she and I are gone. But there are also frustrating gaps, making it very difficult for me to piece together important segments of our family heritage. Don't flatter yourself by thinking that you have done more digging than I, Greg. Not only those campanile bells but many others near mission archives are still ringing in my ears, too.

"And my imagination? Of course I'm imaginative. Sometimes my imagination runs wild, but there has been little need to embellish the account of Maria. She kept a very complete personal diary. Also, she possessed not only the ability to describe in vivid detail the events of the day, but also her innermost feelings. How her diary wound up with Grigory rather than Paca I am not sure, although I do have some thoughts on the subject."

"Meanwhile, bag-g'd the ranch . . . or the mission?" Andie pleasantly prompted Peter to return to the narrative and gave me a saccharin-sweet grin as he complied.

"Yes . . . well, the man was Paca, of course. Fr. Amoros immediately recognized the half-turned face as he and Maria, having rushed forward, bent over the man to determine his condition. Paca was not one of the mission's patients or neophytes, but he had assumed the role of occasional courier for communications between the mission and the Russians' establishment at Bodega Bay, or as they called it, Port Rumiantsev, which was situated some forty-five miles northwest of the mission. His people's encampment at Pakahuwe was about five miles off the established route between the port and mission, but Paca frequently had occasion to travel to both sites.

"His business at Bodega Bay was primarily with other villages, or

rancherias, of fellow Coast Miwoks. As the very able eldest son of Pakahuwe's chief, or captain, it most often fell to Paca to oversee trade between the inland and coastal communities: salt, abalone, sea otter pelts, mussels, shells from the coast for obsidian, game, and some of the finest, most tightly-woven baskets in all California from inland. But his business was also with the Russians. For more than a decade their presence among his own people at the bay and farther north among the Kashaya at Fort Ross had intrigued him. At first his people had regarded them as supernatural beings but gradually had come to accept them as fellow mortals. Still, their way of life was so different and, to Paca, so fascinating. More than once his father had cautioned him to remain aloof, but Paca found it impossible to ignore a people who were constructing great seagoing ships and forging useful implements of iron and fashioning leather into shoes which lasted much longer than the Indians' moccasins. His principal concern was to make sure that those Miwoks who were employed by the newcomers were treated fairly, but he was more of a mind to welcome than to fear what he envisaged as a new age.

"Initially Paca had also welcomed the arrival of the Spanish, with the establishment of the *asistencia* at San Rafael only five years after the Russians' appearance. The Miwoks had heard of the terrible sickness and death among the Indians at Mission Dolores. Provision of a place for rest and healing seemed a good idea, although to his thinking those in charge would have been well advised to observe obviously essential taboos and rituals in the curative process. He was also much impressed by the Spaniards' knowledge of agriculture, their style and methods of building, and their introduction of horses and cattle. Indeed, he had become an excellent horseman himself, an achievement which served him well as courier for the newcomers and emissary for his own people.

"As the *asistencia* developed into a full-fledged mission, however, and as the purposes of the Spanish, or by then Mexican, presence became clearer to him, Paca grew increasingly disturbed. True, he had experienced some blatant violations of labor contracts negotiated with Fort Ross. For the most part, however, his people and the Russians had been able to resolve most of the difficulties with some degree of mutual respect. With the Hispanics the relationship was almost entirely different. He soon learned that their intention was not

to negotiate with his people for their labor, let alone do business with them. Rather, they had come to 'save' his people . . . from or for what Paca was not quite clear . . . and in the process so dominate and exploit them that there could be no return to their own heritage."

"Uh, Peeder dear, d'ya remember that nide . . . the moan, the groan . . . ?" I could hardly believe that that had come out of Andie. But despite the not so subtle interruption and the lateness of the hour, Peter was still game for one more try.

"Yes, well, let's see. Where are we, Andrea?" Peter was toying again.

"Oh, you know, Peeder. Bee-yoo-dee-full sweed lil' Maria and the kindly ol' padre were bending ov'r thad grade big bee-yoo-dee-full hans'm hulg of masg-yoo . . . masg-yoo . . . masg-yoo-lin-uh-dee." (Andie barely managed to get it all out before slumping back in her chair. I had to hand it to her, though. She had made masculinity sound very Amerind—and me feel quite inadequate.) Peter continued unperturbed, if somewhat patronizingly.

"Yes . . . well, you are absolutely right, Andrea. Paca was a powerfully built, handsome young man. That night, however, he lay very close to death. As they learned the next morning, he was carrying a very important letter from Captain Charles Schmidt, present commandant of Fort Ross, to Fr. Amoros. Unfortunately Paca had got a late start, and it was already dusk when, still almost a mile from the mission, he dismounted in order to drink at a spring. He was attacked by a grizzly bear, an encounter which few have survived when alone and with only bow and knife accessible for protection. Before he succeeded in driving the knife home, he was badly mauled. His horse having bolted, Paca was obliged literally to crawl the remaining distance to the mission."

Andie, roused from her semicomatose condition, moved forward to the edge of her chair.

"By the time he reached the mission he was totally exhausted, running a high fever, and completely incoherent. The padre summoned one of the oarsmen who was just then emerging from the dining room, and together they carried the limp, bloodied form to the closest bed. It was in the guest quarters toward where Maria and Fr. Amoros had been walking. The bed, a rawhide-seated chair, a stand with washbowl and pitcher, and a crucifix were the only adornments of the little white-washed adobe room, but they were enough.

"Although the padre was quite capable of tending to the emergency, it was Maria who 'took charge'—a fact she noted with embarrassment in her diary. She immediately ordered hot water, soap, salves, and clean cloths and was soon cleansing and bandaging Paca's wounds, with the friar looking uncomfortably over her shoulder and assisting when requested. Once the wounds had been dressed to her satisfaction she began to apply cold compresses to Paca's forehead, hoping to control the fever. Father Amoros, considering it inappropriate to leave the pair alone, dutifully lingered on for some time. Ultimately, however, torn between propriety and the needs of his new arrivals, he opted for the latter."

Having breathed in the brisk night air during our walk up the path to the pickup, as well as having pulled herself up the stairs to our room, Andie was somewhat revived. At least she had become aware of her less than sterling performance at Peter's, the fact making her totally disconsolate and fearful that she would never be able to face the man again. Blessedly, sleep proved to be a marvelous healer.

In the morning, however, it became clear that Andie was still hazy about some of the details of the previous evening. Hence, I reminded her of our agreement to pick up Peter at 9:00 A.M. for the short drive to Freestone and the walk to the inscription site. Our brief but pleasant stop at the coffee shop served further to bring Andie around, and at nine sharp we pulled up at the entrance to the Castro drive. Peter was at that instant stepping over the guard wire. Explaining that his mother was too weary from the Fort Ross outing even for morning greetings, he hopped in behind us and we were on our way. En route to Freestone, Andie poured out her apologies to Peter, who did his utmost to dismiss the need for any regrets.

We parked up the road beyond town, once again maneuvered our way through the barbed wire fence, pacified the barking, tail-wagging Labrador, and walked along the old aqueduct to the arroyo, this time with camera in tow. I feared for Peter's red and black plaid jacket as we inched our way up the creek bed on all fours, but the route seemed preferable to Andie's previous descent from atop the monolith. Dirty, panting, and disheveled, we finally arrived at the foot of the boulder. There was scarcely enough room among the brambles for us to stand together, but somehow all three of us achieved a vertical position.

Andie was the first to see it, but only a whispered "Oh, no" escaped her. The inscription had been vandalized—methodically and thoroughly. It looked as though a hammer and cold chisel had been used to complete the desecration. Here and there bits of what she and I knew had been letters still remained, but that was all. For a long time we just stood there staring blankly at the blank wall, unable to move and not knowing what to say. At last Peter broke the silence.

"It's all right," he said. "I believe you."

6

The crawl upstream had been so filled with anticipation that we were oblivious to the inconvenience. Now, as we worked our way back to the aqueduct, brambles clutched us at every opportunity and sharp stones deliberately tore at our hands and knees. I could see tear streaks running down Andie's dirty cheeks. When we reached the ramparts of the little rock dam, we sat down for a while to catch our breath and, as each was able, to calm down a bit. It was some time, however, before quiet rage gave way to conjecture concerning who might have committed such an atrocity and for what possible reason.

It occurred to me that any number of people were aware of Andie's and my interest in the old Chernykh ranch. We had never been secretive about it. Also, people had suggested places to investigate, and other folks had overheard those people making suggestions. Anyone who was curious could have observed us searching under the poplar trees and following the course of the old aqueduct. They could have returned later to retrace our steps and discover the inscription for themselves. But why anyone should want to destroy it eluded me.

Again, it was Peter who broke the silence. I had assumed that he was also struggling with the motivational problem, and so the substance of his comment came as a total surprise.

"You know," he said, "I've always considered the disposable flip-top can to be one of American technology's predictable but less commendable achievements . . . a contemporary symbol of American society's self-indulgence and tragic disregard for the beauty of the earth. But in this case it was just that, a discarded beer can, which became an object of inestimable value . . . a beacon, so to say, guiding you to a rendezvous with the richness of our heritage." Andie and I sat there nonplused, not quite knowing what to do with the observation now that it had been delivered to us. But Peter was not finished.

"On a number of occasions I have sat exactly where you and I are sitting right now, but at no time was I ever inclined to fight my way to that boulder . . . even though I knew the inscription must be somewhere in the vicinity."

"You what?" Andie and I voiced our disbelief almost simultaneously.

"Yes, as I mentioned last night, Maria kept an excellent diary. The making of the inscription was a very important event in her life. The writing was as you have it, although my translation of the Spanish varies slightly from yours."

"But how did you know it must be somewhere around here?" Andie asked.

"Let's climb up the creek bank and get out on the open hillside where we can see better. I think it will help if I show you as well as tell you."

The mid-morning sun felt good after sitting in the chilling shade of the trees overhanging the arroyo. It also reflected cheerily from Freestone's little cluster of homes and stores which nestled comfortably less than a mile off in the upper Salmon Creek Valley. Looking into the valley, we could follow the southerly course of the stream by the vegetation which lined its banks, then could see it rounding the town before it was lost from sight on its way west toward the Pacific.

"For many years there were three Miwok villages here in the upper valley, all of them close by the creek. One, called Oysyomi, was situated just downstream from where the town is now. A second, named Patawayomi, lay just opposite the present townsite to the east. The third . . ."

Here Peter directed our attention to a relatively flat area, now a ranch, between us and the town and just below the confluence of our little arroyo and Salmon Creek. "The third," he said, "was Pakahuwe. It has always seemed incredible to me that the three were able to co-exist in such proximity, but there is nothing in the tradition to suggest any major conflict among them. I suppose the abundance of the annual salmon run and other fish in the stream, game in the hills, and acorns, berries, and tubers were adequate to sustain them. Still, it must have required some very skillful diplomacy to stabilize the arrangement."

The sun had thawed us sufficiently so that we took off our jackets, spread them out on some smooth sandstone that projected above the yellowed wild grasses, and sat down again. I wondered if our foursome might have done the same a century and a half before.

"So Paca lived just below us down there when he made that trip to the mission in 1823," Andie said, mentally pulling events and dates together. "And Grigory and Laughing Woman were here when Maria wrote them from Sonoma in 1837, and all four of them were here when they carved the inscription in 1839."

"Yes," Peter responded, "or at least in this vicinity. That's confirmed by Maria's diary and by her correspondence with Grigory. My principal concern, of course, has been to glean from Maria's diary and letters whatever shed light on Grigory's life. There are some terribly frustrating gaps, but the material has been of immeasurable help because their lives and Paca's and Laughing Woman's were so closely bound together. I'm not sure what part of the story would be of particular interest to you two, and so you'll have to tell me what you would like to know."

Grasping at the opportunity, I rushed in before Andie had a chance. I knew she was dying to hear the next installment of the Maria-Paca affair, but that letter from Schmidt to Amoros had me intrigued. "It's probably not the question you were expecting, Peter, but did Maria say anything about the letter Paca was delivering?"

"Actually I had expected you to ask the question last night . . . because of the 'Russian connection.' I'm surprised that you've held off so long. I was concerned with the same question when I first started poring over Maria's diary years ago . . . and for the same reason, the 'Russian connection.' Anything that touched on Ross harbored the possibility of some mention of Grigory.

"But, no, there was nothing more in the diary about the letter, and so I turned to other sources. It seemed possible that Fr. Amoros might have made reference to it in his 1823 *Informe*, his report to the Fr. Presidente of the California missions, who by the end of that year was Fr. Vicente Francisco de Sarria. The Bancroft Library at U.C. Berkeley has a copy of the report from the mission archives at Santa Barbara, but no luck. However, I did learn that there had been a succession of three mission prelates that year, two of them having died before Fr. Presidente Sarria took over in August. It was Fr. Mariano Payeras who was chief administrator at the time Paca carried the letter . . . which, by the way, did get 'delivered.' It fell to the floor at Fr. Amoros's feet when he and Maria were removing Paca's rabbit-fur coat to get at his wounds.

"In any event, I finally ran down a letter from Fr. Amoros to Fr. Payeras . . . in the Santa Barbara archives . . . dated shortly after Paca's arrival at San Rafael. It's a long, detailed and highly confidential letter, most of which would be of interest to you two. Only the last few sentences bear directly on my own primary concern."

"How is that?" I asked.

"Well, Fr. Amoros closes by assuring Fr. Payeras that the information concerning the Russians is to be trusted, since it was contained in a letter to Amoros himself from Fort Ross's commandant, Captain Schmidt. Further, although he had not met the commandant personally, the letter must be authentic because it had come to him through two trusted couriers. He could vouch for the one who had delivered it—Paca, of course—and he assumed that Fr. Payeras himself trusted the other, who had carried the letter from the fort to Bodega Bay, where he relayed it to Paca."

"Whoa! You've lost me, Peter. I don't understand why Fr. Payeras was supposed to be able to trust the first courier, the one who received the letter from Schmidt and handed it to Paca. And why all of the concern about trusting the postmen? Was there a big problem with mail-tampering on the frontier?"

Peter lapsed into one of his accustomed, interminable periods of silence. "And just when he was really wound up and going," I thought to myself. Andie and I sat there soaking in the sun and enjoying the view, figuring he would eventually get his response together—which he did.

"You have to remember that in the 1820s, California's *Frontera del Norte* . . . in a sense, right here where we're sitting . . . was not exactly the serene haven which its earth and seascapes suggest. There was as much contention in this idyllic Eden as there was in the original. Mexico, Russia, Great Britain, the United States, the Pomo, the Coast Miwok—all of them had their own 'plans' for this place. There were deep feelings of 'manifest destiny' among those who had a stake in the future of this bit of God's good earth. The Indians didn't have a chance, of course, but that didn't mean they were about to turn over their homeland without a struggle. The Mexicans' position was weak, but they were about to strengthen their claim to the area. San Rafael was already a foothold, and Sonoma was on the drafting board. The Russians knew their position was tenuous, but they still hoped that they could get the tsar behind them. The Americans' westward movement was picking up momentum, and the British, with their settlements to the north and longstanding maritime presence, were not about to throw in the towel. Colonial competition was ruthless and rumors were rampant. Yes, I'd say that Fr. Amoros was well advised to reassure his superior concerning the reliability of his sources."

"But why" I persisted, "why would Fr. Payeras have trusted the first courier or, for that matter, Captain Schmidt himself?"

"Yes, I was about to explain. The previous fall Fr. Payeras had visited the San Rafael *asistencia*. In fact it was then that he had proclaimed it a full-fledged mission. The visit was a stop-over on his way north to Fort Ross in the company of the imperial commissioner, Canon Augustín Fernández de San Vicente. The two church dignitaries had talked earlier with California Governor Luis Argüello in Monterey and had determined that a fact-finding visit at the Russian settlement was crucial to Mexican interests. Fr. Payeras kept an excellent journal of the expedition.

"The journal notes not only that they were well received and given free access to all areas of the fort, but also that on their departure, Commandant Schmidt assigned one of his men to assure their safe passage as far south as the Russian establishment at Bodega Bay. I'm sure you have already anticipated the man's identity. And indeed, it was Grigory Kostromitinov. Other than for Maria's diary and correspondence and Fr. Veniaminov's marriage record, the only primary

source I have for Grigory is one paragraph from Fr. Payeras's journal—but that paragraph is priceless."

"We're all ears, Peter," Andie put in, then reconsidered. "Well, *almost* all ears. Promise me you'll get back to Maria and Paca, and I'll give my undivided attention to the padre's priceless paragraph."

Peter smiled and went on: "As it turned out, Captain Schmidt had arranged for the padres' party to travel south to Bodega Bay by launch along the coast. Father Payeras, unaccustomed to a small craft on a rough sea, almost immediately fell victim to the motion. When the seemingly interminable voyage did finally come to an end, he was so weakened by nausea that he could hardly stand. They had tied up at one of the warehouses in the calmer waters of the bay, but at low tide there was still a ladder to climb in order to reach the dock's surface planking. The dignitary was anything but dignified when, being assisted upward, his knees crumpled. His sudden weight wrenched him free of his helper's grasp and, barely missing the launch's gunwales, the prelate plunged headlong into the bay. *And,* becoming entangled in the long, heavy cloth of his Franciscan habit, he did not surface. As you might expect, it was Grigory who dove to the rescue, and the priceless paragraph is not only Fr. Payeras's ode to, but also his description of, the man to whom he attributed his survival.

"Grigory, so the account goes, was a sturdily built young fellow with sky blue eyes and a full head of sand-colored hair. His parents were both Russians and, at the time of Grigory's birth, were in the employ of the Russian American Company in Kamchatka, a Siberian outpost close to the Aleutian Islands leading to the Alaskan mainland. His mother died giving birth to Grigory, and not long thereafter his father, who had been reassigned to the company's farthest outpost at New Archangel, or Sitka, was swept overboard during heavy seas en route to the New World. The orphaned child, who was being nursed aboard ship by an Aleut woman, first became a kind of mascot for the crew, then a foster child of Sitka and, ultimately, of Fort Ross, where he was reared. He was apprenticed in his father's trade, namely, carpentry and cabinet-making. Although he was only seventeen when he and Fr. Payeras met, Grigory had already become a skilled and creative craftsman. In addition, the commandant had observed in the young man the makings of an able administrator and increasingly entrusted to him the responsibilities of a personal aide."

Peter shifted from the concerns of a biographer to the more intimate reflections which kinship prompts. "I often wonder," he mused, "about what life was like for my great-great-grandfather in that rough-and-tumble company of intrepid seamen and pioneers. I wonder, too, if that Aleut woman continued to mother him. From Maria's writings, I, at least, know that the Kuskovs took him under their wing. Ivan Alexandrovich Kuskov was the fort's first commandant. According to Maria, his gifted wife, Yekaterina Prokhorovna Kuskova, made certain that the lad became steeped in the culture of their people as well as that of the Kashaya, to whom she had given herself so completely.

"But more of that later . . . if you are interested. Suffice it to say that Fr. Payeras, impressed as he was with deep feelings of indebtedness, must have given Fr. Amoros a highly favorable impression of Grigory when the party again stayed overnight at San Rafael on its return from the Russian settlement. Hence Fr. Amoros's assumption that Grigory could not only be trusted as a courier, but also respected as a young man of affairs."

Obviously there was no way to undo the tragedy which lay behind us in the arroyo. Also, the sun had more than warmed us through. As if by silent consensus we rose, picked up our jackets and began sauntering back along the remnants of the old aqueduct. I was still lost in the world which Peter was exposing to us. Indeed, for a moment I was sure that I saw a wisp of smoke curling skyward from a teepee where the Pakahuwe *rancheria* had once stood, but it proved to be from smoldering refuse at the local dump. The next moment I envisioned Grigory handing the commandant's letter to Paca at the Bodega Bay embarcadero. Perhaps it was the first time that they had ever laid eyes on one another, the instance that marked the inception of a long and intimate friendship. I speculated about the content of the message which passed from the hand of one to that of the other. Its actual substance, however, would have to await my own visit to the Santa Barbara archives or Peter's decision to resume that particular segment of the foursome saga.

But what drew me back to the present was laughter. During my reverie Andie and Peter had gone far enough ahead of me so that I could not make out what they were saying. Still, there was no doubt about it. Peter was laughing. It was not a timid or affected laugh, just a

good, hearty belly laugh. Although I was interested more in the fact than in the cause of it, my guess was that the reason must have something to do with an attempt by Andie to cajole Peter back onto the Maria-Paca track. Quickening my pace, I was soon at their heels again. Peter turned as he heard me behind them and, still chuckling, said, "Your wife is a hopeless romantic, isn't she, Greg? According to her scenario for that dramatic night at Mission San Rafael, Paca revives almost instantly after the padre leaves, opens his eyes, and is completely overwhelmed by the angel of mercy he sees looking down at him. She responds in kind, and the next morning they ask the good father to bless their new estate, which is so obviously a part of the divine plan."

"Oh, come on, Peter," Andie defended herself, "you know that isn't fair. All I said was that I bet the experience had a profound effect on the two of them . . . or something like that."

Peter was not inclined to give an inch, but proceeded to explain what, according to Maria's diary, had actually transpired. What she had chosen to record from her reflections on that first day away from home was the incredible difference in her feelings concerning the two Amerinds she had served. On the one hand, there was the exhilaration that had come from assisting in the delivery of a new human life; on the other, the horror of a ravaged human body. Apparently, judging from the lacerations on the side of his head, Paca had received a sweeping blow from one of the grizzly's powerful paws. For several days the young courier was delirious and struggled with a high fever, a condition which Fr. Amoros attributed to a severe concussion resulting from the blow. Maria's only further mention of Paca at the time had to do with his gradual recovery and return three weeks later—by *carreta*—to Pakahuwe. Otherwise, the entries in her diary were given to personal impressions of life on the *Frontera del Norte*.

Although she drew much satisfaction from her contribution to the healing ministry of the mission, Maria was also painfully aware of its inadequacy. Soon after her arrival, an occasion presented itself through which she was able to ease her frustration. Her father appeared at the mission on what, ostensibly, was an official inspection tour. In reality, he was there for the purpose of persuading his daughter to return to the presidio and, further, to discuss with Fr. Amoros government plans for reinforcement of the Mexican claim to the

northland. Maria was of no mind to abandon her new charges. On the contrary, so convincing was she concerning the need for her presence at San Rafael that her father was soon jotting down essential items to be shipped from the presidio's supplies, such as disinfectants, purgatives, bed linens, and medical texts. Señor Aguilar's failure to persuade a determined daughter must have been terribly frustrating to the man, himself, as well as a great disappointment for Maria's mother. For Maria, however, he was (at least for the moment) a heroic figure.

Maria was also privy to and much interested in her father's conversations with Fr. Amoros. Here Peter smiled wryly as he noted that they had to do primarily with the schemes of that "headstrong maverick Fr. Altimira at Mission Dolores" as well as with the letter from Commandant Schmidt. Historical records confirm Peter's characterization of Fr. Altimira's personality, but one would not be justified in assuming that the padre's "scheme" was entirely of his own making. True, it was Fr. Altimira who activated the plan to abandon the ailing San Francisco mission in favor of establishing a new mission and presidio on the frontier north and east of San Rafael. But, at least initially, he did so with the understanding that he was simply carrying out the intentions of his superior, Fr. Payeras. Unfortunately, Fr. Altimira became the victim both of historical circumstances and of his own impetuosity.

When Maria's father and Fr. Amoros were discussing the matter, Fr. Altimira had not yet formally presented plans for the mission transfer, but his aspirations were clear. It was also clear to them that the San Francisco padre, being the young, ambitious and autocratic missioner that he was, had become impatient with what he judged to be the political ineptitude, or lethargy, of his church superiors. Hence he had tended to nurture relationships not with his fellow clergy but with California's civil leaders, notably Governor Argüello. Still, neither Fr. Amoros nor Maria's father could have anticipated that within two months Fr. Altimira would have the Mexican government's approval, not only for the establishment of the new mission and presidio, but also for the transfer of all converts, inventories, and authority at the San Francisco and San Rafael missions to the new establishment in Sonoma. What Fr. Altimira might have expected, but did not, was the institutional outrage which he provoked.

The determined friar had, without authority, succeeded in obtain-

ing from the state a decision which clearly lay within the province of the church. Not only that, but by the time he dispatched the decision as a *fait accompli* to his ecclesiastical superior, it was not the sympathetic Fr. Payeras who presided over the California Franciscans but, rather, his successor, Fr. José Senán, who had played no part in the political process. As though completely innocent of any violation of church protocol, and without Fr. Senán's approval, Fr. Altimira then proceeded with civil assistance to explore the northern frontier, select the Sonoma site, and actually begin construction of the new mission. Finally, in August 1823, he received instructions from Fr. Senán's successor, Fr. Presidente Sarria. The dispatch was dignified and authoritative, its message clear: Cease and desist!

Peter had been recounting the Altimira affair as we continued our lackadaisical ambling back toward the pickup, proving himself to be a peripatetic lecturer in the finest Aristotelian tradition. But now he stopped abruptly. We had arrived at the Lombardy poplars and were standing next to an old Ford tractor which was harbored in their shade. As we paused there, Peter leaned against one of the big rear wheels of the tractor, hands in his pockets, and for a moment we all watched his boot toe tracing meaningless patterns in the soft earth. Then, without warning, he unleashed a venomous diatribe that must have been pent up for a long time.

"I loathe the Altimiras of this world," he said quietly and evenly. "Or, perhaps, I detest myself because I tend to be intimidated by them. They are *so* sure of themselves and their causes, *so* self-righteous. Even before they're finished—which they seldom are—they've left a trail of broken community. It's always the same. In their conceit they either presume there is no human community worthy of the name until their brand is firmly in place, or else, when they do recognize that folks have some tradition going for themselves, they move in with their own regimented 'correctives.' I'm not saying that any community ever outgrows the need for correctives . . . and that includes the Russian and Pomo and Miwok . . . but correctives without interest in or appreciation of what's already there? Never. All that the Altimiras produce is a lot of hostile, alienated nonparticipants, or a lot of mindless or fearful followers marching in lock step."

Although Peter was speaking quietly, he was doing so with great intensity. I really did not know what to say in response, but Andie at

least had the presence of mind to make what seemed to me to be an intelligent observation. "Given your roots, Peter," she said, "I imagine you and your mother have had more cause than most of us to agonize over the damage done by such ideologues."

But he disagreed. "Actually we haven't. We probably have less than our share of Altimiras in Occidental. Oh, there *are* some all right, and there always have been. I suppose that it was because one of them got to me at an early age that I became one of the hostile-alienated type of casualties. Like Fr. Altimira, the man was a preacher . . . a preacher with an unquestioning sense of 'divine calling.' He was determined to make a Christian of me—*his* kind of Christian—and he worked very hard at it. For him, the only thing that was more satanic than Pomo and Miwok animism was Russian Orthodoxy. Mother was as incensed as I . . . and as impotent. Confrontation is not our people's way. Had my father still been living, the assertiveness of his Orthodoxy might have saved the day. As it was, Mother and I, like so many of our people, simply withdrew into our private worlds. You can understand why the construction of our house had such spiritual significance for us.

"But there really were no mitigating circumstances to which we could appeal to vindicate our withdrawal from the American mainstream, a mainstream which clearly includes options other than that of falling in behind the preacher's cadence. In fact, our decision came at a time when there were some very persuasive voices of hope for our people—voices from outside our tradition for whom 'Indian reservation' and 'digger' and 'redskin' were as much anathema as they were for us. There was the 'painter lady' from up in Ukiah and the anthropologists from over at the University of California. There were a number of locals, too . . . like Papa Bettini. All of them understood and appreciated the differences between an American Indian—or Amerind, if you wish, Greg—and an Indian American. Mother and I were gradually becoming the latter—by choice—but we weren't quite up to all that it involved. No, we were simply intimidated and we backed off."

"Peter, you're being much too hard on yourself," I insisted, and Andie nodded her agreement. "You say that there were no mitigating circumstances to justify your withdrawal. That's hogwash! You know as well as—no, much better than we, that would-be Indian Americans have had to fight tooth and nail for even the smallest concessions

from the American mainstream. It wasn't just a fanatical fundamentalist who scared you off, it was the fanaticism of the mainstream itself. Sure, you heard supportive voices, but they were as much on the fringe as you and Mother Castro. They still are. Andie and I have everything going for us. We're white, middle class, even Protestants of sorts. But when we move from fringe benefits to fringe *issues*, we invariably find it necessary to take account of a chill factor in our relationships. You know, it strikes me that you haven't withdrawn at all. If you haven't really been allowed in, how can you pull out?"

"Well, that may be good rhetoric," Peter replied, "but I'm not convinced. We didn't withdraw from *being* in. What we abandoned was *wanting* to be in, and that was neither reasonable nor necessary. There's much that is worthy in the mainstream of American community, but we let a spokesman for one of its uglier strands tear us right out of the heart of the larger complex fabric.

"Mother and I know where the responsibility lies . . . within ourselves, that is . . . but, still, it's very hard not to indulge a resentment until it festers and deteriorates into genuine loathing—all of which I suppose brings us back full circle to Fr. Altimira again."

Our moment together under the poplars had been very revealing and, to some extent, distressing. Peter, and no doubt his mother along with him, must surely have struggled with a heavy load of self-doubt through the years. I wondered, too, if he had ever really given up the desire to gain recognition as a first-class citizen of the larger society. We had only begun to know one another, but already it was evident that he was a lover of life, enjoyed substantive discourse with others, and appreciated, as well as possessed, a sense of humor. These did not strike me as being the characteristics of a recluse, but, as Giulio had pointed out, "Pietro, he's a very strange a fellow."

Peter pushed himself perpendicular from off the tractor wheel, smoothed over his boot musings, and we commenced the last leg of our return to the road.

"Oh, yes," he said when we were under way again. "I neglected to mention the content of Commandant Schmidt's letter as discussed in Fr. Amoros's correspondence with Fr. Payeras. As would be expected of the competent commander of a colonial outpost, Schmidt made it his business to keep abreast of the competition. The Franciscan establishment at San Rafael was his closest colonial competitor, and

he was well aware of its advance from *asistencia* to mission status. Assuming that the change signaled plans for increased grain cultivation, cattle raising, and the production of other commodities, he was eager to establish a workable and mutually beneficial trade agreement between the two settlements. As you will recall from your own research, Greg, Fort Ross was having terrible problems trying to raise grain along the coast, and, in 1823, the development of its inland farms was still a decade off. Schmidt was convinced—and rightly so—that Fr. Amoros would welcome the opportunity to trade some of its surplus wheat, beef, and hides in exchange for what the Russians had to offer."

"Which was?" Andie queried.

"Well, Schmidt was a very enterprising fellow. For one thing, with San Rafael's immediate proximity to the bay, he knew that well-made, dependable boats were in demand, and his people were turning them out at their Fort Ross boat works. Also, strange as it may sound in view of the Franciscans' enormous supply of steer hides, they depended on Yankee merchant ships . . . coming clear around the Horn from New England . . . for a supply of decent shoes. The Russians had some excellent cobblers right there in their own back yard, so to speak. Another of the mission's needs was for an ironworks. The Mexicans knew their way around metals, but San Rafael was on the northern frontier, had been concentrating on health care, and was short on iron implements and hardware like tools, hinges, nails, bolts, wheel bands, and barrel stays. Again, experienced Russian blacksmiths were ready at hand. Needless to say, Fr. Amoros found the commander's offer very attractive and had little trouble in gaining his superior's tacit assent."

"Why tacit?" Andie prompted.

"Given the volatile political situation, Fr. Amoros knew that Fr. Payeras would hesitate to commit his approval to writing. If my memory is correct, Fr. Amoros spared him the need to do so by stating that if he, Fr. Amoros, did not hear to the contrary, he would proceed informally to work out the trade arrangement with the commandant. Maria's diary indicates that not only did a lively and mutually beneficial trade develop, but that the two overseers themselves came to enjoy each other's friendship during the year remaining before Schmidt's replacement at the fort.

"Perhaps the two men were drawn toward each other because they sensed that they were among the last of a breed that, even then, was being replaced by a new order. Just three years previously, when Fr. Amoros had come from Carmel to San Rafael, Alta California had still been a Spanish colony. Many of the missions' Franciscan padres had been born and reared in Spain, and their loyalty to the mother country ran deep. But now, with Mexico having declared its independence from the mother country, Alta California was a *Mexican* colony. The padres, with their divided loyalties, not to mention their coveted holdings, were not only losing the respect of the new regime, but were becoming suspect as well.

"Commandant Schmidt could appreciate the dilemma faced by his Hispanic neighbors. Russian loyalties were equally entrenched and equally steeped in religious tradition. The tsar might have been able to negotiate a settlement of rival claims had they still been with the Spanish crown, but to recognize those of the young Mexican upstarts was, while crucial, apparently too much to ask. The problem was that while Mexico was allowing international trade in California, it had ruled that all foreign merchandise must enter and tariff be paid at one of its ports of entry. This new policy included Russian goods, of course, and so the friar and commander were left to work out their own arrangements as quietly as possible.

"I had a feeling I should have done it day before yesterday." Andie was talking to the ceiling from where she was stretched out, hands behind her head, on our hotel room bed. We had dropped Peter off at his driveway and then proceeded straight to our room for a couple of long soaks in the old, footed tub. Andie, having already had hers, was relaxing, and I was just emerging from mine.

"Done what?"

"Photographed the inscription before I called on Peter and his mother."

"Andie, you know that was no place for you to be crawling around on your own. Besides, who could ever have imagined what we found this morning?"

"Yes, but now . . . now you and I and Peter . . . and whoever destroyed it . . . will be the only ones who *really* know the inscription was there. Come to think of it, even Peter accepts it as fact only

because it's consistent with Maria's diary . . . and I'll betcha' he doesn't let loose of that book—or those *volumes*—of hers so long as he and his mother are alive."

"Yes, I was thinking about that while I was soaking. But you know, silly as it may sound, I find myself wondering more than worrying . . . wondering about who did it, that is. Whoever it was had to be both very strong and very determined. Sandstone is comparatively easy to work with, but it's still stone. Also, by the looks of the chipping marks, he used a pretty good-sized cold chisel, which means he was swinging a one-handed sledge, not just a carpenter's hammer. Even with heavy tools, though, the job must have taken our Paul Bunyan at least an hour—maybe more."

"If all that hammering—or sledging or whatever—was going on for an hour, wouldn't somebody have heard it and become curious and investigated? There's nothing up there but woods, no buildings or anything."

Andie was still talking to the ceiling, and so I pulled a chair up beside the bed, stood on the seat, and hovered over her for more direct conversation. From years of classroom experience, I had found that eye contact facilitated meaningful discussion. Still, standing there at a somewhat precarious angle and with only a bath towel around my midsection, I was grateful that our little chat was going unobserved.

"I don't mean to be talking down to you, but maybe someone *did* hear it, got curious, and investigated. We don't know. It's possible that with the site being a mile away from anything, and down in the creek bed under heavy foliage—it *is* possible that the sound didn't carry. But I think you're right. Somebody *must* have heard. And if whoever heard got curious and investigated, there's one person in these parts who knows about it, right? Right! In unison now: GIULIO BETTINI!"

"It would be nice to know," Andie said, smiling up at me, "but how are we supposed to put the question to him *this* time?"

"What do you say we put our heads together over it and see what we come up with?"

Hearing no objection—no objection at all—I stepped gingerly from the chair to the bed and plunked myself down beside her. I had forgotten the plywood board, and so the descent was less cautious than was prudent. Fortunately, despite a few protesting creaks from the old

bed frame, there was no serious damage either to it or to my back. Once settled with our heads together, Andie was first with a suggestion, the only suggestion needed.

"Greg, now that there *is* no inscription, why do we have to worry about Giulio—or anybody for that matter—finding out about what *was* there . . . or, more realistically, about what we *say* was there? Can't we simply tell him what's happened and ask him what he's heard? Anyway, I've felt kind of guilty about not taking him into our confidence from the very beginning, Nicholas's adage notwithstanding."

As usual the obvious had escaped me. Also, as usual, I made a somewhat lame attempt to save face.

"You could be right, but you know there are always the curiosity or curio seekers who'll descend greedily on anything at the slightest provocation. It's like those magazine articles that describe heavenly, undiscovered Shangri-Las for the perfect vacation. Heavenly or not, once the magazine hits the stands, they certainly don't remain undiscovered. Do you remember that one in . . . ?

"Honey, the only concern I'd have would be for Peter . . . and I guess the property owners. Now that he has seen it, I think the inscription site will become sort of sacred for Peter. But don't you think Giulio would appreciate that fact and respect our trust?"

I may have been the logic teacher, but Andie was the logician—and rhetorician. We decided to locate our genial host and see if, once again, a late dinner together might fit into his plans for the day. For the moment, however, neither of us was inclined to spring off the bed and hop to it. The morning had taken its toll on body, mind, and spirit. It was so comfortable lying there together. Then, too, we had discovered a new source of bedtime entertainment. One could hardly believe how many little boat-shaped fillers were hidden in the old plywood ceiling. At last count, Andie had detected twenty-three and I, twenty-six. My self-confidence was beginning to return. Just before dropping off I remembered that Peter had left his red and black plaid lumber jacket in the pickup. How would he get along without it? I must get it back to him immediately—or maybe soon would do.

Giulio was in an especially good mood. For once the cook had managed to season the minestrone *almost* to Giulio's satisfaction. In addition, an influential guest—a columnist for the *San Francisco*

Chronicle—had just promised to spread the word concerning the excellence of the hotel's hospitality, accommodations, cuisine, etc. Giulio continued to exude charm as he backed away from the writer's table all the way to our little hideaway booth in the corner. It was the right kind of night for revealing secrets.

"You look like a man who's just sold his soul," I said as he slipped into the seat beside Andie.

"No, no, my friend. I'm a just sell that a beeg shot on a my hotel. He's a good a fella. No deals. He's a tell it the way it is. I'm a just try hard to make a the way it is the way he's a like it . How's a the back, Greg? And how's a Mama Castro today, Andie? That was a one a beeg trip for her you take a yesterday."

I assured Giulio that my back was in good shape again, thanks to the bed board, and that, according to Peter, his mother was well, but resting up after the previous day's outing. Then, since the opportunity presented itself, Andie explained that we had been out with Peter during the morning while Mama Castro was resting.

"Mama mia, I'm a think you two and those a two, you become a friends already!" Giulio was all enthusiasm and so I plunged in.

"Yes, well you see, Giulio, we were with Peter this morning for a very special reason. We asked you to join us for dinner tonight because we would like you to know that reason. We have a question to ask, too."

"I'm a . . . how a you say? . . . I'm a much flatter." He looked at me seriously, then at Andie, and with a nod indicated that he was ready to listen.

Between the two of us, Andie and I managed to relate the whole episode in some detail. There were distractions, of course. Giulio was breaking in another young member of the clan on waiting tables and felt obligated to make suggestions as she tended ours. But he was fascinated by what he was hearing and was right back with us after each interruption. When, finally, we reached our tragic conclusion, his reaction was, if anything, more mournful and irate than our own had been.

"What's a the matter with people these a days? They have a no respect. They make a no sense. But I'm a so happy Pietro, he's a know. And you two, you trust a me with a pretty beeg a thing. Have a no fear. I'm a not tell nobody."

I was about to pose our question, but Guilio made it unnecessary. With an "aha" expression he continued: "And a that explains it."

"Explains what?" we both asked reflexively.

"Saturday . . . the day after you find a the beeg rock . . . Saturday I'm a talk with my old friend Giorgio. He's a live in Freestone, but he's a come up here. We have a some coffee, and he's a tell me about the night he's a have before."

Giorgio, we learned, was a retired viticulturist and his vineyard lay on the edge of Freestone nearest the inscription site. Friday night his wife had turned in early, but Giorgio had become immersed in a good book—*Zinfandel At Its Best,* Giulio noted—and was reading into the wee hours. About 2 A.M. he stepped out onto the front porch to light his pipe, promising himself he would join his wife after just one more chapter. He was about to light a match when he was distracted by a faint chinking sound that seemed to be coming from some distance up in the direction of the little arroyo. Moving out from under the porch cover and holding his breath in order to hear better, he stood there under the stars and listened more intently. There were other sounds— an owl hooting, a truck passing on the valleyed road—but there was no doubt about it now. Intermittently the clinking continued, as though someone were hammering on metal.

Not wishing to disturb his wife, but curious beyond endurance, Giorgio returned to the house, tiptoed into the kitchen, and fished out a flashlight from the catchall drawer. Outside again he paused briefly to reassure himself of the continuing tapping and then set out in its direction. The terrain was familiar to him and there was enough moonlight so that he had only occasional need of the flashlight. Following a succession of cow paths and deer trails he was soon well up the hill and on the bank of the arroyo. Judging from the sound, which was much louder now, Giorgio estimated that he must be within two hundred yards or so of its source. Holding as closely as possible to the bank and using moonlight exclusively, he moved cautiously until the noise, obviously a heavy hammering now, emanated from below where he crouched in the brush at the edge of the arroyo. A huge boulder, rising from the darkness, loomed up above the trees into the night light on the side across from him.

The overhanging trees and dense foliage made it difficult to see below, but for an instant, as the pounding went on, a glimmer of light

made its way to the surface, disappeared, then shone again. It was as though something, or someone, kept coming between him and the light. Attempting to obtain a better vantage point, Giorgio inadvertently dislodged a rock at the bank's very brink, sending it crashing down through the brambles. Immediately the hammering ceased and the light went out. The sudden silence was eerie, almost menacing. Giorgio had only one thought in mind, namely, to back off as quietly as possible and high-tail it back to the house. For an old man, he accomplished the feat with remarkable speed.

Not until he was again on home ground did he stop to listen. For a moment there was nothing, but then, as he turned to enter the house, the hammering commenced once more. Perhaps it was because a racing heart and a pair of laboring lungs made it harder to hear, but the sound seemed more muffled than before. Or perhaps whoever it was up there, deciding that some nocturnal creature had loosened the rock, was back at it, but with less gusto. A few minutes later the hammering stopped again, the task, whatever it was, apparently completed. Giorgio, exhausted and still mystified, at last gave up the vigil and headed for bed.

In the morning, having only half convinced a doubtful wife that there was no danger, he returned to the hillside scene. Managing somehow to fight his way to the base of the boulder, he at least had the satisfaction of confirming that the night's adventure had been more than a bad dream. For the life of him, however, Giorgio could make no sense of what he saw. Why on earth would anyone want to go out in the middle of the night and pound away at an old boulder? But what a story. He could hardly wait to drive up to Occidental and tell his old friend Giulio and see what *he* could make of it.

What Giulio made of it was thoroughly fascinating table talk, concluding with the reassuring observation that his lips were sealed. "I'm a guess Giorgio, he's a just have a to stay in a the dark."

The three of us lingered a while longer over our fourth and final cup of coffee. Giulio again expressed his very genuine regret concerning our loss, and we again thanked him for his invaluable help. We all knew they were sentiments that needed no verbalizing. It was simply that we were talked out but not quite ready to bid each other "Ciao." Words helped to delay the inevitable. But when at last I did excuse

myself to do business with the cashier, I could see that Giulio and Andie, still together by our booth, had hit upon yet another cause for conversation. The exchange was brief, and, having decided that we *should* walk *this* one off, Andie and I were soon outside and on our own.

"What got you and Giulio going again?" I asked casually as we moved along in stride.

Just as casually, she replied, "Oh, nothing important. Giulio forgot to mention part of the Giorgio affair. Whoever was doing the chipping up there left his tools behind. Giulio thinks he may have left in a hurry because of another falling rock. Whatever the reason for the abandoned tools, Giorgio had had it with nocturnal sculpting. He picked them up and toted them home. Then his conscience got the better of him—or maybe it was his curiosity—because he returned to the site once more and left a sign penned on an old piece of cardboard."

"Which said?"

"Which said: 'Owner of tools left here can pick them up at Giorgio's in Freestone.' "

"Well, we know that somebody, presumably the (quote) sculptor (unquote), took the sign. At least it was gone when we were there this morning. Did Giorgio have any callers?"

"Nary a one at the front door, but there was one at the back . . . where Giorgio left the sledge and chisel lying on the stoop. The caller took the sign literally. He picked them up."

7

"Greg, you've *got* to get a haircut!" I lowered my newspaper and looked over the rims of my reading glasses at Andie. Andie, with elbows on the table and a mug of coffee nested in her hands, was inspecting my grooming—or lack of it—from across the table. As usual the coffee shop was alive with pleasant people-sounds and breakfast aromas.

"I didn't think there was enough hair left to worry about."

"Well, what's left of it looks pretty sleazy."

I was into the editorial pages and had just finished an article on the sleaze factor in government. I knew perfectly well that *looking* sleazy and *being* sleazy were two quite different conditions. Still, I felt somewhat self-conscious.

"Okay, I'll see if I can locate the local barbershop. I assume your hidden agenda is to get rid of me while you browse in Ye Olde Book Store across the street."

"Am I that transparent?"

"Only when you're looking longingly through a coffee shop window at the bookstore across the street."

Beset by the same mania as she, I browsed a bit with Andie before tearing myself away and wandering off halfheartedly in search of a spiraling red and white pole. I did not recollect encountering one during the previous night's walk, and so an inquiry seemed prudent. As though placed there in response to the need, an elderly gentleman was sitting on the retaining wall of a sidewalk planter, soaking in the morning sun. His gnarled hands rested on the knobby handle of an equally knobby cane which rose between his knees. His chin was extended and settled on his knuckles so that his head appeared to be set on display for my benefit. It was obviously a head which had recently frequented a barbershop.

"Good morning. Could you tell me where you got your hair cut?"

"Mornin'. Yep, I can tell y'all right, but I doubt she's opened up yet. Nice young gal, the barber lady . . . comes over from Santa Rosa . . . usually gets her OPEN sign out on the sidewalk 'bout ten . . . down the street there where y'see the shops stop . . . just past the church . . . little build'n stand'n by itself, kinda on a list . . . can't miss it."

He reached down into the bib pocket of his overalls, withdrew an ancient railroad watch and studied it for a moment. Still looking at the time piece, he calculated, "Nine fifty-one . . . 'nother nine or ten minutes and she oughta be there."

"From that watch I take it you used to work for the railroad."

"Yep, when I was a young fella I brought them narrow-gauge, steam-powered jobs right into Occidental here. Used to pull up at the station not more'n a hundred feet from where we're talkin'. Everything's diesel now though . . . not like the old days. Engineered for S.P. over in the valley when they closed out the narrow gauge . . . came back here when I retired . . . 'lot quieter and cooler than Sacramento . . . pretty lonely, though, since my wife died last year."

I had not expected to be transported into another man's life on my way to the barbershop. Damnit! Andie and I were going to lie fallow today. Now I would be worrying about a lonely, old locomotive engineer. I wondered if he and Mother Castro might make a go of it, then reconsidered. She would have trouble with his grammar. Besides, my matchmaking efforts had never been very productive. Perhaps male companionship was what the man really needed.

"Do you know Giulio Bettini?" I asked.

"Who don't! Yep . . . known ol' Giulio for a long time. Used to

116

room and board at his hotel when his daddy was still livin'. Me and him and a couple other ol' timers get t'gether afternoons for cards now'n' again when things are kinda slow."

I sensed that he had little need for assistance with introductions, especially from a newcomer in town, and so thanked him for his directions and moved along. As I approached the church—St. Philip's by name—it occurred to me that the local Catholics had come a long way since their humble beginnings in the hotel sitting room, assisted by Giulio as altar boy. I tried the door and, finding it unlocked, entered and stood quietly in the narthex. Although ornate and even sometimes breathtaking, Catholic sanctuaries often had impressed me as being depressing rather than uplifting. What appeared before me was a refreshing exception. The bright reds and blues of hymnals and missals in the backs of the varnished pews brought life to the edifice. Even the chancel, while dignified and serious, was not somber. As at the fort's little Orthodox chapel, sunlight poured into the room through clear windows. The air was fresh and scented only with the natural surrounding fragrance of laurel and redwood rather than the heavy aroma of imported incense. It seemed appropriate that Giulio gathered with the faithful in such a place for worship.

The old engineer's calculations were correct. As I stepped outside again, a young woman was just then placing a sandwich board sign on the sidewalk. The letters from top to bottom did indeed read OPEN, and beside them was a hand-painted barber pole. What arrested my attention, however, was the fact that she and I were the only folks in sight. It had been a long time since I had been first in line—or without a line—for a haircut. Understandably the paucity of patrons did not have the same pleasing effect on the barber.

"Hello. Do you think you could work me in for a haircut this morning?"

She continued to fiddle with the sign legs, no doubt playing for time to think up a good comeback. Then she straightened up to her full five feet, tossed back her mane of straight blonde hair, and laughingly said, "Hi. Just a minute and I'll check my appointment book. You new in town? My name's Jackie."

"Mine's Greg. Yes, I'm new, all right, but, sad to say, just visiting. It looks as though you could handle a few more unshorn heads on a regular basis." Chee, I thought to myself, first a lonely retiree and now

a struggling business woman. Maybe guarded-gate communities were the way to go to get protection against direct contact with people's problems and threatening situations.

Jackie, as it turned out, was pretty well resigned to the time and scrimping that lay between her and a going shop. She and her husband had loved their life in forests to the north, but she had lost him to the perils of logging. Now here she was, ulcers and all, trying to break into the limited business world of another woodsy little town. But three things were in her favor: first, real professional ability; second, abundant enthusiasm; and third, the successful barber's gift of gab.

She had me settled comfortably in the shop's single, somewhat antique chair and was both clipping and talking with great finesse when it occurred to me that hers was not the usual variety of non-stop monologue. Instead, she possessed an uncanny ability to elicit dialogue. Within the span of a few minutes, she had determined Andie's and my reason for visiting the area, and in a couple more we were discussing the Sonoma coast's history of successive national hegemonies. The subject was primarily of personal rather than academic interest to her, and centered in concern for the plight of subjugated peoples, in particular the Pomo. When she and her husband (another Peter) made their home in the redwood country to the north, they had become captivated—perhaps obsessed is the word—by a collection of paintings. The paintings were works of Grace Carpenter Hudson that she discovered in Searles Boynton's biography, *The Painter Lady*.

"Hudson," Jackie expounded, "who was born and reared among the Pomo in Ukiah, devoted most of her life to creating portraits of their children, young women, men, and old folk. The productions are beautifully sensitive to the human condition, dignity, and artistry of her subjects." So much so, that the young couple had begun to seek out those among them who were still living, to befriend them and their progeny and, ultimately, to be befriended by them. In fact, less than a year before her husband lost his life, Jackie and he had actually adopted a little orphan baby boy of Pomo extraction. Not only that, but they had done so with the blessings of the baby's kin. The adoption had taken place seven years previously, and so Jackie was both barber and single parent.

She had scarcely begun to tell me about her pride and joy when a

little fellow, shy but definitely all boy, appeared in the shop's open doorway.

"Speak of the devil," she said to me, laughing, and then, turning to him, "Hi, honey. I was just telling this gentleman about you. I'll have his hair done in a few minutes; then we can finish sweeping up the shop."

The boy, who no doubt was familiar with male specimens trapped under barber cloths, studied me seriously for a moment then turned and darted out of sight up the sidewalk. Jackie and I both smiled at the empty doorway. She turned to me once again and said, "Please forgive Peter's lack of formal greeting. He gets a little tongue-tied around strangers, but his intentions are good. Normally he'd be in school today over in Santa Rosa. They're having a teachers' institute, and so the kids get a holiday. We're living with a friend there until I build up enough business to rent a place here in Occidental.

"Peter!" I repeated the name more for myself than for her. "It appears that this town is enveloping me in a pocket of Peters."

"Oh? How's that?" Jackie's tone of voice was understandably defensive. "I love the name. It comes from the Greek word for *rock,* you know . . . Couldn't have fit my husband's personality better, and I think our little Peter II out there is going to be a pretty solid citizen himself."

"Agreed; it's a fine name," I said, and then moved quickly to explain the reason for my remark. Jackie had been told about the Castros and their reclusive life together south of town. Indeed, because of their Pomo roots, she was very much interested in getting to know them. The problem, as she put it, was that Peter didn't seem to be a very hot prospect for a haircut, and haircuts were her principal entrée to new relationships. Otherwise, she was reticent about imposing on people's privacy.

Jackie gave the barber chair a whirl so that I could view her completed handiwork in the shop mirror. She had done a beautiful job of reducing my sleazy appearance without making me look like a West Point cadet, an accomplishment for which I expressed genuine appreciation. She had removed and shaken out the barber cloth and was engaged in the final whisking operation before the obvious occurred to me.

"Jackie, I was thinking that you and young Peter might enjoy

having dinner with us at the hotel tonight. Andie and I have invited the Castros to join us there around seven o'clock. On us, of course."

There was no hesitancy whatsoever in her enthusiastic response. "You mean it? We'd love to! Peter can be a little hellion in restaurants sometimes, but I'll read him the riot act before we arrive."

"Don't worry about Peter—your Peter, that is. Andie and I have managed to survive five of our own kids and we're three into the next phalanx already. As for the Castros—well, Mother Castro strikes me as being totally imperturbable, and Peter will be so engrossed in the historical thing we have going that he'll be oblivious to any distractions."

"Thanks for the reassurance" she said, relieved. "You know, the more I hear about that pair the more intrigued I get. Is he really a descendant of the Russians at Fort Ross? 'Castro' doesn't sound very Russian."

I told Jackie what I had heard about the Kostromitinov connection and brought her up to date on Peter's rendition of the Maria-Paca affair. When I mentioned that at dinner he would probably see us into Maria's and Paca's years at the Sonoma mission, Jackie could hardly contain her anticipation. She had grown up in Sonoma.

Andie had her doubts concerning prospects for a successful evening. "About the time big Peter starts to get really interesting," she said, "I'll bet little Peter and I will be on our way to the grocery store to get him a *real* dessert . . . like a candy bar or Twinkies or something. He's going to be bored to tears, and the promise of a little scoop of spumoni just isn't going to hold him." The scenario was realistic, coming as it did from considerable practical experience. It was not, however, what actually transpired that evening.

Giulio had arranged an ample table for six for us back by the dining room fireplace. A seventh chair was ready at hand to be pulled up to the table whenever he could steal a moment to sit in with us. At first he was totally given to getting Mother Castro situated comfortably. Then, as though we were already family, there were hugs for Andie and me. Finally, saving the best for last, he turned to Jackie and Peter II. "Ah, Signora, I'm a so happy you come a to Occidental. Now a the men, they don't a look a like shaggy dogs. I'm a think we make Rossini's *barbiere* sing a for you tonight. And a who's a this beeg fella?"

Both Jackie and little Peter were quite taken with Giulio's exuberant welcome. Jackie even more so when the strains of *The Barber of Seville* actually did begin to pour forth from the dining room loudspeakers. "What Giulio says isn't just idle chatter, is it?" she observed.

But it was Mother Castro who really entranced Peter II. From the moment they drew their chairs up to the table, he simply could not take his eyes off her. It may have been that he was fascinated with the bone comb or the beads she was wearing. More likely it was that he detected in her face something of his own. Occasionally she would look up from her plate to see him staring. Rather than prompting him to turn quickly away embarrassed, the response from those dark, deep-set eyes of hers held him more closely still. Before long the rest of us were snatching covert glances at the two of them, intrigued ourselves by their quiet mutual attraction.

Jackie and big Peter were hitting it off well, too—and very verbally. I had divulged nothing of the inscription incident to Jackie, nor had I indicated either the personal sources or reasons for Peter's historical research on Maria and Paca. By the time we were into our spaghetti, however, Peter, especially after learning of Jackie's Sonoma roots and little Peter's Pomo stock, was talking as freely with her as he had with Andie and me.

"Greg tells me that you've uncovered some very interesting information on the daughter of a San Francisco Presidio officer," she said to Peter. "I understand she was a nurse at San Rafael in the 1820s and then moved to my old stomping grounds in Sonoma."

Peter, as well he might, took her comment to be an invitation to continue the story. "You were reared in Sonoma . . . " He repeated the fact as though pondering how to proceed. It was very important to know to whom one was speaking concerning a particular plot of earth. One must approach another person's native soil with great respect and tact. And yet, to his mind, there was so little in Sonoma's early years to commend, so much to decry. Even Maria's years assisting Padre Amoros at Mission San Rafael were at first marred by tensions stemming from repeated confrontations with Sonoma's Fr. Altimira. And at the last, when she and Paca returned from Sonoma to San Rafael, it was to escape and never again set foot in that hellhole. Clearly Peter would have to proceed with considerable care.

"Perhaps Greg has already told you about the disturbing event that

occurred only a few months after Maria's arrival at the San Rafael mission," he began, referring to Fr. Altimira's visit there en route to his exploration and selection of the Sonoma mission site.

"No," Jackie replied, "Greg didn't get into that particular incident, but coming from Sonoma, I'm familiar with Altimira's role as founding father of the mission. The man was kind of a pathetic figure, wasn't he? The impression I get is that he was driven by some sort of need to *be* somebody politically. In fact I read somewhere that he got acquainted with a Russian nationalist revolutionary—Zavalishin, I think his name was—who was visiting at Fort Ross, and the two of them actually did some plotting for a Russian takeover of California . . . really crazy. But what did he lay on the folks at San Rafael?" Andie and I smiled, knowing that Jackie's response, while unexpected, was music to Peter's ears. Needless to say, he quickly abandoned his concern for caution.

"Well, according to Maria Aguilar, Altimira was indeed the 'takeover' type. He came marching up the hill from the San Rafael mission's embarcadero followed by a government agent and a lieutenant with nineteen soldiers. It was less a visit than an inspection tour, with Altimira taking inventory of everything usable within sight and treating Amoros as though his function was simply to assist in the process. The scene must have been incredible, much like a guest poking around in his host's dresser drawers to see what was of value. Altimira, as you know, was way ahead of himself, of course. Contrary to his assumption at the time, the San Rafael mission was not about to be closed down nor its total assets transferred to his new mission in the Sonoma Valley. Amoros was too big a man to abandon his fellow friar to his own resources in Sonoma, but it must have been terribly difficult for him to support the fledgling mission so long as Altimira was its resident priest."

"If I recall the record correctly," I added, "Fr. Amoros leaned over backward to maintain at least a professionally responsible relationship with his Sonoma colleague. Didn't he invite Fr. Altimira to lead in celebrating mass at San Rafael on his return from the exploratory expedition?"

"That's true, Greg, but Altimira would have expected it, no matter what personal feelings prevailed. It was simply protocol. More impressive, I think, was what Amoros did to preserve some semblance of

mutual respect between the Russians and Mexicans on the *Frontera del Norte*. As you pointed out, Jackie, Altimira became briefly involved in an improbable plan to replace Mexican with Russian rule in California. For him, the mother country, Spain, was the epitome of all that was culturally and spiritually meaningful. Now Mexico, having declared its independence, had, to his mind, severed itself from the civilized world. Russia held California's only hope of returning to that world of European tradition, of respect for the *gente de razón*. The irony, of course, was that while despising Mexican authority, it was that very political power which he used to establish himself in Sonoma. At the same time, while presumably a dedicated servant of the Catholic Church, he ignored its established authority in a matter which far overreached his professional prerogatives. Altimira may have been pragmatic, but his duplicity was certainly showing.

"Amoros, on the other hand, evidenced an integrity, a singleness of purpose and action which, if unheralded, was crucial at the time. This is not to say that the man was completely selfless or without his own vested interests. He was in charge of what he held to be a humane and spiritually, socially, and politically significant institution at San Rafael. He was a good administrator. The mission was growing, and he was not about to let some idiot topple the enterprise. He made his sentiments clear not only to Altimira but to their superior, Fr. Presidente Sarria. But he was also cognizant of the destructive force of national ambitions which he knew he could influence but little. Hence, he turned his creative energies to staving off locally as long as possible the larger violent conflict he believed to be inevitable.

"Maria describes one undertaking in Amoros's pacification program that proved to be particularly productive. The 1823 to-do over Altimira's establishment of the Sonoma mission had been pretty well resolved through compromise between church and state, and the padre had set Passion Sunday, April 4, 1824, as the date for the dedication of his newly constructed church. Understandably, Altimira was concerned to acquire as many accouterments as possible to adorn the interior of the new edifice. Ordinarily, contributions—unsolicited contributions—could have been expected to pour in through the good will of neighboring missioners. Unfortunately, Altimira, with his acerbic criticism and rumor-mongering, had pretty thoroughly negated normal expectations and so was drumming up what response he could.

Rather than leaving the friar to sink further into his self-created morass, Amoros seized upon the situation to engage in a bit of peace-making.

"Aware of Altimira's Russian leanings, Amoros set about making certain that his friend, Commandant Schmidt, was informed of Sonoma's need for contributions and that a worthy gift be forthcoming from the fort. Entrusting his message to the recently rejuvenated Paca for delivery, Amoros assumed the matter tended to. Hence, he was more than curious when, three days later, a trail-weary horse bearing a trail-weary Paca pulled up in front of the padre's quarters. The courier delivered his message orally, namely, that the commandant was *most* grateful for the information received and that, unless he heard to the contrary, he hoped to meet with Amoros four days hence on neutral ground in Paca's village of Pakahuwe.

"The meeting did indeed take place, but it was not simply a gathering of the two principals and Paca. Also in attendance were Grigory, as Schmidt's aide, and Maria, who had gained the priest's consent to accompany him. She had never visited a "gentile" *ranchería,* that is, an Indian settlement other than those of neophytes at or near mission compounds. Paca had done his preparatory work well, satisfying the elders of the village that the foreigners came in peace and that, in addition to their desire to talk with each other, they also hoped to exchange gifts and speak seriously with the elders."

Peter paused, seeing that, one by one, Jackie, Andie, and I had begun to glance intermittently in the direction of the dining room fireplace. Unnoticed at the time, a bored young Peter and an understanding Mother Castro had slipped quietly from the table and gone to take up their positions on the hearth. Mother Castro had removed the necklace of agates and seashells from around her neck and given it to Peter, who was fingering and studying it piece by piece. Although we could not hear what she said, it appeared that she was telling him something about each individual stone and shell. Big Peter was as amused and fascinated as we. "What a relief," he sighed. "For twenty-five years she's been after me to make her a grandmother. Who could have imagined that it would be Occidental's new barber to the rescue?" Turning to Jackie with mimed solemnity he intoned: "Please accept my humble and heartfelt gratitude, madam. No longer shall I have to suffer unbearable harassment in my remaining sunset years."

"Think nothing of it, old man," she taunted. "That little guy and I have had to face more S.O.S.'s—that's for Sobs Over Something—in seven years than most folks in a lifetime."

"Touché! But one more reference to this 'old man,' madam, and I won't tell you the story Mother's telling your son. It's the story of the proud young agates and the wise old shells. You'd love it."

"I'll squeeze it out of Peter."

"Not if I threaten him with no dessert." Jackie and Peter were hitting it off even better than Andie and I had thought.

The distraction and banter had provided a needed break, but we were also anxious to get big Peter back on track before Grandmother Castro had stretched little Peter's attention span to the limit.

"Okay . . . for now," Jackie conceded. Then, still quite animated but with a slightly furrowed brow, she continued, "That Pakahuwe parley seemed to be turning into something more than either Amoros or Schmidt had bargained for."

"Yes, Paca was not your run-of-the-mill errand boy. Maria notes his role as a kind of master of ceremonies, first making sure that the notables were properly introduced, guests welcomed, and all participants comfortably seated on blankets in the outdoor council circle. Gifts were exchanged and refreshments were served to the weary travelers. Maria recalled that the smoked salmon and honey-sweetened juice were particularly good. Conditions for amicable relations among the mission, fort, and *ranchería* communities were discussed at length, with Paca and Grigory functioning as interpreters when the conversation became too complex for the notables. A number of grievances, particularly Indian grievances, were addressed—Russian and Mexican poaching, unfair labor practices, and mission jurisdiction over recalcitrant neophytes. The issues were resolved insofar as that was possible by Amoros and Schmidt, the latter being disadvantaged because of his pending replacement by Commandant Shelikov. Finally the pipe of peace was passed. Only then were the visitors left to pursue the original concern.

"Perhaps 'left' is not the most accurate word to describe their situation. Although they remained in the council circle, the inquisitive eyes of young and old alike peered at them from every direction, normal village activity having long since ceased. Pakahuwe's men folk were inspecting the foreigners' horses and saddles and gear. The

women couldn't keep their eyes off Maria. But, despite the distractions, Schmidt quickly explained his reasons for requesting the meeting. He fully agreed with Amoros concerning the importance of a Russian contribution to Sonoma's new mission church. He was determined to leave a legacy of Russian good will to his successor at the fort. The problem was that he considered himself decidedly unqualified to determine what from among the Russian Orthodox paraphernalia available at the fort would be appropriate as a gift to the Roman Catholics. He had even brought along an inventory of all such items and now placed it in the padre's hands. In turn, Amoros and Maria dutifully studied the list, checking those entries which they deemed most needed at the Sonoma Mission and indicating others which would also be quite acceptable.

"It was two weeks later but still several days before Nurse Aguilar and Fr. Amoros would be making their journey at the head of the San Rafael delegation to attend the dedication at Mission San Francisco Solano de Sonoma. She was first to sight Paca as he descended the hills from the north and approached the mission compound. In the near horizontal rays of the late afternoon sun his bronzed skin appeared to blend with the manzanita that lined the trail. She was impressed by his erect posture astride the spirited mount and heartened by the fact that he was now almost completely recovered from his encounter with the grizzly. Only that part of the deeply etched scar which reached to his cheek from beneath long black hair remained to remind her of the ordeal. She was also aware of the man's dignified demeanor, a dignity which, as she had observed in Pakahuwe, was inbred rather than contrived.

"Paca's reason for the visit was twofold, or, if the whole truth were known, perhaps threefold. First, his official business was to deliver to the priest a package from Commandant Schmidt. Second, and of greater personal concern, Paca was in hopes of obtaining a new supply of the medicine which Maria had administered to sick children in Pakahuwe. During the meeting there she had noticed several children, listless and sitting apart from the rest, their knees drawn up against their chests. She had asked Paca to explain her work to the parents and see if she might examine the little ones.

"There was considerable reticence, but ultimately permission had been granted. Her diagnosis suggested need for a kind of 'spring tonic,'

a flask of which she had brought along. The need was often widespread after a winter on dried foods, and the tonic consisted primarily of citrus juices. Real resistance emerged, however, when she began to spoon it out. Not until both she and Paca had themselves downed generous drafts were the parents satisfied that the tonic was not poison.

"I think we can assume that the third, if unannounced item on Paca's agenda was to see and talk further with Maria." Andie's long sigh came as no surprise and left me as disconsolate as before. Even when she reached unobtrusively across the spaghetti-stained oilcloth table top to take my hand in hers, I knew she was fantasizing. I was no match for a Paca, never had been. But let her dream. I still had my research.

What a delight, though, when she evidenced interest in something beside the "good part." "Peter, you said that Paca came bearing a gift. What did it turn out to be?" she asked.

"One of the most exquisitely handcrafted chalices the padre had ever seen. He thought there must be some mistake, that the commandant must have selected it for Sonoma from among the checked items on his list. But Paca assured him that it was indeed intended for San Rafael; that Schmidt had taken note of the friar's and Maria's raised eyebrows when they were perusing the inventory's description of the chalice; and that the Russians had left it with Paca for delivery as they were returning to Bodega Bay, having taken a whole *pack train* of gifts to Sonoma!

"And so they had. A few days later when Maria and Amoros knelt on the cool tile floor of Sonoma's new church the evidence surrounded them. The Russians, of course, were not the only ones who had contributed to the adornment of the sanctuary. Fr. Presidente Sarria had sent a large and very impressive canvas of the mission's patron saint, San Francisco Solano, who for over two decades had served as one of the Franciscan's inspiring missioners in the Indies and Peru during the late sixteenth and early seventeenth centuries. Mission Dolores and San Rafael, together with other missions which lined the bay, had contributed, too, but it was the Russians who had gone all-out. As Fr. Altimira had already recorded in a letter to the Presidente, there were vases, hammered brass basins, hand-carved missal stands, religious paintings, and beautifully-embossed picture

frames. There were candles, handwoven linens, embroidered silk veils for the tabernacle and mass bells.

"The Russians' largess was the more impressive, because undoubtedly the gifts were originally intended to serve as furnishings for their own chapel, which even then was nearing completion at Fort Ross. They must have left themselves bereft of needed articles, and it would have been months before replacements could have been obtained from their own establishments. One would like to think that the Franciscan padres made some effort to reciprocate, but the record leaves us without confirmation."

All four of us at the table now turned our attention to the two on the hearth. Giulio, who had finally found a free moment, was just approaching and, as we, was touched by the scene. As though in a depot waiting for a long-delayed train, the old woman and little boy sat side by side, leaning against each other and fast asleep. In hushed tones Giulio pronounced the benediction: "Pace, pace, mi' amici."

From my own reading, I was familiar with the fact that within a relatively brief period the Sonoma Mission was extricated from its ignominious beginnings. Fr. Altimira obviously possessed some talent for influencing people, but his impersonal and highhanded, even brutal ways appear to have won him few friends. So unnerved was he by an Amerind uprising and attack on the mission in the fall of 1826, that he fled the scene, never to return. Ironically it was Fr. Amoros who first provided him refuge. But in little more than a year's time, and unbeknownst to the Fr. Presidente, the friar was on the high seas, heading for his beloved Spain.

Fr. Altimira's successor, Buenaventura Fortuny, was truly a godsend for the Sonoma community. Already in his fifties when he arrived, he had for twenty years shown his mettle as capable administrator and caring pastor in his work together with Fr. Narciso Durán at Mission San José. His presence was also a boon to Fr. Amoros, who had long yearned for a compatible colleague on the northern frontier. The years from 1826 until Fr. Amoros's death in 1832 were good years for the two padres. Despite their apprehensions over the Mexican government's increasing hostility toward and manipulation of the mission enterprise, their own missions were growing. The two men were dedicated to their work, and they evidenced a capacity to relate to the

Amerinds as fellow human beings, not simply "souls to be saved." In turn, they had the respect both of the neophytes and, by and large, of the area's gentile Miwok communities. Hence, it was with a profound sense of personal loss that Fr. Fortuny oversaw the burial of his friend in San Rafael.

In subsequent conversation with Peter we learned that that Requiem was also a tragic turning point for Maria. In the nine years during which she shared in San Rafael's rugged life and demanding work, the mission's lean, sharp-witted padre had been not only father confessor to her, but medical mentor and dear friend as well. For a time, Fr. Fortuny helped to fill the void, but the following year, at his own request, he was reassigned to a less demanding post. Unfortunately for Maria, the new post was Mission San Diego de Alcalá, the southernmost of the Franciscan establishments in Alta California.

Most distressing, however, not only for Maria but for the Amerinds and Russians as well, were two 1833 edicts issuing from Mexico City. One directed California's Governor Figueroa to expand Mexican defenses and settlements northward to what was later to become the Oregon border. Fear of the Russian presence, not to mention U.S. and British interests, was clearly the motive. The second, a long anticipated action of the National Congress, called for the secularization of the missions. The old Spanish decree of 1813 had also mandated their secularization, but with the proviso that each mission, ten years after its founding, become an Amerind pueblo under Amerind civil authority. Priests who remained were to have authority only in spiritual affairs. Others were to be reassigned to new mission fields. Such genuine secularization had actually occurred decades earlier in the missions of the Sierra Gorda, but those of Alta California were a different matter. They were too vast, too rich a prize for it to be expected that the Californios would simply cede them to the Amerinds.

Maria's first encounter with the new regime came in the spring of 1833, when the young commander of the San Francisco Presidio made his first appearance at Mission San Rafael Archangel. With him were Maria's father and a party of mounted troops. The commander's orders were to strengthen the military garrisons at San Rafael and Sonoma and to proceed with the establishment of a new presidio, preferably in the area of the Santa Rosa Valley. The commander was Lt. Mariano Guadalupe Vallejo, a man who was California born and bred, proudly

a *gente de razón*, and as pragmatic as they come in affairs of state. There was no question about his love for his native state, particularly its *Frontera del Norte*, nor about his ability and determination to rule it.

Maria was a torn woman. She was a child of the military, but to her mind what Mission San Rafael needed *least* was more soldiers. In the year that had elapsed since Fr. Amoros's death, she had had her fill of conflict "resolution" by shooting and killing. Fr. Amoros's successor lacked the cool head and wisdom of his predecessor and on one occasion had actually armed the mission's neophytes and attacked a nearby group of gentile Miwoks. Whether the threat to which the padre reacted was real or imagined, the resultant human carnage was hideous. Maria wanted no more of it and hoped desperately that the new young commander would be inclined more toward negotiation than toward annihilation.

At the meeting in the spring of 1833, Maria and her father talked long into the night. He was well aware of his daughter's consternation, of her precarious position at the mission, and of the fact that his own identification with the military now rose as a barrier between them. When she informed him of her growing affection for Paca the wall became almost insurmountable. It was difficult for the aging soldier to regard the Amerinds as anything but a lost and hopeless people, doomed to servility under the aegis of Hispanic rule. Still, paternal concern ran deep, and he said what he could to reassure Maria that his commanding officer had no intention of precipitating violence as he moved among those who possessed the land. He knew full well young Vallejo's dreams of empire, perhaps even a sense of manifest destiny concerning his role in the development of the northern frontier, no matter what nation should ascend to the task. But the man was civil, ethical. His rule would be a benevolent dictatorship.

Needless to say, her father's words of assurance were of little comfort to Maria. She had hoped that, at least in confidence, he might express some reluctance to concur in their government's determination to continue its northerly thrust. More important, she had expected him to give some indication that he looked forward to meeting and coming to know Paca. In neither case did he provide her with even a semblance of satisfaction. She had been alone before, but never had she experienced the utter loneliness which enveloped her that night. Only Paca himself was able to console her.

Mysteriously, as if from nowhere, he appeared at her side the next morning shortly after the last of the departing Vallejo party had rounded the hills to the north. On the preceding day, from the shelter of the mission's surrounding manzanita, he had observed the arrival of the troops led by the lieutenant and Maria's father. He had continued his vigil through the night, anxious that nothing untoward befall Maria. Only when the visitors were well on their way again had he felt it safe to venture into the mission compound. He had been informed of the commander's pending visit and was much interested in meeting and talking with him personally, but the time and place for such an encounter would be of Paca's own choosing. There was still much that he needed to learn about Lt. Vallejo and his superiors.

No one noticed as Maria and Paca slipped away to their trysting place. It was a spot much frequented by them now, located beneath a huge, old white oak on a grassy slope which commanded a magnificent view of the bay's sparkling waters to the southeast. As physically exhausted and emotionally drained as she was, Maria recounted in detail the substance of the long night's conversation with her father. Paca listened intently, taking into himself all of the agony that was hers. When, finally, she fell silent, they embraced—very naturally and very passionately. Held close in his strong, bronzed arms, Maria knew that no matter what lay ahead for them on the *Frontera del Norte*, they would be confronting it together.

8

"You know, Greg, now that Peter's got us into it, I'm not so sure I want to hear what ultimately happens to Maria and Paca. The whole thing is starting to sound too much like Ramona and Alessandro." Andie and I were in bed, and I had just about drifted off. Now, of course, I was wide awake again. There ought to be some kind of truce, I thought, or some sort of switch that turns both bed partners off at the same time.

It had been decades since I had read Helen Hunt Jackson's *Ramona*, but the outline of its plot was not long in surfacing. Ramona, the despised but lovely young ward of a tyrannical aunt who ruled one of the last of the old southern California Mexican ranchos, falls in love with Alessandro, handsome and talented head of the rancho's Amerind sheep shearers and heir apparent to the leadership of the tribe. Their life together is a heroic, if hopeless, quest for peace and justice. In a succession of dispossessions by both the old Hispanic and new Anglo regimes, they at last retreat far up into a solitary valley on the slopes of Mt. San Jacinto where Alessandro, by then driven to insan-

ity, is gunned down. Not a favorite bedtime story, admittedly, but Jackson makes her point superbly.

Andie was as well acquainted as I with the history of the *Frontera del Norte*. Hence, there was no use in my trying to slough off her apprehension concerning the fate of Paca and Maria. However, an attempt at a little distraction seemed worth the effort.

"You're right, honey, things didn't look too good for the pair in 1833. But remember, they were still around in the fall of '39 to watch Grigory hammer out their versions of the inscription. What do you say we hang loose on their prospects until Peter gets us half a dozen years farther along?"

"Ah, Grigory," Andie mused. "Somehow he and Laughing Woman got left along the way. The last we heard of Grigory, he was doing some interpreting for Commandant Schmidt at that confab in Paka-huwe. And I don't recall Peter's saying much about Laughing Woman, apart from her marriage to Grigory at Mettini in 1823 . . . oh, yes, and both of them being around for a redo—'Orthodox style'—at Fort Ross in 1836. I wonder if we could get Peter to give us an update on those two."

"My guess is that he's a good deal more interested in talking about them than he is in Maria and Paca. Let's see if we can catch him at Jackie's shop tomorrow morning."

"At Jackie's?"

"Uh-huh. If I'm not mistaken, she just about had him convinced tonight that he really needed a haircut."

"You're not serious."

"No kidding; I think she had him feeling almost as sleazy-looking tonight as you had me feeling this morning. She mentioned something about a neo-Pomo cut, and that really seemed to impress him. Besides, I think it occurred to him that risking her hair-styling talent was a small price to pay for the opportunity to see her again. There must be a ten- or fifteen-year gap in their ages, but I didn't notice that they noticed."

All I got from Andie in response was a "hm-m-m" and slow, steady breathing. The diversionary tactic had apparently paid off—for her.

Next morning at about 10:30 we strolled leisurely in the direction of Jackie's hand-painted barber pole sign. If Peter had indeed taken the big step, he would have done so at the earliest possible moment.

By now, he and Jackie would have had at least a half hour to pick up on their promising beginnings of the previous evening. In fact, we were hoping that we might be able to observe Jackie as she deftly tended to the finishing touches of a neo-Pomo cut.

As we sauntered up to the shop, looking as nonchalant as possible, our carefully calculated speculations evaporated. Jackie was busily involved with the coiffure of an older, pleasant-looking lady who, as it turned out, was one of Occidental's retired schoolteachers. Peter was nowhere in sight. At the moment we did not know what Jackie knew, namely, that Peter was across the street in the hardware store feigning interest in an assortment of wood chisels. Actually he was biding his time until, from behind the store's merchandise-cluttered window and presumably undetected, he could see when Jackie was alone.

We had waved our "Good morning" to Jackie as we passed the shop's open doorway and were beginning to continue on down the street when, scissors and comb in hand, she appeared on the sidewalk behind us.

"Good morning to you two, too," she called out brightly. "Come on in. I want you to meet Occidental's 'Mrs. Historian' herself."

Jackie was right. The woman was a gold mine of colorful anecdotes and genealogical detail, particularly from the Italian sector of Occidental's past. Once she learned of our interest, she moved with gusto into her field of expertise. As Jackie clipped merrily away and Andie and I looked on and listened with rapt attention, the little shop became a veritable classroom. Poor Peter must have been driven close to despair as at least forty interminable minutes ticked by before he saw our instructor emerge from the academy.

"Peter's over there in the hardware store." Jackie nodded in its direction but avoided a direct look. "I'm not sure, but my guess is that he's working up his courage to come in for a haircut. What do you think we can do to convince him it's safe?"

Without a word Andie dug into her bottomless purse and, after a bit of rummaging, pulled out a black felt-tipped pen. Then, writing backwards in bold letters on the inside of the shop's front window, she penned her message, returned the pen to her purse, and suggested that the three of us sit down and wait. Jackie and I obliged obediently, smiling as we deciphered the lettering. From our perspective the message read, "!ЯAƎ⅃Ɔ ꙅI TꙅAOꙄ ƎHT"

We did our best to appear engrossed in conversation when, a moment later, we glimpsed Peter stepping out from the hardware store, saw him hesitate and then begin to move sheepishly toward the barbershop. His complexion was normally a very calm, quiet reddish-brown, but the red was shrieking uncontrollably as, almost apologetically, he stepped into the shop. For an instant I felt that we had gone too far; that I personally had played too loosely with the sensitivities of a fellow male—but only for an instant. Peter's emotions may have got out of hand momentarily, but his head was still working smoothly.

Perfectly deadpan, he faced us squarely and said evenly, "You are probably wondering why I called this meeting." The gag was an old one, but it could not have been better timed to break through the tension and relieve our mounting uneasiness.

Jackie, at once laughing and shaking her head in disbelief, motioned Peter to take up his position in the vacated barber chair, gently tucked the cloth in around his collar, and then studied the challenge which his full head of shoulder-length, coarse black hair presented.

"If you're having trouble determining a price," he said, still deadpan, "just make an estimate and I'll ask Mother if we have sufficient funds." Andie and I settled back in our chairs. This was going to be an even better show than we had anticipated.

As Jackie began to make a few tentative snips, Peter looked down from his lofty seat and studied Andie and me briefly. Then, turning his head aside in postured confidence, he whispered to Jackie, "I have the distinct impression that those two are up to no good. Could it be that their presence here at this particular hour is no mere coincidence?"

Jackie pleaded ignorance concerning our motives, but also told Peter in no uncertain terms that his neo-Pomo was going to turn into a neo-nothing unless he kept his head still. Andie grasped the propitious juncture to make a clean breast of our hidden agenda.

"To tell you the truth, Peter, Greg and I were mulling over things in bed last night, and we were kind of hoping that you might tell us more about your great-great-grandfather and great-great-grandmother. From what you've told us we assume that their lives became more and more closely intertwined with Maria's and Paca's."

Andie's forthright disclosure was all that was needed to spark a lively response from Peter. For the second time that morning the little barbershop was transformed into the locus for a tutorial in California

history, with no one from among the gathered company concerned to raise questions about accreditation.

Before plunging in, Peter just *had* to deliver one more "aside" to Jackie—something to the effect that "when these out-of-towners get obsessed with our fascinating local heritage, they just won't let loose, will they?" But then, with genuine concern, he turned back to us.

"Yes," he said, "the lives of those two couples did become inextricably bound together. But the fact that they did so cannot be attributed simply to a happy convergence of four congenial personalities. Indeed, Maria's diary contains ample testimony to the contrary. No, what bound them together had less to do with personality than with . . . how shall I put it? . . . than with character. Perhaps 'character' is not the right word either, although it comes close. What I mean to convey is that none of the four assumed what was *supposed* to be and generally *was* assumed."

"For instance?" I queried, somewhat perplexed.

"Well, take Maria. It was *assumed* that the gifted daughter of a respected army officer would be groomed to take her place beside some promising young cadet. It was *assumed* that her interest in the Indians would be, at most, proprietary. In terms of religious perspective it was *assumed* that she would conform obediently to her church's tradition as vouchsafed by the Holy See and directed by her parish priest. Obviously Maria was a great disappointment on all counts."

"Did she actually abandon the Catholic Church, Peter?" Andie asked.

"No, she chose instead to be a rebel from within. There was much within the institution that she cherished, in particular its liturgy and its ideals of compassion and concern for healing and social justice. But she came to see that these ideals were by no means absent from the more animistic tradition of Paca's people. In addition, she was drawn toward the Miwok's profound understanding of the unity and balance that must exist between humankind and earth's spiritual forces. It would seem that it was Maria's refusal to accept her own tradition as the sole source of spiritual truth that led to the Church's alienation from her, rather than the other way around.

"With Paca it was much the same. Had he accepted what was expected of him, he would have married into one of his tribe's prominent families, thereby adding to the power already consolidated by his

father. He would have been much less inclined to assume an experimentally open posture in relation to the contending national forces on the *Frontera del Norte*. Most important, he would not have dared to question the sources of pathological fear which eroded the otherwise beautifully affirmative, life-giving elements of his people's world view. In this, he and Maria were completely at one. Whether the fear stemmed from prospects of poisoning or prospects of purgatory made no difference to them. Fear was the destroyer of truth. It was death-dealing, not life-giving."

Jackie was doing her best to concentrate on Peter's hair, but it was obvious that the substance of his discourse was making it increasingly difficult for her to do so. She, too, was naysayer when it came to expected assumptions. "You know, Peter," she said, "when I was a kid at Sonoma High, I had a friend who was very much like Paca. He came from a Miwok family, and he and his folks and brothers and sisters lived in a run-down shack in a vineyard northwest of town. His dad worked pretty much year-round doing pruning, odd jobs in the winery and the like, but it took the whole family picking grapes in the fall to eke out enough income to feed everybody. I remember, especially, one day in our history class when the teacher was recounting the story of the Sonoma Mission in highly romantic terms. My friend . . . his name was Mateo . . . surprised us all by standing and saying, 'B.S.!'

"A good teacher might have reprimanded Mateo for his abusive language but would certainly have gone on to ask, 'Why?' I'm sure that would have been the case if any of us Anglos had made the comment. But Mateo was not an Anglo, and all he got for his honest appraisal was expulsion . . . not only expulsion from the classroom, but from the whole blessed high school."

"Did he get back in?" Andie asked.

"He could have, but he didn't see much point in trying. He was a good student, too . . . knew a lot more about Sonoma history than the teacher did . . . and we were only a couple of months from graduation."

"What happened to him after that?" Andie persisted.

"Well, he went to work with his dad in the winery, but things didn't turn out too well for him there either. He found out that the Miwoks were getting half the pay that the Anglos were getting for doing the

same thing, and so he tried to organize a minority group to negotiate with the owners for a standardized pay scale. It was tough going, because most of his fellow minority employees were either afraid of getting roughed up by the company's goon squad or afraid of losing their jobs. And in this case their fears were not unfounded. Mateo and a couple of other leaders really got clobbered. In fact, Mateo's head was so badly bludgeoned that he was never the same again, and it was a long time before anyone else was willing to run the risk of speaking up."

Jackie, whose professional efforts had all but ceased, began clipping and snipping again with great intensity. "I'm sorry," she said. "I've gotten us off the track. Peter, you indicated that the other two in this foursome you've been talking about were also inclined to think for themselves and run some risks."

Andie and I shifted to the edge of our chairs, eagerly expecting that, at long last, Peter was about to bring Grigory and Laughing Woman alive for us. Instead, he lapsed into another of his long, exasperating periods of silence. Only snipping scissors cut into the quiet of a room that but an instant before had been filled with animated conversation. With the exception of his brief hesitation in speaking about Sonoma the previous evening, Peter's silence was a new experience for Jackie; and she looked over at us uneasily, indicating her perplexity with a questioning shrug. All we could do to signal our reassurance was to settle back in our chairs again and assume a countenance of complete equanimity.

Finally, her patience taxed beyond endurance, Jackie tried once more: "Peter, I was wondering . . . " But at precisely that moment he cleared his throat and, as though no time had elapsed, commenced his response to her question.

"Please forgive me if it sounds as though I am touting my family lineage, but, yes, Grigory and Laughing Woman *were* of a mind to think their own thoughts and act upon their own judgments. As with Paca and Maria, their tendency to do so was less a symptom of obstinacy than of impatience. Oh, they could be stubborn all right. Maria's diary provides ample evidence of the fact. But, more constructively, their impatience reflected an unwillingness to accept or endure assumptions which, in their estimation, gutted the heart of human community."

Andie and I had gone through this theme before with Peter. Hence we were tempted to sigh and say to ourselves, "Here he goes again." But the context was different now, as though he were on the verge of some unexpected disclosure, and so we simply nodded him on.

"You will recall" he continued, "that Grigory was present at the Pakahuwe meeting in the spring of 1824. Actually, that event served as the first of a number of proving grounds for plans which he and Paca had begun to lay during their frequent encounters at Bodega Bay. Their usual meeting place there was on a pier attached to one of the Russian storage buildings. On occasion, to get out of the weather, they would retreat to the interior of the decade-old storehouse, where the pungent, convergent aromas of redwood, steer hides, grain, and other trade commodities bit into their nostrils, but for the most part they met outside. When a ship was in, their conversation was all but drowned out by the hustle and bustle of Russian and Miwok stevedores. At other times, they might be completely alone, their voices joined only by the screeching of sea gulls and the lapping of bay water against the pilings. In any event, the waterfront was appropriately cosmopolitan for the conduct of their international business.

"Normally their routine responsibilities could be completed with dispatch—a message from the fort relayed from Grigory to Paca for delivery to the mission and/or vice versa. At times, oral explanations would have been passed along from one courier to the other, explanations concerning urgency, confidentiality, need for response and the like. Still, almost invariably there was sufficient time for the two men to cultivate their own deepening friendship and to react to each other's perspectives—sometimes quite disparate perspectives—concerning developments on California's northern frontier. Their conversations were at first cautious and defensive, then contentious, but ultimately conciliatory. Descended from such starkly different traditions, they were yet men of compassion and considerable vision, and, with a kind of dogged persistence, they gradually came to trust and respect each other.

"Both had, of course, been privy to the concerns of Commandant Schmidt and Fr. Amoros which prompted the Pakahuwe parley. But the initial part of that meeting dealing with Miwok and Pomo grievances was due entirely to the strategy of Paca and Grigory. Although it was Paca who so skillfully executed it, the plan was

Grigory's brainchild—surprising on first hearing, but quite under-
standable when one becomes acquainted with Grigory's life at Ross.

"As you know—or at least as Andie and Greg do, Jackie . . . and I
shall be most happy to provide you with a private tutorial if provoked
by the slightest sign of interest . . . at any rate, as an orphan and as
the fort's only full-blooded Russian child, Grigory was a kind of
darling of its Russian constituency. This favored position had its
advantages, but it was also beset by some profound yearnings. Apart
from the obvious, that is, the yearning for father and mother, he
longed for companionship with others his own age. Perhaps more
than any other, it was Yekaterina Kuskova, wife of the fort's founder
and first commandant, who sensed the lad's need and moved crea-
tively to satisfy it.

"This dignified woman, with dark, sad eyes and black hair parted in
the middle and drawn tightly into a bun behind, was a gifted linguist
and teacher. During the early years of her husband's tenure as com-
mandant, she not only mastered the Kashaya tongue but also organ-
ized classes in which Kashaya children and youths became acquainted
with the rudiments of Russian language and culture. Most important
for Grigory, Mme. Kuskova counted him in on her pedagogical under-
takings. Hence, from earliest memory his classmates and closest
friends were Indians. One, however, was to become much more than
friend. Her name, as you might suppose, was Laughing Woman or,
at the first, Laughing Girl. An incident from the pair's years at the
fort—one which Laughing Woman later divulged to Maria—bears
repeating.

"The year was 1821, and in but a few days Ivan Kuskov would be
relinquishing command of the fort to his successor, Captain Schmidt.
Mme. Kuskova, in addition to overseeing the packing of their house-
hold belongings, was busily engaged in bidding farewell to the many
Russians, Aleuts, and Kashayas with whom she and her husband had
shared life at Ross for nine years. Among those with whom she
wanted especially to talk at length were Laughing Girl and Grigory.
Grigory was, by then, sixteen and Laughing Girl, fourteen.

"Eight years previously, when Mme. Kuskova had sufficient grasp of
the Kashaya tongue to make the project plausible, she and the
commander had discussed her idea of informal instruction with the
Kashaya captain and other notables at Mettini. Mettini, you

140

remember, was at that time a principal village of the Kashaya Pomo and was situated close by the fort. There was some apprehension among the elders that the children of the village might be dissuaded from continuing loyalty to the tribe's ancient traditions, but for the most part Mme. Kuskova' offer was welcomed as a sign of generosity and desire for amity between the two peoples. No doubt it was her own demonstrated interest in and respect for the Kashaya that won the welcome—that and her insistence that she come to them, not they to her. From the first the little school was housed in one of Mettini's hogans that was situated on the edge of the village nearest the fort, and it was always 'open for inspection.'

"From the first, too, Laughing Girl, who was not yet quite six, sat cross-legged with the other children, innocently laughing at the way the strange-looking new teacher pronounced their words, but attentive and quick in learning the funny-sounding foreign words that had the same meaning as their own. Perhaps it is no coincidence that the word *Kashaya* signifies 'agile or nimble people.' But while Laughing Girl was attentive and quick to learn, she was also distracted—or better—awestruck by the equally strange older boy whom the teacher had brought along with her from the fort. His eyes were blue instead of brown. His hair was much lighter than her own, and his skin looked very pale. He was also taller than any of the village's eight-year-old boys. The really funny thing, however, was that he was all dressed up in shirt and trousers and even shoes! He seemed very uncomfortable as he sat there silently, arms wrapped tightly around his knees, trying to be inconspicuous.

"It was days before Grigory spoke a single word, and he spoke then only because Mme. Kuskova pressed him to do so. She had been helping the girls and boys to say 'Good morning' in Russian, then one by one instructed them to greet their mute classmate with 'Good morning, Grigory.' The words were dutifully rendered with varying degrees of intelligibility, all of which Grigory endured without once lifting his eyes to face his well-wishers. Then, turnabout being fair play, Mme. Kuskova instructed Grigory to return the greeting in Kashaya, selecting Laughing Girl as the recipient. Slowly and with great effort the lad raised his head, looked timidly into Laughing Girl's smiling eyes, and uttered words so incoherent that no one could understand them. All the children roared with laughter . . . all, that

is, save the girl who laughed so much. Embarrassed 'beyond words,' not for herself but for Grigory, she fled to the sanctuary of her own hogan.

"Neither Laughing Woman nor Grigory, nor for that matter, Mme. Kuskova, could forget that moment of utter humiliation. And, as is so often the case when we mortals have shared an instant in which we were pushed to our extremity, the moment established a bond among those three. Indeed, it was the first thing of which they spoke when, eight years later, Grigory and Laughing Girl met with their beloved teacher for the last time. She had invited them to join her for tea in the old commandant's house, an imposing two-story redwood structure just inside the north wall of the fort, where she and her husband had living quarters above the first floor's well-stocked armory.

"All of Mettini's children knew and loved the large sitting room, with its warmth and glow pouring forth from the hewn-stone fireplace. Each Epiphany, twelve days after the celebration of the Christchild's birth, the Kuskovs had invited them there for tea, nut breads, sweets, and the sharing of gifts. All had also gathered there just a few days previously for their visit with Mme. Kuskova, and so Grigory and Laughing Girl were well aware that they had been singled out for a very special return engagement.

"The familiar smell of oiled rifles and gun powder greeted them as they entered the building, but as they mounted the plank steps to the second floor, the odor gave way to the appealing aroma of hot drink and pastries. Their teacher was drawing tea from the great samovar as they stepped into the room, and she beckoned them to join her by the fire, where chairs were drawn up around a little table laden with good things to eat. They could laugh heartily now as they reminisced about that mortifying moment years ago and about many another which attended their journey from childhood to adolescence and, for those days, the threshold of adulthood.

"After a period of unhurried banter, their teacher and friend looked at them quite seriously and said, 'It is very painful when I think that I shall probably never see you again. I have loved all of the children, but it is to you two that I have been drawn closest. It is not because you are my prize pupils . . . you are, you know . . . but because you are so full of life, so open to and unafraid of what each new day may bring, so instinctive in including the others. It is my fervent prayer [here she

crossed herself in the Orthodox manner] that no person or power may ever dissuade you from what comes so naturally to you.'

"Turning to Laughing Girl and speaking in the Kashaya tongue she said, 'Laughing Girl . . . no Laughing *Woman,* as you and Grigory have grown older you have helped me to bring the younger ones along . . . even without my asking . . . and I am grateful that your people permitted me to observe the rites whereby you became a woman.' And to Grigory in Russian, 'Grigory, as a boy you were very timid, but it is no longer so with you. You are becoming a leader of men. Your Russian roots run deep, but the Aleut and Kashaya have nurtured you also, and you have embraced them as well. It will be your vision that will help them to walk together.'

"Finally, taking a hand of each in hers, she smiled and said, 'Your love for each other is transparent. I know, as you do, that one day you will make your vows to each other according to the tradition of *your* people, Laughing Woman. I regret that we have no priest here at Ross. Someday, however, a priest will come, and I hope that you will confirm your vows in his presence. None of us knows what may lie ahead for you two in your life together, but I believe that much good will come to others through you.'

"She hesitated, as though uncertain whether or not to speak further, then decided to complete her intended remarks. 'Of one thing I am sure. There will be much conflict, much suffering as persons and nations contend for possession of this little part of God's good earth. The conflict, the suffering will be of particular concern to those who are compassionate, such as you, my dears. I say this not to frighten or discourage you, but to challenge you. You are not of a kind to run from conflict nor to cause suffering nor to harden yourselves against it. There will be much need for your presence.' "

Peter looked quizzically at Andie and me in turn, and then twisted his head and glanced back up at Jackie. "That's what she said," he assured us, "or words to that effect. One can never tell what lies hidden in the heart of a schoolmarm."

"Or more likely," Jackie shot back, "what lies *not* so hidden in the heart of an old Pomo who lives with his mother south of town."

"No, actually what I have told you is a fairly accurate rendering of what Maria recorded . . . tidied up a bit here and there perhaps, but, all in all, a fairly accurate rendering."

Jackie was not entirely convinced, but, as we, she had no intention of abandoning Peter midstream . . . or mid-neo-Pomo. "So, was Mme. Kuskova right about Laughing Woman and Grigory?" she asked.

"Oh, yes. It was only a couple of years later that their marital relationship was established in Mettini . . . Kashaya style. But, as Andie and Greg know, it was not until after thirteen more years had elapsed that a Russian Orthodox priest finally showed up at the fort. By then, there were not only nuptial vows to be repeated but a son to be baptized. Grigory and Laughing Woman, after over a decade of trying, had despaired of ever having a child of their own, but a few months before Fr. Veniaminov arrived, the blessed event occurred. It was as though conception had been denied until blessings by holy rites—Orthodox style—were accessible. The good priest must have spent the greater part of his stay documenting a backlog of births and 'regularizing' a backlog of conjugal relations.

"Actually, Fr. Veniaminov's baptismal record simply confirmed what I already knew about the birth of my great-grandfather, Nikolai. Laughing Woman and Grigory had perpetuated the Epiphany celebration initiated by Mme. Kuskova, shifting it from the commandant's quarters to their own home. Along with those of several other Kashaya/Russian families their house was situated on the gentle slope between the fort and Mettini. Grigory had designed and constructed it himself and had patterned the sitting room after the Kuskovs'— fireplace and all. It was on Epiphany, 1836, with the house full of happy and boisterous children, that Laughing Woman, well into her ninth month, signaled to Grigory, and the two of them slipped unnoticed into the bedroom. Laughing Woman's mother and the village midwife were summoned, and before the evening's celebration was over, little Nikolai's raucous voice had joined the happy chorus.

"Almost thirteen years after their marriage!" Andie exclaimed, "and on such an auspicious occasion!"

"Yes, Epiphany, the feast of manifestation," I put in, proudly recalling my Greek Biblical exegesis, "the coming of the wise men from the East to Bethlehem, signifying the showing forth of the divine gift to all peoples. Very fitting, considering the multi-ethnic setting at Ross."

"Thirteen years *was* a long time to wait for their first-born," Peter

agreed, passing over my astute observation, "but perhaps it was just as well. . . . "

"Only a man could say that," Jackie retorted, "or maybe a career-oriented woman, which it seems dubious Laughing Woman was."

"Patience, m'lady," Peter responded calmly, although he did look somewhat concerned about what might be happening to his hair. "I was about to say that it was probably just as well because Grigory would have been one helluva lousy father during those early years. Apart from the few months when he was building their house, he was 'on the road,' to speak, or out at sea almost continually. You will recall that Ivan Kuskov, before he assumed command of Ross, had worked closely with Baranov in Alaska. Hence, Kuskov was intimately acquainted with what it took to serve effectually as the aide of a great leader. He recognized in Grigory the makings of such a functionary, and he groomed the lad well. Grigory may have lacked the desired social status for anything more, but the deficiency would not constitute a serious impediment to possible service with the Russian American Company's remote operations in California.

"No doubt Kuskov convinced his successor, Captain Schmidt, of Grigory's potential. Shortly after Schmidt took command he pressed Grigory into service, first as a courier to Bodega Bay, then gradually into responsibility for much of Ross's trade with the Pomo and Miwok as well as the missions at San Rafael and Sonoma. Ultimately, under Shelikov and Kostromitinov, Grigory even found himself riding herd on the fort's shipments to Sitka. The mad pace and long periods of separation were not exactly what he and Laughing Woman had envisioned for their life together. Had it not been for Grigory's powers of persuasion and a project undertaken by Commandant Kostromitinov in 1833, things might have continued much the same.

"Ever since his arrival three years before, the commandant had become increasingly concerned over the inadequate supply of wheat which the fort's limited and rodent-ridden farmland was able to produce for shipment to Sitka. He was also aware that just a dozen miles down the coast, where one of his crews maintained a ferry service on the Russian River, there was a considerable area of good bottom land. This, by the way, was near my mother's home village. He decided to establish a ranch there, and Grigory, quick to take advantage of the opportunity, was able to convince him that he was

the commandant's man to oversee the construction of the needed ranch house, barracks, granary, and other buildings. He and Laughing Woman would have to live and work out of an on-site hogan rather than their comfortable home at Ross, but the sacrifice seemed minimal in view of the chance to be together again. Laughing Woman was particularly intrigued by the prospect, because apart from the fall acorn gathering excursions, she had never ventured far from Mettini. Later she told Maria that, despite the hard work, it had been an adventure . . . as though she and Grigory were commencing their marriage all over again."

"I can think of less demanding agendas for a second honeymoon," said Andie.

"Like crawling through brambles in an old creek bed?" I queried teasingly.

"No, not quite. But then, if you'd told me this was a second honeymoon, I wouldn't have egged you on into that scramble."

"Oh, yes, you would've."

"Oh, no, I wouldn't've."

Peter, sensing a possible impasse developing, deftly moved in to continue the narrative.

"Well, in any event, so impressed was the commandant by Grigory's work at the Russian River site that the very next year he assigned him to do much the same thing at a second farm which was to be established by another Russian, Vasily Khlebnikov, and was to be near Salmon Creek, a few miles inland from Bodega Bay. But whereas Grigory himself had instigated his and Laughing Woman's move to the Russian River, he was less enthusiastic about the new assignment. Many of Laughing Woman's own people had been employed at the former location because of their farming experience at Ross. Hence, she had felt secure among familiar faces, needed in the preparation of food and for other domestic duties, and of some social stature because of Grigory's position. Grigory knew that the situation would be quite different at the Khlebnikov ranch. Not only would they be almost twice as far from Ross, but Laughing Woman would be dwelling among strangers, namely, the Southern Pomo and the Miwok.

"Grigory's work went as well as it had at the Russian River, perhaps even better because of his previous experience. In addition, he had the satisfaction of experimenting successfully with some adobe construc-

tion, using methods and materials he had observed at the missions. But, for Laughing Woman, it was as he had feared. Despite her *joie de vivre* she found very little to laugh about during their months at the Khlebnikov ranch. The Southern Pomo and Miwok workers had, at best, consigned her to the periphery socially; and it was clear that her efforts in food preparation were suspect, no doubt because of the widespread fear of poisoning. Had it not been for an unexpected visitor to the ranch late one night in the fall of 1834, Grigory might well have requested reassignment to his former duties as personal aide to the commandant.

"Grigory was roused by the snorting and stomping of the horses that were corralled near the hogan where he and Laughing Woman lay asleep. Fearful that the cause of the disturbance might be a prowling grizzly, he slipped quietly from beneath their blanket, crawled to the low doorway, and groped until his hand touched the rifle which lay just inside. No sooner had he poked his head out cautiously into the starry night than a chuckling voice in tones no louder than a whisper, said: 'It's all right, Grigory. No grizzly, just Paca.' And there he stood like a bolt from the blue—or more accurately, a thief in the night— towering above the little entry and smiling down on his friend's upturned face. Grigory could hardly control his elation. Not only had it been two years since they had laid eyes on one another, but, because of Laughing Woman's depression, both she and Grigory were ripe for a real morale booster.

"Only a moment was required for Grigory to return to Laughing Woman and explain to her who it was that had come. As she made herself presentable he rekindled the fire, then welcomed Paca in to join them by its warmth. Until that moment Laughing Woman and Paca had known each other only through Grigory's descriptions, but so vivid and winsome were those oft-repeated profiles that the pair felt a sense a kinship immediately. Still, Paca was well aware that she must be suffering serious misgivings, stationed as she was among strangers, and so he quipped about his being one more suspect Miwok, there for the express purpose of troubling her Kashaya dreams. Not until later, when he and Grigory were alone outside, did he learn what relief her responsive laughter had brought to his friend.

"Having but recently heard of Grigory's presence at the Russian's new ranch, Paca had bided his time until he could make his way there

unobserved from Pakahuwe, which lay some seven miles upstream on Salmon Creek. He did not relish acting in secrecy, but neither did he wish just then to broadcast his Russian connection, either to his fellow Miwoks or to the Mexicans, both of whom were apprehensive about Ross's ancillary additions to the south and inland. The reason for his visit was two-fold. In part, of course, it was simply to be with a dear friend again, to meet and begin to know his wife, and to tell them of his own relationship with Maria. Indeed, so much had transpired during the past two years and so eager was each to enter the world of the other that few lulls found entry into the ensuing conversation. Laughing Woman was particularly entranced by Paca's self-conscious, sometimes awkward references to Maria. Grigory's observations of Maria were limited to the fleeting glimpses he had had of her a decade earlier at the Pakahuwe consultation and, shortly thereafter, to a formal introduction at the Sonoma dedicatory service. His descriptions had served to pique Laughing Woman's curiosity, but were hardly enough to acquaint her with the real Maria.

"Paca's concern to reestablish contact with Grigory had a broader dimension as well, albeit one which was inextricably bound to the two couples. Grigory was aware of the recent secularization of the missions and of Lt. Vallejo's presence on the *Frontera del Norte*. With his complete absorption in the Khlebnikov ranch project, however, he was unaware of the speed with which the young, but able, commander had moved to strengthen and consolidate the Mexican positions at San Rafael, Sonoma and beyond. Paca informed his friends of the recent developments, beginning with what was for Maria and himself, Vallejo's disturbing overnight stay at San Rafael in the spring of the preceding year and his decision to establish Sonoma as the seat of the Mexicans' northern stronghold.

"Fortunately, before they had become completely morose, Paca realized that his report of gloom and doom was becoming more than either Grigory or Laughing Woman could handle at that midnight parley. Hence, he took the occasion to make the happy announcement that he and Maria were also married. In fact, they had become so just two months before in Pakahuwe . . . Miwok style. Then, but a fortnight later, their marriage had been blessed by Sonoma's new resident priest, Fr. Lorenzo de la Concepción Quijas. The news of Paca's and Maria's residence in Sonoma was, of course, quite bewilder-

ing to Grigory, but Paca hastened to explain. He was going to establish the same policy with the Mexicans that he was presently pursuing with the Russians, namely, 'if you can't beat them, join them.' He had secured employment with Vallejo, and he fully intended to humanize the man."

Jackie's neo-Pomo cut left Peter's previously long strands much farther "off the shoulder" than he had anticipated, but he discreetly kept his evaluation of the completed work of art to himself.

"Giulio's going to love it," I encouraged.

"A real *pièce de résistance*," Andie chimed in. "I'll try to control myself."

Jackie smiled impishly over her shoulder as she turned to the cash register. "It's going to cost you, you know."

Obviously it was time that Andie and I should *exeunt*, which we did, at last leaving the unlikely pair a shop and a moment to themselves.

9

Petaluma advertises itself as the wrist-wrestling and egg center of
the world, but there was no evidence of hand-to-hand combat
as we approached the town early the next morning. Even the chicken
coops seemed to be tucked away out of sight behind McDonald's,
Denny's, and other telltale signs of the growing community's entry
into the sad sameness of modern America. What did attract our
attention was the stark contrast between the wooded mountains that
rose to the west back toward Occidental and the open plains and low
hills that lay before us as we turned east from "101." It must have
looked much the same to Fr. Altimira when he first explored the area
in 1823.

At dinner the previous evening Giulio had relayed a message to us
from Jackie, to the effect that she, Peter, and Mother Castro were
planning to drive in her car to Sonoma the next day. The Castros had
invited her to stay overnight with them so that they could get an early
start. She had phoned the friend with whom she and little Peter lived
in Santa Rosa and all was well for getting him off to school. There was

plenty of room in her old Pontiac, and we were invited if we cared to
join them—just be at the Castros' at 6 A.M. if we decided to go.

"So, what a you think?" Giulio inquired.

"I'm not sure," Andie equivocated. "I wonder if they'd just a soon
be left to themselves. With Jackie taking the day off and all, the
outing sounds kind of special."

"No, no. She's a say that's a what you say. She's a no want a 'No' for
the answer."

When Giulio learned that we really were interested, he insisted
that his chef, Antonio, would have coffee ready and waiting for us in
the kitchen at 5:30. He, Giulio, would see to it that a hamper with
lunch for five was ready to go, too. And when Giulio insisted, there
was not much point in trying to resist. Hence, at 5:55 the next
morning, coffee downed and hamper in hand, we once again lifted
that gorgeous old oak knocker to announce our arrival at Peter's.
Responding to a jovial "Come on in," we found Peter and Jackie
busily engaged in doing up the breakfast dishes, but, to our surprise,
saw that Mother Castro was still in bathrobe and slippers. While I
helped the pair with a few things to the car, Andie took time to talk
with Peter's mother.

Later, when we had a moment to ourselves, Andie said, "Would
you believe it? That lovely old lady told me that this day was intended
just for us 'young people.' Jackie may qualify, and a few old-timers may
still think of Peter as part of the younger generation, but you and I
don't stand a ghost of a chance. If I read the situation correctly,
Mother Castro has no intention of lousing up what could well be a
golden opportunity for romance. I think she'd really like to have some
female companionship in that house, not to mention the pitter-patter
of little Peter's not so little tennies. That kid's so beautifully unself-
conscious. I hope he doesn't wake up to that fact too soon and spoil it
all."

Hordes of commuters were already crowding Highway 101, many
moving south for their routine eight-to-five stints in Marin County
cities or San Francisco. Others were headed north for the day's work
in Petaluma, Santa Rosa, or on campus at Cal State Sonoma. I
wondered who from among the throng might be casting a glance or a

thought toward Olompali, the old Coast Miwok village site which lay near our junction with the freeway.

With Peter navigating, Jackie had just driven us from Occidental over some twenty-five miles of narrow farm roads, most of which approximated the old "Russian Branch" between Bodega Bay and "101." The route, which wound its way up the valley of the Estero Americano, through open hill country and down San Antonio Creek, had been used alike by Miwok, Russian, Mexican, and Americano. We had had a good laugh when passing a swarthy rancher who was mounted and riding along the road shoulder. We had all burst out with "Paca!" Peter had done a masterful job of bringing that diary of Maria's alive for us.

Now, as we turned north with the pack on 101 to cover the few remaining miles to Petaluma, Peter reminded us that we were on the final leg of El Camino Real, the road that had begun far to the south as a trail in 1769. By 1824 it had become Alta California's overland arterial. Stretching from San Diego to Sonoma it had ultimately come to connect all twenty-one of the Franciscan missions—*if* one was willing to brave Bay waters between the San Francisco and San Rafael embarcaderos.

Traffic still streamed toward us as we crossed the Petaluma River and branched east from 101 toward Sonoma. After a few miles, however, our road became less encumbered, and we found ourselves once again slipping back a century and a half to rejoin Paca and Maria. The entire valley through which we were passing had been granted to Lietenant Vallejo by California's Governor Figueroa in June of 1834. As they made their way through the valley in the early fall of that year, Paca and Maria would have seen the beginnings of Vallejo's *Palacio,* the enormous, fortified adobe hacienda which was being constructed on a rise a few miles to the north of the road. Apparently the new commander had neither lost time nor spared expense in making it clear to Amerind and Russian alike just who it was that was in control.

The grant to Vallejo had extended from the Petaluma River behind us on across the plain and over the Sonoma Mountains, which lay between us and our destination. North to south the rancho stretched from well up the creek above Sonoma down to San Pablo Bay—to us an incredibly vast area totaling over ten square leagues, that is, over

ninety square miles! Even when expanded later to fifteen square leagues, the Vallejo Rancho included only a part of what had been the Sonoma Mission's domain. But by the close of 1836, Vallejo—by then Commandante General Vallejo—was in a position to control grants within the entire domain, a process that was marked by unrestrained nepotism.

We were beginning to twist our way through the hills which rose to the east of the plain when Jackie remarked, "I simply can't understand how Paca and Maria could have walked voluntarily into such a trap. The situation at San Rafael was bad enough, but at least they weren't right under Vallejo's nose."

"Yes, but that's precisely the point, Jackie," Peter replied, noting also that the driver of an approaching semi was taking his half out of the middle of the curving road. Jackie veered to the edge of the pavement as the truck roared past. "Paca, and Maria with him," Peter continued, "knew that there was very little they could do from their peripheral position to influence the commander's perception and pursuit of his commission on the northern frontier. Hence, their intention was to move to center, either in Sonoma or at the Palacio, and offer their services to Vallejo, hoping thereby to establish themselves in slots which would eventually become indispensable to his *modus operandi*.

"But you're right. Either they were foolhardy or else they grossly underestimated Vallejo's determination to rule—as autocratically as prevailing politics permitted. The man was as possessed by a sense of manifest destiny as were the Americanos who succeeded him to the throne. As a matter of fact, it's probably inaccurate to think of Vallejo and the Americans in terms of succession, because he found little difficulty in switching loyalties. His personal fortune and that of Alta California were so inextricably tied together that national hegemony was a secondary matter . . . No, that's not quite accurate either. Actually there was much in the American way that he preferred to his own Hispanic traditions . . . *if* the Americanos would just back off a bit from their boorish egalitarianism and cultivate a little respect for the *gente de razón*. No doubt it was, in part, Vallejo's elitist arrogance that made it so difficult for him to relate to Paca, a mere Miwok, on something more than paternalistic terms."

"Peter, you mentioned that Maria and Paca offered their services to

Vallejo," Andie interjected. "I assume that Maria continued to serve as a nurse, but what about Paca?"

"Well, first, your assumption is correct. Maria did serve as a nurse at the Sonoma mission. Indeed, de facto she became a kind of physician in residence, doing all that a woman might in the medical field at the time. But it should be noted that when she and Paca arrived in Sonoma in the early fall of '34, Maria was already well-known and respected there. She and Fr. Amoros had been present a decade earlier at the dedication of the mission's first church. Later, after Fr. Altimira had fled the premises, they made frequent trips to the mission, in part, because of amicable relations with Fr. Fortuny, but also because he was in need of medical services for his charges. When Fr. Quijas took charge in early 1834, he was not long in learning where medical assistance was available.

"The new padre was a remarkable person. Not only was he impressive physically, but he was, so to speak, an 'officer and a gentleman' and a man of affairs. An Ecuadoran by birth, he was well-educated and had learned worldly ways as a trader before turning to become a man of the cloth. True, his proclivity for the fermented fruit of the vine and other spirits was perhaps less disciplined than that befitting a man in his position, but what he was to confront at Sonoma proved to be more than enough to drive any man of conscience to drink. The point, however, is that early on, he penned a most gracious note to Maria, requesting her professional services at Sonoma and offering whatever assistance he might render to her at San Rafael. Clearly he was already aware of the consternation she was suffering there because of Fr. Amoros's successor and the first distressing signs of mission secularization.

"As you might imagine, Maria and Paca were in the throes of determining how and where they would work out their life together. The padre's letter couldn't have arrived at a more propitious moment. Sonoma, or its environs, would be their *place* of residence; the health and defense of the Miwok, their *cause* of residence. Much remained to be settled, of course, especially with Paca's people in Pakahuwe. The marriage of their captain's heir apparent to an outsider could have constituted grounds for considerable apprehension, perhaps deep resentment, among the prominent families of the village. As it turned out, however, they had not forgotten the nurse who had healed their

children; indeed, who had continued to inquire about their condition and supply the village with additional curatives. There were some rumblings of discontent but, by and large, Maria's credentials were accepted, as was she. Had anyone predicted a decade before that she would be honeymooning in a hogan on Salmon Creek, she would have been incredulous."

As we cleared the summit of the hills and descended into Sonoma Valley—Valley of the Moon, the Amerinds called it—Peter lamented that we were not riding double on a couple of horses. Also, bringing up the rear there should be a faithful Miwok friend driving a *carreta*, wherein rested the sum total of our earthly possessions. Looking at the scene through framed windows from the comfortable interior of an automobile moving at forty-five or fifty miles per hour was definitely *not* the way to recapture what Paca and Maria had endured that day in the fall of '34. Indeed, according to Maria's diary, there had been a heavy rain. Hence, the smooth asphalt strip and concrete bridges were depriving us of even minimal appreciation of the cold, the wet, and the often precarious fording of swollen streams and, when the newlyweds had joined Sonoma's embarcadero road, their muddy sloshing north to the mission quadrangle.

"Thanks anyway, Peter," Jackie said, her eyes remaining focused intently on the road ahead, "but I'm having enough trouble just getting us to Sonoma in one piece in this old Pontiac. Come to think of it, Pontiac was an Indian, wasn't he? That's as much simulation as I can handle right now."

Peter grinned and then, sans simulation, returned to the narrative.

He informed us that Maria had written ahead to Fr. Quijas, responding affirmatively to his request for her assistance and also noting that she would be accompanied by her husband. Apparently, the friar's reception of the rain-soaked newcomers was so genuinely warm and hospitable that friendship began to germinate almost immediately. Fr. Quijas was surprised but not perturbed to find that Maria's husband was a Miwok. As Peter put it, "The priest's head went into action at once, selecting and discarding a dozen possibilities before coming up with what he was confident would be the most congenial and productive assignment for Paca."

What the padre had in mind was not entirely devoid of self-interest. It was only too clear to him that his own task at Mission San

Francisco Solano was to see to it that a dying era received decent burial, and that the newborn was properly baptized. Within the month Sonoma would cease to function as a mission under the auspices of the Franciscan Order. Under the administration of Vallejo and his designees, the mission was to be transformed into Mexico's northernmost pueblo and military headquarters. The padre would be stripped of all authority save that of a parish priest. He had the capacity for the requisite humility in such a transition, but he had no intention of suffering humiliation and degradation, either for himself or for the mission's neophytes.

"What Fr. Quijas needed," said Peter, "was a confidant—someone whom he could not only trust implicitly because of common concern, but one who was able and willing to run the risk of getting close enough to Vallejo to anticipate his next move. The good father had already become sufficiently acquainted with Vallejo to discern that the man was not about to include a passe padre in *his* circle of confidants. Somehow Vallejo must be watched, and, if possible, checked by higher authority if he used his position to exploit, rather than protect, those with legitimate claims to the mission domain. The padre recognized and accepted the justice that underlay the imminent distribution of mission holdings. Indeed, he saw the Sonoma distribution as, in a sense, a case of poetic justice. Of Alta California's twenty-one missions, Sonoma alone was, by historical accident, in a position to conform to the original plan; that is, to terminate church control of a mission after ten years and place oversight of its lands and other assets in the hands of qualified native inhabitants. It was the word *qualified* that worried Fr. Quijas. Vallejo was the one who would be interpreting the criteria for qualification, and the padre had no illusions about the outcome.

"As at the other missions, most of the Indians who had been enlisted in Sonoma's development had achieved competence in one or another of the skills essential to traditional Spanish construction and ranch operations—lumbering, carpentry, adobe brick and tile work, livestock and agricultural husbandry, and the like for the men; wool spinning, weaving, sewing, cooking and such for the women. Only a few, however, had been groomed for and entrusted with the kind of managerial and business operations that would have prepared them to assume control of the multifaceted mission enterprise.

"Again, as at most of the other missions, the new administrator at Sonoma would most probably succumb to the temptation—or, less kindly, grasp at the opportunity—to take the easier and personally more lucrative path. That is to say, he would most likely secure ownership and control for himself and his cohorts, and employ or, more accurately, conscript or exploit the Indians as laborers. Predictably, their rationalization for this coup would be the Indian's lack of brains, or inability or unwillingness to adapt to 'civilized' ways . . . or some such rot."

"So what was Paca's reaction?" I asked.

"Well, for one thing, it didn't take him long to get the picture. In fact, he already had a pretty good idea of what the Mexican government had in mind and of how Vallejo was apt to go about achieving it. Then, too, while he respected the Russians in general, he was apprehensive about the grandiose plans of a few of the more aggressive ones. In particular, he had found that many of the Pomo workers at the Kostromitinov ranch had been conscripted and were receiving less than fair wages.

"Later, in his conversations with Grigory at the Khlebnikov ranch, he learned that, despite his friend's efforts to treat the Miwok workers as apprentices in training, he was under a great deal of pressure to 'just get the damn thing done.' As far as Paca could see, two interloping nations which distrusted each other were capitalizing on his people's land without any intention of including them in on profit-sharing or decision-making. Not only that, but his people stood a good chance of their land becoming a Russian-Mexican battlefield. Needless to say, Paca was all for exploring ways of resistance with a kindred spirit among the dispossessed."

We were down in the Valley of the Moon now, still out in the country among the orchards and vineyards, but fast closing in on the Sonoma Plaza. All four of us knew full well that the gift shops, eateries, and hotels surrounding the plaza had become a tourist trap par excellence, but, given our absorption in Maria's and Paca's troubled times, we were not too worried about the present potential for exploitation. At four bits a head we would be exploring the old mission compound and pueblo, and when it came time for fine dining—Presto! Out would come Giulio's luncheon for five—to be consumed by four.

We were still several blocks from downtown when Jackie unexpectedly turned right from Broadway and steered us into a quiet old residential neighborhood where the houses were almost lost to sight behind orchards, gardens, oak, and ivy. Pulling up in front of one of them, a plain, but inviting, two-story frame structure of 1920s vintage, she turned to the three of us and queried, "Guess what?" It was, of course, the home where she had spent her childhood and youth. Peter was immediately captivated by the scene and listened appreciatively as Jackie reminisced about some of the happier moments in those growing-up years during which she had shared family life with a half-dozen brothers and sisters. It was difficult for him, an only son and fatherless from infancy, to envision a home with such population density. We sensed, too, that he was finding it difficult to veil his interest in anything and everything that touched on the life of his new-found companion.

Our attention was drawn toward a path that led to the rear of the house when Peter asked, "Did your father put up the tire swing that's hanging from the big oak in the back yard?"

"I'm sorry to disillusion you, Peter, but no, that's a later addition . . . must've gone up after my folks sold the house, when we kids had grown up and moved out. I do see one thing, though, that brings back a lot of memories. See that big, rounded granite surface over to the left of the front porch? Well, it's full of holes from centuries of acorn grinding. Nobody seems to know for sure whether this spot was Wintun or Coast Miwok territory . . . right on the border line between the two it seems . . . but now that we've got acquainted with Paca, I'd like to think it was his people who did the grinding. The neighbor kids used to come over and we'd spend hours grinding acorns there ourselves; then we'd boil the meal, but we never did learn how to get the bitterness out. It was terrible-tasting stuff, but we pretended we liked it—to show we were real Indians, I guess, not cowboys like the kids in the next block."

The interlude at Jackie's old home was a welcome diversion. Not only had it brought a personal dimension to our day in Sonoma, but the nostalgia it produced had provided at least momentary relief from the unhappy, at times grim, reality of the 1830s in which we were so immersed.

But there it was now, rising from the plaza green up ahead—

Sonoma's logo, the "Bear Flag" monument. Andie and I and every California child from our generation had had the story of the raising of that flag drummed into us from the first grade on. Its theme was the "rebellion" (unopposed actually) in Sonoma on June 14, 1846, led by a small group of American frontiersmen who proclaimed California an independent republic. We native sons and daughters were not much competition for our Texan counterparts, who could claim nearly ten years of independence, but we could at least boast a few weeks of "splendid isolation" before the stars and stripes went up.

Diagonally across the street from the plaza's northeast corner rose the restored and reconstructed mission buildings, with their red-tiled roofs and whitewashed adobe walls. They had all become part of the Sonoma State Historic Park and were being beautifully maintained, an arrangement Fr. Quijas might well have appreciated during his tenure in them—except for the uniformed park ranger selling tickets in the padre's house. In any event, there we were in those very quarters, tickets in hand and free to roam the premises at will. The problem was that none of us appeared to have much will to move at the moment. We just stood there in the middle of the room on the old, clay floor tiles—a kind of leaderless foursome, each of us waiting for one of the others to make the first move. Finally, Andie broke rank and wandered over to the fireplace, where the ranger had a good fire going. The day had turned cold and damp, and our early morning drive in Jackie's heaterless old Pontiac had left us thoroughly chilled. One by one, we followed Andie's lead until all four of us were grouped facing the fire with our hands outstretched to absorb the welcome warmth.

"Talk about simulation," Andie exclaimed in a sudden burst of inspiration. "Why, Maria and Paca and that *carreta* driver could have been standing right here drying out and warming up while Fr. Quijas mulled over possibilities for guerrilla tactics. Let's see, you're a natural for Paca, Peter; and Greg, you and the padre are theological types . . . of sorts. I'm not sure about us, Jackie, but with you at the wheel today I suppose there's a case for your being the faithful Miwok *carreta* driver. On the other hand, didn't I read somewhere that barbers used to double as doctors . . . bloodletting and that sort of thing? That would make you our Maria Nightingale . . . which leaves me with the reins, I suppose . . . having bounced along in that cart all day behind some old ox."

Jackie and I were chuckling, but Peter, having taken Andie's proposal in all seriousness, slipped into his role as Paca immediately and without effort—no doubt a spinoff from long-time exposure to Giulio's thespian talents.

"How would it be, Father, if you were to introduce me to Lieutenant and Señora Vallejo after mass tomorrow?" he began. "You might tell the commandante that Maria and I have asked you to bless our marriage at a later service and that we would be honored by their presence."

I (alias Quijas) was taken off guard but, feeling obliged to rise to the occasion, responded brilliantly, "Fine, fine."

"It might be well, too," Peter (alias Paca) continued, "if I were to inquire concerning his preference for our place of residence. It would assure him that we recognized his up-coming authority against yours in such matters, Father."

"Good, good," I (alias Quijas) agreed eagerly.

Andie and Jackie were already showing signs of restlessness with the pace of the dialogue.

"I think I'll see how the ox is doing," said Andie (alias the faithful Miwok *carreta* driver).

"I'll give you a hand," Jackie (alias Maria) quickly added. "He may need a vet, and I double as vet nurse."

Jackie managed to keep a straight face, but Andie and I let loose with a resounding "Boo" at the vet nurse. At her ticket table behind us, the eavesdropping ranger simply put her head in her hands. Peter, understandably, had a vague feeling that the rest of us might not be taking the simulation—or whatever it was supposed to be—seriously.

"Forgive us, Peter," Jackie consoled, putting her arm around him. "We really don't know what in the hell we're supposed to say. You're the only one who has the faintest idea of how this drama actually pans out."

Jackie was unaware that, thanks to Peter's earlier disclosure to us, Andie and I *did* have an idea of the outcome, at least in broad outline, but we were as anxious as she to hear the details.

"Well, if you're really interested . . . "

"You *know* we are, Peter," I insisted.

It took our combined powers of persuasion to get Peter going again, but go he did. What he had attempted in the simulation was actually a

plausible approximation of what had taken place, perhaps by this very hearth, because Fr. Quijas did introduce Paca to the Vallejos after mass the next day. Maria, of course, had already become acquainted with the commandante during his brief stay at San Rafael the previous year, but it was her first meeting with his wife, Doña Francisco Felipa Benícia Carrillo Vallejo, a daughter of San Diego's distinguished Joaquín Carrillo family.

As Peter conjectured, it may have been because Sra. Vallejo was herself newly arrived in Sonoma, or because of her acquaintance with Maria's father and mother at the San Francisco Presidio, or because the nurse's presence assured her and her family of proper medical care, or it could have been that Maria's coming held promise for female companionship with her own kind on that remote frontier, but whatever the reason, Sra. Vallejo was drawn almost immediately to Maria. And although she had always felt uncomfortable around people of wealth and high social standing, Maria was likewise drawn to the commandante's attractive and graceful wife. She knew that, for Paca's sake, she would have to keep on top of her emotions with the Vallejos, but at the moment the potential friendship seemed to hold little risk.

Paca's place in the new order developed rather rapidly, too. The Vallejos had taken temporary quarters in part of the padre's house, where they intended to remain until the completion of La Casa Grande, an enormous residence which was to rise by the plaza, a half block west of the mission. It was to the Vallejo's quarters that Paca and Maria were invited for dinner a few days after their arrival. Fr. Quijas was also among the invited guests that night, which was perhaps one of his last social times with the Vallejos. Good food and drink, together with the ladies' genial feelings and the quick, sophisticated wit of host and friar, made for a pleasant gathering around the table. Maria recalled being particularly surprised by how quickly the Vallejos had managed to get their table service, furniture, and personal effects for gracious living shipped from the Presidio.

After dinner, when the three men had stepped outside for a breath of fresh air, Vallejo made it clear that in the upcoming transfer of mission control to secular authority, Fr. Quijas should deal directly with the commandante's newly appointed major domo, Don Guadalupe Antonio Ortega, or with his assistant, Salvador Vallejo, Mari-

ano's younger brother. There was no animosity in the announcement, Vallejo explaining that his own responsibilities as the governor's commissioner would make it impossible for him to tend to details at the mission quadrangle. But the directive was abrupt and served to discourage, if not preclude, any potential for a personal or professional relationship between the two men.

In Paca, on the other hand, Vallejo recognized the makings of an important ally. The commandante had already negotiated alliances with the leaders of several Amerind communities on the *Frontera del Norte,* but he had not yet established significant contact with those which were situated near the Russians' operations at Bodega Bay and Fort Ross. Paca was obviously the right man at the right time, and Vallejo moved quickly to retain him as personal emissary and, less touted, as spy. Being much less disturbed than Maria by people in positions of power, Paca was quite forthright in pointing out to his prospective employer that, insofar as he had been able to observe, the Russians' activities were quite open to public inspection. He welcomed the work as emissary, but he had no intention of either spying for, or spying on, anybody.

If Vallejo found Paca's candidness distasteful, he made no mention of it. Actually there was little he could say by way of rebuttal to his guest's statement concerning public access to activities at Bodega and Ross. He himself had been graciously received by Commandant Kostromitinov during a visit to the fort the previous year, and he had had full run of its defenses. But Vallejo was under orders to contain the Russian presence, and for that he considered surveillance to be essential. Apparently he was also confident that his new recruit from Pakahuwe would eventually concur in this need, because, inside with the ladies once again, the commandante called for a toast to his latest appointee. Paca was to report in the morning for his first assignment.

We turned our backsides to the fire now and the penetrating heat was beginning to make us feel almost human again. As we turned about, I noticed that our inquisitive ranger quickly and self-consciously busied herself rearranging brochures and papers on the card table which served as ticket booth and information center. Obviously, she had been soaking up Peter's curious rendition from the 1830s while our backs were to her. I had a tinge of conscience,

thinking that perhaps we were doing the public a disservice by not counting her in on our little circle of enlightenment. No doubt she was wondering why there was no mention of Paca and Maria in those park pamphlets she was handing out, and she was going to have a devil of a time deciding whether what she had heard was fact or fancy. Whether, because of his and Maria's relatively brief residence in Sonoma, or because of his "minor" role in the commandante's illustrious career, Paca's name never found its way into Vallejo's memoirs.

"Will we be able to see the church where Fr. Quijas blessed the marriage?" Andie asked as we faced the fire again for a final cooking.

Jackie was the one to reply. With growing fascination, she had roamed the old mission compound scores of times as a child and teenager, and was more intimately acquainted than Peter with its history. "In 1834," she said, "the celebration would have taken place in the big church that had been constructed during Fr. Fortuny's tenure here. It occupied most of the east side of the mission quadrangle. Unfortunately, it's long gone. The original little wood church on the west side . . . the one where Maria came for the dedication in 1824 . . . that's gone, too, but in 1840 Vallejo had it replaced with the adobe chapel that's there now. We can see that if you'd like."

Being deprived of the romance in standing where Paca and Maria had repeated their vows was a great disappointment to Andie, but she dutifully abandoned the fireside and traipsed along behind the rest of us to the chilling, dismal interior of the chapel. As was the case in other sanctuaries of the mission chain, the sacred setting before us was very sobering in its solemnity. One could hardly look upon such sacrificial suffering as that depicted in the many paintings and representations of the crucifixion and remain quiescent. For the faithful, the agony of the innocent worked a profound reverence and purging of the soul. For others of us who contemplated the ancient symbols, such spiritual quietude was more illusive. Something was awry in a universal plan which not only permitted, but required, the suffering of the innocent in order to satisfy the divine demand for justice. The gift of selfless love held my heart captive, but my head could not help but rebel against the pathos which almost invariably was the price for its presence.

We escaped out into the mid-morning daylight in the nick of time. A minute longer in contemplation, and I should have destroyed the day for all four of us.

For most of the remainder of the morning we were in and out of the historic sites which surround the plaza. All of them were old haunts for Jackie, and she brought life to them as only intimate acquaintance and interest can do. But she was saving her favorite for last. Out from town a half mile to the west and north stood *Lachryma Montis*, or Mountain Tear (as in teardrops). Set in a wooded plot close up against a hillside from which flowed clear, cool spring water it was the graceful, two-story Victorian house into which the Vallejos moved in the mid-1850s and the center of their family and social life until the general's death in 1890.

"You'll love it," Jackie announced enthusiastically, "and it's the perfect spot for a picnic . . . especially now that the sun's beginning to break through."

"How would it be if we were to *walk* out to *Chincuryen?*" Peter suggested, preferring the Amerind's "Crying Mountain" to Vallejo's Latin designation. "Approaching the estate on foot, listening to bird songs, breathing in the fragrance of eucalyptus and pine, feeling the sun on our backs—it's so much more enjoyable . . . and authentic . . . than covering the distance in an automobile."

Andie and I were not sure whether it was "authenticity" or the chance to stroll down a country lane with Jackie that prompted his suggestion, but all of us thought it a splendid idea. Having sent the two of them west on Spain Street—on their own—Andie and I retrieved the hamper from the car and, carrying it between us, set out ourselves, following our friends at a discreet distance. After a few residential blocks we were, indeed, literally out in the country, and it was as Peter had predicted –bird songs, pleasant scents, and a welcome sun. In a few minutes, the long, cottonwood-lined lane to the Vallejos' came into view. As we came abreast of it and turned, we could see Jackie and Peter far up ahead between the two rows of trees. They were walking hand in hand and appeared to be doing a good bit of talking and laughing. Peter's step also had a spring to it which we had not noticed until then. Reflexively, Andie and I fingered our way up the hamper handle until our hands, too, were touching.

"I think she'll look nice in pale blue," Andie mused. "She has the right eyes for it, and it'll go beautifully against Peter's jet-black hair and black tux. Then, probably a bridal bouquet of . . . "

"Oh for Pete's . . . for *heaven's* sake, Andie!"

"Well, it doesn't hurt to plan ahead a little, you know."

We had reached the arbored path to the house when we heard Jackie calling to us from the hillside.

"Come on up. We're starved and you have the lunch."

She and Peter were sitting on the soft, leaf-covered earth beneath an old madrone tree. We scrambled up to their vantage point and discovered that it really was an ideal place for our noon repast. The Valley of the Moon lay spread before us to the south, with gentle hills rising to left and right above the town and orchards and vineyards. Our thoughts, however, were on the hamper. As a matter of fact, we were on our knees surrounding it, as though gathered to pay homage at the foot of some great shrine with none daring to enter the holy of holies. Finally Andie broke the taboo, lifted the lid and exposed an interior covered neatly with hotel napkins. On top of them lay a piece of hotel stationery containing a message in Giulo's bold hand. Jackie reached in, extracted it, and began to read aloud.

"My dear friends at Lachryma Montis. . . . "

"How did Giulio know we would be here?" I interrupted.

"I told him when I left word for you," Jackie answered.

"Sh-h-h," Andie scolded, silencing me with a withering glance. "Try it again, Jackie." (And she did.)

> My dear friends at Lachryma Montis,
> though this po'm's not so good as dear Dante's,
> Just as everyone knows
> when the zinfandel flows
> It's okay 'cause my restaurant is.

With that for a taste teaser, nothing could divert us from devouring what lay beneath those napkins, which, as anticipated, included a bottle of excellent Sonoma Valley zinfandel. It was only after the last slice of Italian sourdough bread and the last vestige of roast chicken had disappeared that I ventured, tentatively, to prompt Peter for more of the past. I supposed it was his hesitancy to expose more of the Paca and Maria saga in the presence of the ranger down at the mission that had caused him to cut short his narrative earlier in the morning. I hoped he would be more inclined to continue it, now that we had a place to ourselves.

Andie and Jackie had stretched out full-length on the leaves, and their eyes were already half-closed. The wine and substantial meal had done their work. Strangely, neither Peter nor I was feeling drowsy, and so he suggested that the two of us walk back to get the car while the ladies rested. With the Pontiac on hand at the Vallejo estate we could begin our homeward trek without backtracking through town. Jackie managed to rise up sleepily on one elbow, dig into her purse for the car keys, and toss them to Peter. There was no further response from our sleeping beauties. Confident that they were tucked away safely out of sight, we made our way down the hill and once again onto the long, tree-shaded lane.

"It's probably just as well that, while Andie and Jackie are having a siesta, I recount Maria's and Paca's Sonoma sojourn to you. Their two and a half years in the valley here were very depressing." Peter had needed no prompting. In fact, he seemed almost eager to take advantage of our walk together in order to see me through the sad story.

"Paca's first assignment with Vallejo was tame enough. The commandante was much concerned over making sure that the Russians were not about to extend their operations farther inland. Actually, in 1836 they were able to establish a third ranch . . . the Chernykh ranch, in which you are so interested, Greg . . . but that was the end of it. At the same time, Vallejo was also concerned about drumming up as much trade with the Russians as he could. Hundreds of square miles of mission land were now his, some of it literally his, but all of it his to distribute as he saw fit among Indian, and Mexican—and even a few American—cohorts and settlers. Much of the land was already highly productive in wheat, cattle for beef, hides and tallow, sheep for mutton and wool, and timber for fuel and construction. Under his oversight, cultivation, variety and yields were about to increase fantastically. The Russians were not only a convenient and welcome market, but a source of needed trade items as well. Hence, Paca found himself once more in the courier business, carrying correspondence between Vallejo and Kostromitinov as the two commanders negotiated their initial trade agreements.

"As can be readily visualized, Paca was on the road constantly during those early months of his association with Vallejo. It was on the home front, however, that cause for serious tension between the two men first began to develop. At Fr. Quijas's suggestion, Maria and

Paca had settled into a room next to the spinning and weaving area, near the northeast corner of the mission quadrangle. The room was close by the *monjerío* . . . the dormitory for single neophyte women . . . where the padre had set up a dispensary and where Maria would be doing much of her work. Although convenient, the arrangement meant that Paca had little contact with the state of affairs in what presumably was still the padre's wing on the south side.

"Maria had spoken to him about Fr. Quijas's increasing unhappiness under the new regime, but Paca did not fully appreciate the depth of the discontent until one morning when he was on his way to pick up dispatches from the commandante. Passing the priest's office, he heard angry voices issuing from within. Through the half-open door he saw Vallejo's younger brother, Salvador, raise his arm as if to strike, but then, thinking better of it, reach out and grasp the friar's robe. Sensing another's presence, Salvador turned, saw Paca standing at the doorway, cast him a disdainful glance, and went stomping out of the room.

"Paca, distressed that the priest might be injured, rushed into the room. Fr. Quijas was standing by his desk, trembling but dignified and unscathed. Aware of the priest's proclivity and, at that moment, need for spirits, Paca inquired where the supply was kept, went to the cabinet to which he was directed by his friend's unsteady gesture, and poured a generous portion of brandy into an earthenware cup. Seated behind his desk now, the father received the oblation gratefully, downed it in one long draft, and then remained silent for some time. At last he looked up at Paca, smiled weakly, and, in disheartened tones, slowly explained the reason for the preceding fracas."

"Presumably this was the incident of which, among others, Fr. Quijas later wrote in his letter to Fr. Comisario García Diego," I said.

"Then you are acquainted with the details. Yes, Fr. Quijas was being treated like scum by the major-domo, Don Ortega, and by Salvador Vallejo. As attested in his later residence at San Rafael, the padre accepted and was well able to bear up under the church's drastically reduced role as its missions were secularized. What he could not, and would not, abide was men who hadn't the faintest idea of the difference between responsible, humane exercise of authority, and the imposition of raw power by physical coercion. Undoubtedly, there were also men of the cloth whose obsession with the conversion of

souls obliterated any sense of religious or social ethics, but Fr. Quijas was not among them.

"Understandably, Paca did more than pick up dispatches from the comandante that morning. He could not fathom how, practically under his nose, a man of Vallejo's stature could permit such a rascal as Ortega, let alone his own brother, to run roughshod over the rights and sensitivities of the Sonoma community. Paca told his employer as much, making it clear that he himself could not remain party to such atrocities as the padre had cited. Vallejo's response was conciliatory, with the promise of looking into the matter, but it was also defensive and evasive. He had broader, long-term responsibilities which necessitated his leaving the immediate oversight of mission affairs at Sonoma in the hands of strong disciplinarians.

"Paca's misgivings concerning the commandante's determination to act were confirmed as days, weeks, and months moved relentlessly on without redress of grievances. Under Ortega's and Salvador Vallejo's iron fists the Indians who remained, or who were recruited for the Sonoma pueblo construction projects, were often treated less like hired laborers than as indentured servants or slaves. Fr. Quijas, although continuing as Sonoma's parish priest, had in desperation taken up residence at San Rafael, which was also his charge. In addition, with only occasional visits by the padre and with a husband who was continually on assignment elsewhere, Maria had become an object of Ortega's womanizing.

"Rather than putting a stop to the abuses and removing his major-domo from office, Vallejo actually advanced Ortega to the position of acting *comisar*, or administrator! The action was unbelievable and the straw that broke the back of Paca's increasingly tenuous relationship with the man who was soon to be known as *General* Vallejo. No, that is not quite correct. The action was one of two which terminated the relationship. The other had to do with Vallejo's policy on land distribution.

"Paca's hope that his own people might become participants in the new age had been rapidly eroded. His disillusionment stemmed not simply from his people's resistance to change, but also and, more significantly, from the fact that they were powerless in the face of it. They were without power to slow the juggernaut of European and American colonialism to a pace at which they could have a look for

themselves, in order to determine how, and where, they might fit into the new scheme of things. They were without power to penetrate the contempt in which they were held by the powerful—a contempt which was fed not only by prejudice but, ironically, simply by virtue of his people's very powerlessness. Realistically, only two alternative courses of action were open to them: they could strike out blindly and futiley in defiance or they could acquiesce and be told what to do."

"But what in particular was it about Vallejo's policy on land distribution that was the last straw for paca?" I asked.

"Well, Paca saw what was going on . . . Vallejo's own enormous grant west of Sonoma and his recommendations to the governor which issued in other vast areas to the north and east being gobbled up by the comandante's family and friends and friends of friends. He also knew that Vallejo had his eye on lands farther west, closer to the Russians, and that when he moved in that direction, Paca's own village and hunting grounds would become subject to the authority of another of the comandante's favorites. Paca racked his brain, trying to come up with some alternative that might head off such a fate for his people. He talked with Maria, with the padre, with Grigory and Laughing Woman, and with his father and the elders of Pakahuwe. He even discussed the matter at some length with Commandant Kostromitinov.

"At last he approached Vallejo himself, dubious about the outcome but at least fortified with a plan. Why, he reasoned, might it not be possible for the Mexican government to grant rancho status to the cluster of Miwok villages, including Pakahuwe, on upper Salmon Creek? Ownership and oversight would remain in the hands of village leaders but could be expanded into a kind of tribal council acceptable to the Mexican government. He, Paca, as the eldest son of Paka-huwe's captain, would convince his people to promise fealty to Mexico and obedience to Mexican law in order that they might become citizens. The size of the rancho he was requesting, only enough to sustain them in their traditional habitat, paled in contrast to other ranchos already granted on the *Frontera del Norte*. He, Paca, could be trusted. Had he not, despite many grievances, served the comandante faithfully for more than a year? All that was needed was for the comandante to champion the plan.

"Maria's diary describes in detail that meeting or, better, confronta-tion between Paca and Vallejo. Never had her husband exposed his

rage and despondency to her as he did following that bitter exchange. Almost to the end, the comandante had remained calm and dignified. He had listened politely and, with seeming interest, as Paca explained his proposal, even raising some practical questions concerning the location and extent of the projected rancho. Then, assuming an air which, while not imperious, was completely patronizing, he had in turn explained to his courier why the proposal was totally impracticable. The site of the projected rancho was beyond the bounds of lands previously claimed by the San Rafael and Sonoma missions, and its inhabitants were heathens, not neophytes. Hence, the government's laws of restitution did not apply in such a case. Further, he saw no possibility that the government would approve ownership by a council of natives. Paca had responded to Vallejo's objections one by one, but to no avail. When Paca persisted, the comandante had finally become impatient, lost his composure and hotly declared the whole idea as absurdity, wherewith Paca resigned his post."

"But why was Vallejo so adamant in his objection to the idea?" I asked. "In some ways he was so generous . . . almost to a fault. Miwok control over a small area on the periphery of his empire couldn't have posed any major threat to his own rule. On the contrary, I should think his support of the scheme would have been to his advantage; it would have been interpreted as one more forward-looking act of generosity. Or do you think he was simply unable to envision the Amerinds as possible peers among his fellow Hispanics?"

"Your conjecture is as good as mine, Greg. But there is also the possibility that he may have viewed the proposal as precedent setting. In any event, it would have stirred up a hornet's nest in Monterey, and he was too astute a politician to run that kind of risk."

"So did Paca give up?"

"Oh no, not that man. He set out the very next day for San Rafael to see Fr. Quijas. He outlined his proposal for the padre, who promised to write a supporting letter to the Fr. Comisario, who in turn would write to the new governor, Nicolás Gutierrez. All they got in return for their efforts was a letter from the governor's secretary stating the governor's annoyance at the church's meddling in political affairs. Vallejo received a letter, too, in which the governor asked if the comandante knew anything about a crazy plan that some discontented Indian up in his territory was trying to get approved."

"Which no doubt really endeared Paca to Vallejo's heart," I commented sarcastically. "But that was in the fall of '35, Peter. According to her letter, Maria and Paca didn't move to San Rafael until the spring of '37. Given the wretched situation you've described, how could they possibly have endured that year and a half in Sonoma?"

"It does seem incredible that it took Ortega's nearly raping Maria and his vowing to kill Paca to convince them that someone else would have to carry on the good fight in Sonoma. And it would appear that even those two factors have to be taken in relation to a third if one is to understand correctly the reason for their decision to relocate. Actually, from the time of his resignation, Paca was far from resolute in his determination to remain in Sonoma, because he feared for Maria's safety. Ortega's advances to Maria had grown increasingly bold, and, despite Paca's close watch, the administrator was mindlessly intent on having the nurse as one of his 'prizes.' But Maria, almost as mindlessly oblivious to the threat, was set on persisting in her work. The impasse continued until the day of the attempted rape, when both she and Paca concurred that the need for their departure had become critical . . . not because Paca feared for his life nor she for hers, but because of their mutual concern for one yet unborn. Maria was three months pregnant."

It was dusk when Jackie brought the old Pontiac to a halt in front of The Arno. A light, misty rain had begun to sift down through the redwoods and the chill of evening was coming on. On the way back, the ladies had done their best to lift Peter and me from our morose mood, but their efforts had met with only partial success. They couldn't imagine why we had become so lifeless upon our return to Lachryma Montis, nor why our tour through the quiet beauty of the old house and grounds of the Vallejo estate was (for Peter and me) obviously more an exercise in duty to Jackie's enthusiasm than the delightful finale she had intended it to be.

However, there was one thing we did all throw ourselves into together on the return journey, and that was a limerick in response to Giulio's. It would be waiting for him in the otherwise empty hamper, and it read as follows:

Dear friend and superb lunch supplier,
You're right, you are surely no liar.
You vow you're no poet—
and, wow, don't we know it!
Still, your hamper filled ev'ry desire.

10

W hat in heaven's name got into you two this afternoon, Greg?" Andie and I had just left the hamper at the front desk for Giulio, who was already making his rounds among the "early bird" dinner guests, and we were on the stairs, struggling to gain altitude. "You were about as full of life as a scarecrow in a cornfield . . . in the rain."

"I'm sorry, honey. I'll tell you about it when we get up to our room."

I suspected that Peter was confronting a similar query from Jackie at about the same time. I could picture them at his place, sullen and out of sorts, with Mother Castro listening at a discreet distance, despairing for the future of their relationship.

As we were washing up and changing for dinner, I recounted the salient points of the Sonoma saga to Andie, sparing her most of the depressing details. "I'm afraid Peter and I just couldn't shake ourselves loose from the pointless pathos of it all. That guy can really suck you into a situation."

Andie was definitely not about to be sucked in, especially not

tonight on the brink of what promised to be a convivial conclusion to a (by and large) fascinating day with our new friends. Jackie had volunteered to prepare her specialty for dinner at the Castros'. All she would tell us about it was that it was *not* Italian. She had no intention of trying to upstage Giulio in his own field of expertise. Jackie's girlfriend would be driving over from Santa Rosa with little Peter, and we were to bring Giulio, who had promised to make the supreme sacrifice of abandoning his hotel guests at eight o'clock.

"Well, I hope you two guys manage to shake yourselves loose tonight," Andie said as I zipped up the back of her green jersey dress. "Tonight's for tonight, not the 1830s. Besides, we already know that Maria and Paca were happily reunited with Fr. Quijas in San Rafael . . . and even made it to Pakahuwe to join Laughing Woman and Grigory. . . . At least I assume they did. What's your guess?"

Obviously Andie could not steer clear of the 1830s any better than I. The difference was that I wanted the facts. She was after a happy ending. "My guess is that . . . well, I guess my guess is that I'll hold on until Peter is inspired to wrap this whole thing up for us, one way or another."

Giulio kept his promise. As we descended the creaking stairs we could see him at the front desk. When he caught sight of us, he moved quickly in our direction, opening a pink box as he did so.

"So, you like a the roast a chicken, eh? Antonio, he's a do it just a right . . . the way I'm a tell him. No more rhymes a, though. I'm a know when I'm a get beat."

With Giulio around, no one was going to be worrying about Peter or me casting a pall over the party.

"Lunch was really special, Giulio," Andie said happily, "and the setting for it at Lachryma Montis was delightful. But what's in the box?"

"For a you, Andie," he said as he withdrew one red rose from among four in the carton. "You put it in a the hair. That place of Pietro's, it's a all green down there, like a the dress. You signoras and signorinas, you make it like a Christmas tonight, eh?"

Andie was quite touched by the gift, as was I. She arranged the rose in her hair, gave Giulio a thank-you kiss, and then extended an arm to each of us as we made our exit.

Once again Peter had left the driveway gate wire down. Given the cold drizzle, we were especially grateful for his thoughtfulness. Having descended the drive, we found Jackie's old Pontiac and another car of similar vintage—presumably her friend's—already parked in the turn-around. Like most Californians, we had not thought to dress for inclement weather, and so we moved down the overhung path as rapidly as the flashlight beam permitted. We had almost reached the clearing in front of the house when a piercing *"Yi-i-i"* split the night air behind me. It was Andie.

"Sorry. I'm okay. I just got caught on a branch, and it decided to pour everything it had down the neck of my dress. Didn't touch the rose, though, Giulio."

What a contrast, once we were inside! The aroma of dinner was heavenly—a fondue, as it turned out—and, much as at the padre's quarters in the morning, a welcome warmth emanated from the hearth. Jackie called her greeting to us from the kitchen counter where she was putting the finishing touches on a salad, and Peter left off his table setting long enough to introduce us to Jackie's friend, Geraldine. Geraldine, a large, mid-thirtyish woman with kind, brown eyes and long, dark hair swept back behind her shoulders, was sitting by the fire and had been playing the guitar and singing a cheery folk refrain as we entered. Now she laid her guitar aside, rose and came forward to shake our hands and greet us. Her speaking voice was as rich and melodic as her singing.

"Don't a stop," exclaimed Giulio. Then, extracting a rose from the box, he suggested, "You put a rose a where it's a close to the guitar so the music, she's a *smell* good, too! Here, Pietro," he continued, turning to Peter and handing him another of the roses, "I'm a leave it to you to do a the honors with Jackie." After searching the room with a quizzical look, he added, "Where's a Mama Castro and a the little Pietro?"

Jackie explained that it was her son's first time at the house and that he was literally overwhelmed by all the mysterious nooks and crannies waiting to be explored. "When I told him that Peter had built the whole thing," she said, "he could hardly stand it until Peter took him on a personally-guided inspection tour . . . and, by the way, Peter, you scared the living daylights out of me when you two were up there in the cupola."

"In the cupola?" I asked, wondering if I had heard correctly. "That's two stories high. How do you get up there, Peter?"

"It's really perfectly safe," he said, looking over to Jackie reassuringly. "There are iron rungs mortised in between the stones on the backside of the chimney. They provide a handy way up to wash the cupola windows and clean out the cobwebs, not to mention the pleasant view you get through the trees. Oh yes, and it's one of the finest vantage points around for bird watching."

"But back to the missing persons bureau" Jackie said, still skeptical, but returning to Giulio's question. "I think *young* Peter is with Mother Castro in her bedroom. The last I heard he had talked her into showing him her other necklaces."

Giulio bounced off toward the bedroom, Geraldine picked up with another song (which smelled terrific), and Andie and I pitched in to help Jackie and Peter. Not until quite some time later, when they were called to dinner, did Mother Castro, Giulio, and little Peter emerge. Little Peter, sporting an impressive shell necklace, led the way; and Mother Castro, with the best of the red roses adorning her silvery white hair, was on Giulio's arm. Geraldine could not resist the opportunity to strike up "Here Comes the Bride," and the rest of us lined their path to the nuptial table. For once Giulio was without words. Red as a beet, he busied himself seating the beaming "bride," whose only comment was, "How nice of you all to come."

Jackie knew what she was doing in selecting fondue for the evening entrée. Nothing could have brought the gathered company closer than dipping chunks of bread into a common pot. The experience must have been akin to reclining over a meal with Socrates at one of his symposiums. In any event, the table talk went on unbridled until all appetites were more than satisfied and all thirsts quenched. Unwilling to break the circle, we gathered again around the fire to sing with Geraldine. It was the kind of night one could not help but cherish and relive from time to time as the years rolled on. The night also included a touch of the unexpected and, briefly, of anxiety.

We had become so engrossed in our close, four-part harmony that we had lost all track of time. We had also lost track of little Peter. Suddenly Jackie became conscious of his absence and shouted, "Where's Peter?" It was as though the needle had been jerked from a phonograph record. The music stopped and the search began, first

with calls, then more diligently with room-to-room coverage. Big Peter flicked on the cupola light, but no little Peter peered down from the upper reaches. Calls outside into the raining night proved equally unsuccessful. Inside again, we gathered by the fire to plot our next move. As we did so, I noticed that Mother Castro had motioned her son to the side of the chair where she was sitting. She spoke to him in hushed tones, and then Peter called the rest of us to attention.

"Is possible," he said, looking slightly impish, "that honorable mother here has solution to whereabouts of truant boy."

All of us, but especially Jackie, sighed a deep sigh of relief and looked expectantly at Peter.

"We sing for considerable length of time, is not so?"

"Yes," we responded in chorus.

"And none of us paying particular notice to small fry, is not correct?"

"Yes."

"And so what is such young fellow under such circumstances desiring most?"

"Attention!" Andie volunteered.

"Please to remember boy in question rise early, have full day of school, drive to mountains, have exploratory tour, and sumptuous dinner."

"Sleep!" we responded, proud as Punch of our powers of deduction.

"Ah! But where?"

Here our Charlie Chan stand-in had us stumped. We had searched the bedrooms but to no avail.

"Please to remember singing very noisy and boy very full of adventure."

Geraldine was ahead of the rest of us: "He's sleeping in some secret hideaway that's quiet. Right?"

Peter nodded affirmatively, and Andie and I looked at each other, wondering if what we were thinking could possibly be.

"Please to observe," he continued. "Pillow is gone from chair where honorable mother sits. Also, shell beads seen on boy now lie on floor behind chair by wall bookcase."

Giulio was smiling now, giving us to know that he, like Andie and me, was also acquainted with the secret hideaway. Gently he turned to Mother Castro's chair to face the bookcase, and a bewildered Jackie and Geraldine joined us to see what was coming next.

"Please to remain silent as honorable Papa Bettini reveals sleeping boy." Peter was thoroughly enjoying Jackie's perplexed absorption in the proceedings.

Giulio, surprised, but ready to make the most of the stage call, carefully removed his coat, pushed back his shirt sleeves, and vigorously rubbed his hands together as though scrubbing for surgery. Then, kneeling ceremoniously before the bookcase, he probed under one of the lower shelves until he located the spring release, gave a final sign for silence, and the small, book-filled door swung slowly open. And there was little Peter on his side, with knees pulled up against his chest and head resting comfortably on the seat pad—a bit cramped for space, but obviously oblivious to the inconvenience.

I could imagine little Peter's chagrin as, blinking from the sudden light, he looked out at the circle of smiling faces gathered around the mouth of his cave. Jackie was immediately on her knees beside Giulio and reaching in to assure herself that the little fellow was really all right. The next moment he was out and into her arms, and a round of applause went up for Mother Castro's and son Charlie's masterful piece of detective work.

Andie and I probably should have been more sensible and set things aside until morning, but, despite tired bodies, we were far too excited to expect sleep to come easily. Leaning back against plumped-up pillows, we were cozily abed with enough reading to last well beyond the wee hours. On the bed quilt lay a half dozen annual editions of Maria's diary, which Peter had entrusted to us at the conclusion of the dinner party. "Since the safe is open," he had said, "and since our thoughts are elsewhere here tonight, why don't you take the diaries along and read them at your leisure." In that they were irreplaceable and of such value, not only historically, but to Peter personally, we had at first hesitated. However, he was so genuine and insistent in his offer that we had gratefully acquiesced, wrapped the aging books in plastic to protect them from the stormy weather, and, with no little trepidation, toted them off into the night.

The volumes covered the years 1837–1842, enough to carry us through the year of the inscription and even to, and beyond, the Russians' withdrawal from Fort Ross. Fortunately, Maria had been able to find good paper; and her handwriting, already familiar to us,

was not only beautiful but quite legible. Our only impediment was the painfully slow tempo at which we read Spanish. Still, heedless of the hour and our want of a more adequate Spanish vocabulary, we plunged into 1837. Andie read aloud from one day's entry and I from the next, with both of us aiding and abetting each other in translation. Not surprisingly, the style was much more intimate than in Maria's letters to Grigory, and her daily entries were filled with personal impressions of the moment. At times we had to convince ourselves that we were not prying; that, given our pristine motives, Maria would not mind sharing her innermost thoughts with us, just as she had with Peter and his forebears. She had become a very real presence, and it was as though we needed her permission before turning to each succeeding page.

We were eager to get to Maria's and Paca's return to San Rafael, and so we turned first to her entry for April 19—the date of the letter which she had written to Grigory and Laughing Woman just before leaving Sonoma. The departure that night had been a harrowing affair—certainly not the kind of activity one would wish on an expectant mother. Maria was fearful that Paca, who was still enraged by the morning's confrontation with Don Ortega, might not be able to function intelligently, but she also scolded herself for her lack of confidence in him. Paca proved to be in complete command, overseeing the packing of what necessities from among their few possessions could be contained in the saddlebags on his faithful mount, Kik-to, and arranging with a friend to have the horses ready and waiting when the cover of darkness permitted an undetected escape. ("Kik-to" is Miwok for "in the water." The appellation did not have to do with the horse's dangerous hooves [as was assumed by many Mexican and American locals], but with his ability to see the rider safely across swollen streams.)

But they had barely reached protective shadows across the court from their quarters when three men entered the quadrangle. Passing them within a hair's breadth, the trio marched purposefully to the door which Maria and Paca had just closed. One of them banged on it with an empty bottle and demanded entrance. The voice was unmistakably Ortega's. Taking advantage of the momentary opportunity, the pair slipped quickly out through the quadrangle gate to their waiting steed. Paca mounted and drew Maria carefully up behind him

onto the thick blanketing he had prepared for her. At first, they thought they had made good their escape, but, before they were a mile along, the sound of many pounding hooves came to them through the still night air. Ortega had squeezed their plans out of someone and, with his henchmen, was in hot pursuit.

Having traversed their route so many times, Paca was thoroughly familiar with every inch of ground that lay between them and San Rafael. A short distance ahead, trees and undergrowth encroached almost to the road's edge. When they had passed by most of the thicket, Paca reined in, dismounted, and led the horse off the path into the cover of the brush. Handing the reins up to Maria, he detached the coil of rope which hung from the saddle, and then, on foot, quickly disappeared into the darkness in the direction from which they had come. As she waited, all that Maria could hear was the increasingly ominous thunder of the approaching hooves. When they were almost abreast of where she crouched astride Kik-to, there was all at once a lull, as though horses and riders had suddenly become airborne, then a cacophony of thuds, snorts and human cries.

It was all Maria could do to keep Kik-to from bolting. She was on the verge of losing control, when a calming whisper came from beside the stallion's flank. In an instant, Paca was again in the saddle and gently urging him back to the road and on into the night. He had used an old trick, namely, a taut line stretched low across the road, and had managed to secure his rope to the bordering trees only seconds before Ortega and his men reached it. In the sprawled confusion which followed, Paca had recovered the rope and rejoined Maria. He was distressed by the injury, and, perhaps, death which he had brought to man and beast, but there had seemed to be no alternative. At least there was comfort in knowing that some life continued as the bellowed curses of the immobilized men faded in the blackness behind them.

A brightly starlit sky and, now and then, a curious or surprised nocturnal creature were their only companions for the remainder of the journey. They had traveled slowly because of Maria's condition, and so it was not until the wee hours of the morning that they descended the hillside to the welcome protection of the mission compound. Although it was not yet dawn, candlelight flickered through the small window of Fr. Quijas's quarters. They were reticent

about disturbing the padre's morning vigil; but, having heard their approach, he appeared at the doorway, looking to see who but himself could be up and about at such an early hour. His welcome was warm and genuine—and provided an unexpected occasion for sharing in spirits as well as in spirit.

Maria's entries for the ensuing two weeks were in such vital contrast to those written during the discouraging years in Sonoma that they appeared to be from another source. First, there was the joy of expectation for the new life that gave every indication of health within her. There was also the good feeling of camaraderie with Ignacio Martínez, San Rafael's *administrador*, who not only enjoyed his association with Fr. Quijas, but was working diligently to protect the rights of the neophytes. And there was the unexpected delight in finding herself reunited with Inez, the young neophyte whose child Maria had delivered years before aboard the launch. Inez was now one of the pueblo's best weavers and her "child," a strapping young fellow who had all the makings of an upcoming vaquero. Finally, there was the letter from Grigory and Laughing Woman urging Paca and Maria to join them where they had made their home near Paca's own *ranchería*.

Maria wondered how her husband would receive this invitation. He had not ventured to return to Pakahuwe since his falling out with Vallejo. Given the utter failure of his effort to secure some kind of reasonable future for his people, it would be understandable if he should wish to delay the inevitable showdown with them. It was he who had encouraged their openness to the new and strange ways of Russians and Mexicans alike. Now all that his people could expect was exploitation at the hands of people more powerful than themselves. But, again, Maria's apprehension was needless. Paca was not one to languish in past defeat nor to waste himself in a fruitless defense of ego. He had not returned to Pakahuwe earlier because he had been unwilling to leave Maria alone in Sonoma. Now that she was with the padre and an accountable and concerned *administrador*, he was more than ready to probe the parameters of a highly uncertain future.

Indeed, the very next day after Grigory's letter arrived, Paca was astride Kik-to and headed for Pakahuwe. He and Maria had discussed their friends' invitation at length the preceding evening and had, at

first, decided to respond affirmatively by letter. Maria had even written the missive, and Paca was about to entrust it to the courier, a Kashaya whose work and routes Paca knew so well. But then they had second thoughts which eventuated in Paca doing some reconnoitering preparatory to the establishment of their new home. Maria would remain at the pueblo, where anyone versed in the healing arts was never without work. Still, as token of her presence with them, Maria's letter was tucked safely away in Paca's saddlebags for delivery to their friends.

It was early summer before Paca returned to San Rafael. As he and Maria embraced, it was evident that during the two-month separation their prospects of parenthood had increased enormously. It was also evident that Paca had spent most of those two months in the out-of-doors. Following his break with Vallejo, he had sought employment in Sonoma that would keep him out from under the general's feet and, even more, from under Ortega's. Since Ortega rarely darkened the doorway of the church—and then only to roust worshipers out to the day's work—Paca had arranged with the padre to do decorative painting on the interior walls and ceiling of the sanctuary. As Maria put it at the time, "He is not Michelangelo and the Sonoma church is not the Sistine Chapel, but his depictions of Miwok religious motifs are very good." Unfortunately, Paca's artistic talent went largely unappreciated, because within a few years most of the edifice had been ransacked to provide building materials for other projects in the growing pueblo. The point, however, was that due to the many months of indoor work, a pallor had replaced Paca's normally healthy, copper-colored complexion. Now as Maria studied his face again, she saw that the rich color had returned.

Another change had taken place since their departure from Sonoma, and Maria was bursting with the news. Finally, at long last, the general had removed Ortega from office! Apparently the *administrador's* womanizing had become so notorious, his business accounts so inadequate, and indignant citizens' complaints so insistent that Vallejo had been left with no alternative. Paca and Maria, relieved as they were, wondered what the general could possibly have "owed" his appointee. Surely there must have been some well-guarded secret that lay behind the delay in his long overdue dismissal.

Maria was also bursting with curiosity to hear in detail what lay ahead for them in the upper reaches of Salmon Creek Valley. Letter writing was a slow and laborious undertaking for Paca, and so she had received little correspondence from him during his absence. But now, in a mixture of Spanish and Miwok, the words came naturally and enthusiastically as he recounted all that might help her to envision the life and work that awaited them to the northwest. He had gone first to the dwelling of his father and mother in Pakahuwe. To his surprise he was well-received there, not only by his father, but by other leaders of his village as well. Fr. Quijas had on several occasions visited Pakahuwe and nearby Miwok and Pomo settlements between San Rafael and Fort Ross, and he had informed their captains of Paca's ardent efforts in their behalf.

Perhaps it was the very failure of those efforts which prompted the warm reception. As Paca's father and other notables had told him many times, he was young and too impetuous in dealing with strangers to the land. He was learning that openness to the ways of the outsiders was not necessarily a virtue, as his own people had told him. Even his marriage to Maria was injudicious, acceptable only because she had demonstrated concern for his people's children without asking anything in return. But if his reception was amiable, it left Paca with little standing in the village.

His reunion with Grigory and Laughing Woman was a much happier, more convivial affair. Grigory had negotiated with Paca's father for the use of a plot of relatively open land that lay in gently rolling hills a short distance to the north and east of Pakahuwe. Since his intention was to farm the land, he had chosen a site that would interfere least with the Miwoks' hunting and fishing. The arrangement included payment of a portion of the produce to the village and continuing access to the area for late summer and early fall berry-picking and acorn-gathering. Both parties to the agreement seemed quite satisfied with its provisions. As Paca was to learn, Grigory had secured the land less as an agent for the Russian commandant than as spokesman for himself and Laughing Woman, but more of that later.

It was shortly before sunset when Paca rounded the hill that rose between the village and his friends' new home. He dismounted and for a long while looked down on the dale below him. In part what held him transfixed was the sheer beauty of a valley alive with the

golden glow of a setting sun, but it was also what his friends had done to transform the valley into a very impressive human habitat. Smoke curled from the chimney of a snug-looking cabin, a cabin now in the shadows of an old white oak and nestled in the midst of tended flowers and an extensive vegetable garden. Behind and to the left of the cabin stood a sturdy barn, and to the right, a pond with ducks afloat. Rail fencing enclosed some ten or twelve acres of young grain—probably wheat and rye—and a horse's whinny and a cow's lowing drifted up from places out of sight.

Paca had remounted and was about to descend the slope when another sound, a familiar voice, rose to greet him. Grigory had caught sight of him atop the hill and was shouting and waving his welcome from down near the barn. Before Paca reached the nearest of the fenced fields, Grigory, breathless from the run, was at his side and literally pulling him from off the back of a startled Kik-to. The two friends embraced and, at a much more leisurely pace, walked and talked their way toward the cabin. Laughing Woman was on the porch, and beside her, holding tightly to his mother's skirt to steady himself, stood little Nikolai. She was waiting with outstretched arms which terminated in dough-covered hands. Apparently Grigory had convinced her that Russians simply could not live without bread. The hug was warm, if sticky, and alerted Paca to the fact that Laughing Woman was even farther along than Maria toward adding another member to the local populace.

Days became weeks and weeks months, during which time Grigory and Laughing Woman introduced Paca to a new world. The world of farming was one he had observed with great interest, but in which he had not participated. Now he became acquainted first-hand with its long hours of backbreaking work—and accumulated the calluses and cuts and bruises and aching muscles to prove it. There were aspects of the undertaking which disturbed him deeply. Never before had he turned the plow to cut wantonly into the flesh of mother earth. Never before had he constructed barriers to restrict beasts and human kind from access to the land. Had his tutors been less-gentle folk, he might well have abandoned his hopes for a new life there with Maria and their child.

But there was also much that attracted him to this place and to these friends whose ways were both at-one with, and yet so different

from, those of his own people beyond the hill. Paca had always felt gratitude to the great unseen spirits of earth and heaven as green pastures sprang untended from the hillsides each winter and spring. Now he delighted in a new exhilaration as he assisted in the processes of nature. He had always enjoyed breathing in the scents of field and forest, but now there was also the sweet smell of the hayloft and the aura of security that came with a well-filled barn.

Perhaps the place's most compelling attraction was the prospect of an abode like that of his friends, a place protected from the winter's cold and the summer's heat where he and Maria could live year-round. Not long after Paca's arrival, Grigory had led him to a site where a seasonal creek broke free of its forest cover and continued its course alongside the farm's cultivated fields. They talked at length about a mutual commitment to sharing in the work and responsibilities of the farm, after which Grigory had said, "Where we're standing would make a fine location for a cabin." And so it would . . . and did.

Paca's first impressions of the Castro farm were confirmed by Maria when, two months later, she stood with him looking down upon it from his earlier vantage point. Now, in early July, the little valley was dry and yellowed, but still, the scene was as enchanting to her as it had been to Paca. Her eyes darted from cabin to barn to pond to fields, but then came to rest on one incomplete structure, which roused her curiosity.

"What is it that Grigory is building at the upper end of the valley?" she inquired. "There, just into the oak and bay laurel." She pointed to the site where bare rafters angled roofless from the structure's log walls.

"Come, and we shall see," was all that he said in reply.

This time it was Laughing Woman who was first to see them approaching, but she was in no condition to come rushing forward. Paca reined in beside where she stood in the shade of the old white oak, dismounted, and then helped Maria to the ground. Laughing Woman was all smiles, but was leaning against her garden hoe and looking as though she was more than ready to deliver her second-born. In her diary, Maria described the scene, which she thought must have looked quite ludicrous—namely, the three of them "waddling" their way up the garden path to the cabin, her stalwart husband in the middle with one very pregnant woman on one arm and, on the other,

a very, *very* pregnant woman. She likened it to a Biblical scene in the hill country of Judah, where Joseph might well have escorted Mary and Elizabeth in similar fashion. There, however, the analogy stopped. Maria had no illusions about her coming delivery being a virgin birth. Neither had she received word that she was about to give birth to a future messiah—just plain old Clara, if a girl, and, if a boy, Ule-mi-kan (Free me!), out of deference to Paca's wishes.

Maria asked Laughing Woman what names she and Grigory were considering for their second child. Without hesitation she had replied, "Yekaterina." There was absolutely no doubt that the child would be a girl (her dreams were clear on the matter), and she would be named after their beloved teacher. Maria assumed Laughing Woman's ready response to be an indication that she no longer felt the need to be cautious about divulging her *own* true name. Hence, she asked what Kashaya word it was that had led the Russians to call her Laughing Woman.

Although she was confident that her new friend had inquired in all innocence, Laughing Woman hesitated, struggling to rid herself of fears that clung tenaciously to her heart, if no longer to her head. Then, as though a demon had been suddenly exorcised, she said defiantly, "My name is Lekida. It means 'glad,' not always laughing like some buffoon. Only Grigory says *Lekida* and even he, only when we are alone. Now, please, you also shall say 'Lekida!' " It was an unexpectedly intense exchange for first meeting, but it seemed to draw the two women very quickly and closely to each other.

Before the day had run its course, Maria again met with the unexpected and the intense. Paca had made no mention of the fact that much of his time during their separation had been spent with Grigory in the planning and erection of the structure about which she had inquired. Fortunately he had learned well from Grigory during the early stages of their work together, because the master craftsman had been increasingly obliged to tend to the farm's ongoing needs, including many of those tasks which normally fell to Lekida. Hence, Paca had continued the construction largely on his own, calling on Grigory only when his expertise or another strong back was absolutely essential. And he had sworn his friends to silence. Although still roofless and marked by the imperfections of an apprentice, the little cabin that graced the edge of the woods was to be his surprise for Maria.

When, with Grigory, they set foot within it late that afternoon, their new house was as much a surprise for Paca as for Maria. In the several days since Paca had left for San Rafael and before he returned with Maria, Grigory must have thrown himself into a herculean effort to bring the cabin's interior closer to his own standard of excellence. The ill-fitted front door was now hung properly. The rough-hewn floor planking had been planed and made smooth as glass with beeswax. A redwood mantel appeared where none had been before, and a single table and two chairs were placed by a window-opening which looked out onto the open fields. But Grigory's *pièce de résistance*, which stood partially concealed behind a partition, was the heavy, oaken bedstead. Atop its tightly-drawn rawhide strips, and skillfully sewn together by Lekida, lay a more than adequate supply of raccoon and rabbit pelts. It was their belated wedding gift to Maria and Paca, "to be enjoyed," Grigory quipped, "under a canopy of summer stars."

Grigory had remained with them briefly and then returned to look in on Lekida. Left to themselves, Maria and Paca stood for a moment center stage, shaking their heads in disbelief as they surveyed the scene that encompassed them. But when Paca turned to look fully into Maria's eyes, he became aware that her exhilaration was mixed with a terrible tiredness. Taking her by the hand, he led her to their bed, and together they disappeared gratefully into the mountain of fur—and into deep, deep sleep.

The sun had set, and the sky was already dark enough for Paca to detect the first evening star twinkling above the roofless rafters when he was awakened by a metallic sound. Alert now, he waited, listening for the sound to recur. Then it came again, clear and resonant, and from the direction of their friends' cabin. He remembered seeing the iron triangle and striker that hung from a beam above the cabin porch and realized that Lekida must be summoning Grigory—or could it be that Grigory was calling for help? He had not wished to disturb Maria until he was certain; but she, too, was now awake, and so they made their way together in the growing darkness to investigate.

A candle had been placed purposefully in one of the cabin windows to guide them, a sure sign that it was, indeed, they whose assistance was needed. Both of them were fully aware of the probable cause, which prompted Maria completely to forget her own condition as they hurried toward the flickering light. Their moccasins had barely

touched the first step to the cabin porch when the door flew open and a worried Grigory welcomed them in. He informed them that Lekida was already well along in labor, that she was in good spirits, but that she knew something was "different" from her experience with Nikolai. Without waiting for further details, Maria moved quickly but calmly to Lekida's bedside. Bathed in perspiration but still smiling, the expectant mother looked up at her with eyes that reflected both relief and pleading. Maria touched Lekida lovingly, wiped her forehead with a cool cloth, and then reached within to determine what was "different." It was not the baby's head, but its feet, which she touched. Lekida would be all right, but some maneuvering lay ahead for Maria as she helped move the baby outward toward its new environs.

It was a very red-faced and loud Yekaterina who, feet first and with considerable discomfort, eventually emerged. Lekida confided that, just among the four of them, her daughter's *real* name would be "Tsari," her people's word for "Angry!" The laughter of the two women and their menfolk seemed to burst the confines of the cabin and fill the night sky above the little valley.

And the laughter lingered through the summer months. Little Nikolai and his baby sister grew at an astounding rate. The vegetable and grain crops more than compensated for the long days of sweaty toil that the harvest had required of them and Paca's people. Once the harvest was in and distributed, there was even time for the men to tend to the cabin roof, a task that wondrously was completed only hours before the first fall rain and but a few days before Maria (with Lekida at *her* bedside) gave birth to Clara.

Maria's diary normally included detailed descriptions, together with personal impressions of at least two or three occurrences of the day. Understandably, her daily entries for the remainder of the autumn months were devoted almost exclusively to Clara. So utterly complete was the day by day record of every nuance of the child's slightest change that, for me, the reading became decidedly tedious. Had it not been for Andie's maternal, or grandmotherly, fascination with the interminable narrative, we should have passed over crucial events in our haste to arrive at "the new moon of October, 1839."

At one point in the late fall of '37, Maria stole some space from Clara to recount a conversation about which Paca had informed her that morning during breakfast. He had just returned from the barn,

where he had been feeding the horses and cow while Grigory did the milking. Grigory mentioned that he supposed Paca had wondered about the state of his and Lekida's relationship with the Fort Ross community. Paca was, indeed, curious, being especially concerned to know what claims the Russians might have on the farm.

He learned that a new commandant had replaced Kostrominitov the preceding year, one Alexander Gavrilovich Rotchev. Not only was the man an excellent administrator and accomplished literary figure, but his wife, the former Elena Gagarina, was of royal descent. Authority over the Russian settlements at Ross and Rumiantsev, or Bodega Bay could not have been placed in abler, more responsible hands, *and* Paca need not worry about the farm. Having been informed of Grigory's contributions to the development of the Kostromitinov and Khlebnikov ranches, Rotchev had invited him to assist a recently arrived agronomist, Egor Chernyk, in establishing yet another site. (At the name of Chernykh, Andie and I could hardly contain ourselves. But, alas, of all places to cut short the detail, Maria had to choose this one. Not a word, not one single, solitary word, about the precise location of Chernykh's ranch! All she had had to do was use a little judgment in the space she was alotting for Clara's feeding habits, and there would have been plenty of room left over for Chernykh. Oh, she mentioned Grigory's riding over occasionally to get tips from Chernykh on how to farm better . . . hence, his ranch could not have been too far from theirs, but we already knew that. Exasperated, we read on.)

Grigory was able to convince the new commandant of the advantages of an alternative plan about which he and Lekida had been thinking for some time. He noted that he and Lekida were well-acquainted and on good terms with the Miwoks in the upper reaches of Salmon Creek. He and his wife had also learned how to farm, both from their experience at the fort and at its outlying ranches. Would it not make good sense for such a couple as they to establish a farm of their own near the Miwok encampments? It would not be too far from the proposed Chernykh ranch and even farther inland and closer to the advancing Mexican settlements. Being but unofficially attached to Ross, the farm would be less suspect than the Chernykh ranch, and it could serve as a kind of buffer on the frontier between the two aspiring nations. Rotchev had sufficient vision and was personally secure

enough to give Grigory's proposal serious consideration. Ultimately he consented, with the proviso that as the farm became productive, the Russians would have first option on its marketable crops at trade values acceptable to both parties.

Another of Maria's entries commenced tamely enough, but proved to be the introduction to a catastrophe of such gargantuan proportions that its fury was ultimately unleashed on the whole of the *Frontera del Norte*. In the late autumn of 1837, Maria had written to Fr. Quijas, inviting him to be their guest at the farm on his next journey north. She had informed him that she and Paca were now the parents of a baby girl and that she was eager to have the child baptized by the padre. She noted further that their friends were also new parents. The father was Russian Orthodox but was without access to a priest from his own tradition. Would the padre be willing to baptize Yekaterina, as well? If Fr. Quijas had reservations about the second baptism he did not allude to them in his response, which indicated only that he looked forward to joining his friends at the farm in January.

Although the winter's day on which the friar rounded the hill and descended into the valley was cold and wet, the reception from Paca and Maria was warm and, if not "dry," quite welcome. The zinfandel may have been young but it, too, was wet, and he waved off his friends' apologies for the poor fare. What he neither could, nor did, dismiss was the wretched scene he had drunk in at Pakahuwe that morning. Many of the villagers, young and old alike, were terribly sick. He described the symptoms: high fever, chills, headache, backache. On those who had been ill longest, puss-filled pimples were beginning to erupt. Maria could not be certain, but the signs were ominously like those of the initial stages of smallpox! Suddenly the happy occasion for which Fr. Quijas had come was the farthest thing from anyone's mind.

While Paca went to the barn to saddle Kik-to, Maria gathered up what medical and other supplies she thought might be of some use to the stricken villagers. The padre secured the supplies in the saddlebags of his own horse, then followed Maria, who, in the rain and with little Clara in her arms, had already set out on foot toward the Castro cabin. What ensued was a curious confusion of hasty introductions and ab-breviated holy rites. Grigory and Lekida, who were as yet uninformed

of the emergency, had come out onto the porch to greet Fr. Quijas. Maria was about to introduce them to each other when Paca rode up, dismounted, and joined the gathering on the porch. Maria had handed Clara to Grigory so that she might have a free hand to comfort Nikolai, who, frightened by the padre's strange garb, was beginning to cry. Lekida, who was holding Yekaterina, transferred the child to Paca's arms in order to tend to Nikolai, who refused to be consoled by anyone but his mother.

The priest, still unintroduced but knowing a propitious moment when he saw one, decided to act at once in his official capacity. Each couple could serve as witnesses and godparents for the other; the children were in their fathers' arms (presumably); and he had only to hold out his hand from under the cover of the porch to obtain holy water straight from heaven. Hence, he proceeded to baptize Clara as Yekaterina and Yekaterina as Clara, a slight irregularity which, as he assured them afterward, would be adjusted not only in his own records but in the heavenly rolls as well. Still, to be sure, over each child he made the sign of the cross both from left to right and right to left. And, to be absolutely certain, he appended blessings which he had learned from a Miwok shaman and a Kashaya Kuksu doctor.

The baptisms were duly celebrated, but they were the occasion for the last bit of lightheartedness which Maria, Paca, and Fr. Quijas were to know for several weeks. The chilling winter rain had increased to a downpour by the time they reached Pakahuwe late that afternoon. The torrent streamed over the thatched covering of the hogans to form rivulets that converged and rutted their way down to the rising creek. Not a soul was in sight, giving the village the appearance of total, dismal abandonment. Paca had just turned Kik-to toward his family's dwelling when a number of men, perhaps a score or more, emerged from the *temescal*, or sweathouse. Normally they would have been shrieking and racing pell-mell from their steam bath to lunge into the icy waters of Salmon Creek, but these men staggered more than ran. The only sound that rose above the beating rain was agonized groaning as the men collapsed in the frigid current. The old routine had served well as a curative for many of the tribe's indigenous maladies, but it was no match for the white man's viruses, especially one so relentless as smallpox.

Several of the men were swept lifeless downstream. Others barely

managed to pull themselves up the slippery banks to the grass above, where, unable to go farther, they lay shivering uncontrollably. Half of them were dead before Paca and the padre could carry them to the shelter of the hogans, and most of the remainder did not survive the night. Nor did many of the women and children among whom Maria had been moving, doing what she could to ease the pain of the sick and to protect those who had not yet fallen victim to the scourge.

Maria and Fr. Quijas knew that the only hope of survival for Pakahuwe and its neighboring *rancherías* lay in obtaining a vaccine that, while still suspect in professional circles, had been developed and used successfully by Edward Jenner, a physician in rural England. A supply of the vaccine had somehow made its way to Alta California, and Maria had seen to it that modest amounts were on hand at the San Rafael and Sonoma dispensaries. At dawn the next morning, Paca and the padre were on their way to fetch what they could and to determine if additional supplies were available from the presidios at San Francisco and Monterey. The news was far from encouraging. Fr. Quijas rode in the following day with the meager supply which was available from San Rafael, and he and Maria went to work immediately with the vaccinations, stretching the magic potion as far as it would go until both it and they were exhausted.

Another day of desperate efforts passed before Paca appeared—empty-handed. He had ridden to Sonoma, only to find that the epidemic was, if imaginable, of even greater proportions there. The general was doing everything possible to quell the spread of the dreadful disease, but it was simply out of control. The local supply of vaccine was long gone, and so Sonoma, too, was seeking help from the presidios to the south. Vallejo would share what he could when additional supplies arrived.

Eventually the cry for help was heard, but, even so, it was almost two years before the plague had run its course through the *Frontera del Norte*. There were some who spoke of the disaster as the solution to the "gentile problem," heedless of the greater sickness that lay deep within themselves. But in a tragic sense they spoke the truth. Where before, thousands upon thousands of Miwok, Pomo, Wintun, Wappo, Suisun, and others had peopled the land, there were now only pitiful pockets of dazed survivors, who had little heart or capacity for impeding the new order.

Mercifully, the four friends, together with all save one of their wee folk, were spared. Yekaterina, who had made such a dramatic entrance into this world, departed it in like manner, struggling for life. Their beloved padre was also spared, but Paca's people in Pakahuwe and in nearby Patawa-yomi and Oye-yomi were not. Not a single hogan remained by the banks of upper Salmon Creek. Every last one of them had been burned to the ground in order to placate and rid the place of the malevolent spirit which had loosed its fury on their inhabitants.

Grigory and Lekida were as concerned as Paca and Maria and welcomed the survivors to the farm, and Egor Chernykh soon followed suit at his own establishment. New dwellings began to appear here and there on the perimeter of the tended fields. Paca, backed by Lekida and approaching the matter as judiciously as possible, encouraged the construction of cabins rather than hogans. The response was not immediate, but gradually plank flooring, cedar shakes, and fireplaces came to be preferred over dirt, thatch and smoky interiors—in part, perhaps, because the encouragement had come from one of their own. And gradually, too, the new members of the farm community sensed advantages in the staples that had become available to them. True, to produce wheat and rye flour required much work, as did acorn meal, but the new fare tasted very good and (Praise be to the great Marunda!) was much less constipating.

As fears subsided and time permitted, some of the survivors ventured back over the hill and down to Salmon Creek to fish and to harvest berries and tubers from the lush bottom land. Others continued to apply their skill in hunting. Their contributions provided a welcome complement to the farm produce and were visible evidence that the Miwoks were bona fide participants, not simply hired hands, in the new community. As one of the Miwok women confided to Maria, "You and that Russian fellow are the first from over the sea with interest in something beside our bodies, our land, or the saving of our souls." The woman's exposure to foreigners was undoubtedly limited, but her sentiments reflected the spirit that prevailed among the remnants of her people.

As we read on and on, Andie and I lost all track of time, both past and present. We were vaguely aware that we had got fairly well along with Maria's memories of 1839. But because of our weariness and immersion in the record's daily detail, we had apparently lost sight of

the forest for the trees. We continued woodenly from one page to the next until, at the top of one of them and screaming to be noticed, the date line read: "24 de Octubre—luna nuevo." Our blurry eyes and fuzzy brains snapped smartly to attention. We had arrived!

Here and there in her entries for several days previous to the twenty-fourth, Maria had given us clues to the upcoming event. Unfortunately, we had failed to make the connections on first reading. One clue was little more than an aside in a conversation early one balmy evening on the Castros' porch. The chores were finished, and, as they often did, Paca and Maria and Clara had walked over to relax with their friends and enjoy the sunset and twilight together. There was still enough light for Lekida to continue teaching Maria the fine art of basket-weaving, and, at their feet, Nikolai and Clara pursued their own imaginative game with the supply of reeds. Grigory and Paca sat on one of the porch benches, their arms comfortably crossed, backs against the cabin wall, and heels resting on the porch railing.

Conversation had run the usual gamut from crops to kids when, after a lull and in a manner that was somewhat apologetic, Grigory broached a concern about which he had spoken more than once before. The farm was no longer the relatively uncomplicated affair it had been early on when only two families depended on its output. Now upwards of forty men, women, and children looked to it as the principal source of daily sustenance. Not only had their collective efforts contributed to its present success, but the farm had become their home as well. Some kind of agreement—in *writing*—needed to be worked out that would assure the Miwoks of their partnership in decisions pertaining to its present and future operation.

Maria was in complete agreement with Grigory, but Lekida tended to side with Paca who saw little point in, or need for, a written statement. His people had expressed no desire to have such a document. Did they not have his own personal word of assurance? The implication, although unspoken, was clear. He was the son of their late leader. They trusted him, and that was enough. But when Grigory quipped about nobody's being immortal, the expression on Paca's face was unmistakably that of a man reconsidering his position.

Another clue appeared in Maria's journalizing the very next day. It concerned a talk that Paca had had with several of his fellow Miwoks that morning while they were mending a fence together. He had

inquired into their thoughts concerning a written agreement and was surprised to learn that they were, indeed, interested. Hence, he had gone on to ask what they thought should be included in such a document and how it might be worded. One by one, the men had left off their work until all were sitting on their haunches in a circle around Paca. They had plumbed the matter in considerable depth, so much so that he had been able to think of little else for the remainder of the day. He had repeated his people's response to Grigory as well as Maria, making it clear that he, too, was now an advocate of the written word—provided the word was also indelibly written in their hearts.

Their menfolk had been terribly secretive about the reason for it, but Lekida and Maria were well aware that something very special was pending when the sun broke over the wooded ridge to the southeast. It was the morning of the twenty-fourth, and, before the day was out, there was to be a celebration, a gathering of the entire farm community, with, as Paca described it, "a little ceremony and much food and much dancing and singing and many gifts, like a Big Time, like a fiesta, like a *vye-cher'en-ka!*" He had also mentioned that guests would be joining them from the Chernyk ranch, but it was that "little ceremony" which most intrigued the ladies. Less intriguing was the cooking that remained to them before their guests arrived.

It was late afternoon when some sixty-five or seventy well-scrubbed, festively-garbed kindred spirits assembled in front of the Castro cabin. Not only was there a sizable contingent from the Chernykh ranch, but Commandant Rotchev and Mme. Rotcheva, who were visiting at the ranch, had come with them. And as though their presence were not surprise enough, Fr. Quijas and Maria's friend, Inez, had arrived at the last minute from San Rafael. Paca served as master of ceremonies, proclaiming, first, the farm community's welcome to its honored guests, and then announcing that the celebration would commence with a procession. Each holding his wife and child by the hand, Paca and Grigory led off down the path, and the gathered company fell in noisily and expectantly behind them.

The route led toward the little seasonal stream, then followed it a short distance to where it began to course its way down around to the right of the hill that rose between the farm and the ruins of Pakahuwe. There, recently cut into the embankment, steps led down to the creek

bed. At the bottom, an area more than large enough to accommodate the marchers had been cleared of brush and brambles. Once down, they stood in disarray, murmuring speculations about what their hosts might have in mind. Before them and adding to their bewilderment, two large deerskins hung like sheets on a clothesline. The skins concealed a section of smooth sandstone which faced onto the creek bed from its opposite bank.

Paca beckoned the small crowd to move closer, signaled for quiet, and then directed two of his fellow Miwoks to draw the deerskins aside. At first there was a hush in response to what met their eyes, not because of the meaning of the words (most of those present could not read) but because of the beauty of what Grigory had etched so skillfully into the stone. Then came a hubbub of praise and admiration, expressed in a multiplicity of languages.

Paca again called for quiet and proceeded to the "little ceremony" he had promised Maria and Lekida. He asked Maria to step forward first and, in a voice that all could hear, to read aloud the Spanish version of the inscription. She did so and was about to step back, but Grigory came to her side to assist her in the wielding of chisel and sledge. The tools felt awkward and heavy in her hands, but her "Maria" gradually, if artlessly, took shape below the Spanish version. Next came Lekida doing the honors for her fellow Kashayas—and smiling all the while. Grigory, conscious of who was looking on, rendered the Russian version with greater solemnity and was gratified to see that the Rotchevs were nodding in approval. Paca was the last to take his turn. His concern was that all present should know that not only the spirit, but the very words of the agreement, were those of his people, that he signed it as their representative, and that the gathered company stood as witness to it.

In her diary, Maria went on to record in great detail the festivities which continued well into the night under colored lanterns around the Castro cabin. But Andie and I lingered over the familiar words, words that all had heard that day in their own tongue.

> This valley is our home.
> We are one with her and she with us;
> We breathe of her air,
> We drink of her streams,

We eat of her plants and trees and creatures,
We sleep under her sky,
We rejoice in her beauty.
She belongs to no man or nation—
Nor do we.

Knowing who had labored to draw those words together into a harmonious whole and the occasion for their having struggled to do so, brought a vitality and dignity to the inscription which could not otherwise have been fully appreciated. The authors had not simply drafted a property agreement. In a sense, their work was akin to a declaration of independence, but it was also more than that. It seemed that the words might best be understood as a tribute to those Miwoks whose remains lay buried near Salmon Creek. The words were a promise to perpetuate that people's understanding of mortal existence in which the heavens and the earth and humankind were one. And the date was fitting. On another October 24th, a century and more later, not far to the south in San Francisco, people from 'round the earth would assemble to express similar sentiments in their hope for the unity of all nations.

Epilogue

From the vantage point of the front terrace I could see the mail carrier's little white jeep with red and blue stripes making its way up the road that led past our house. As usual, our allotment of mail for the day was heavy on advertisements, solicitations, bills, and the like but very light on anything personal. It was always a delight to discover a letter from one of the kids or from an old friend sandwiched in among all the printed matter addressed to "occupant." Fortunately the letter from Jackie and Peter slipped out from between the pages of an advertiser before we discarded it.

It had been well over a year since our trip to Occidental. At first, Peter and I had remained in close touch, exchanging ideas about possible locations of the Chernykh ranch. But after he had explored several dead ends, our correspondence had gradually tapered off. Hence, Andie and I were eager to open the letter and be brought up-to-date with our friends on the *Frontera del Norte*. As it turned out, the envelope contained not only a long letter but their wedding invitation as well. The sacrament of holy matrimony was to take place

at St. Philip's Catholic Church two weeks hence, and its pastor had obtained permission from his bishop to invite a Russian Orthodox prelate from San Francisco to officiate with him. A reception would follow at The Arno. The body of the letter was in Jackie's hand, but there was a brief postscript from Peter: "Please come. It is very important that I see you."

We loved St. Philip's, and the clear, crisp wedding day showed it off at its best. Sunlight poured through the immaculately clean windows, giving a vivid intensity of color to the pageantry within. Little Peter, noticeably uncomfortable in his formal attire, served as ring bearer, and Geraldine was matron of honor. Giulio stood as best man for Peter, but once he had seen Jackie's wedding ring safely from little Peter's into the priest's hands for blessing, he reclaimed his place in the pews beside Mother Castro.

Jackie, who appeared to be highly dependent on her father's supporting arm, caught sight of us as she passed our pew. She smiled a very special smile, leaving us with the good feeling that our friendship had not diminished during our many months apart. Up front the two priests presented a most interesting contrast. Although at ease and united in their conduct of the holy rite, one was clean shaven and bareheaded, while the face of the other was hidden behind a full, black beard, and his pate was lost beneath a brimless black hat. Andie nudged me and whispered, "I think their traditions are showing. Nice, though, after a thousand years, to see them getting their act together."

If the church had been alive with light and color, the hotel dining room was all of that and more. Streamers and balloons of every color imaginable graced the walls and hung from the rafters. The best of Giulio's happy-time Italian music issued from the loudspeakers, and the aromas of what promised to be a full-course, sit-down Italian dinner enveloped us. As I recall, the only time that the music and dancing and eating and chatter came to a standstill—and then only momentarily—was when Peter and Jackie made the first cut into their wedding cake and several toasts were offered. Mother Castro lifted a glass, as had the others, but her words were not so much a toast as they were a blessing. One did not need to understand the words in order to know that they comprised a confirmation—Pomo style—of her son's new marital status.

From where we had dinner with Giulio, Mother Castro and young Peter, Andie and I watched the newlyweds as they moved from one table to another, talking briefly with each of their guests. As all brides do, Jackie looked flushed and beautiful, whisking about in her white gown, but it was difficult to get used to Peter in something other than his red and black plaid lumber jacket and dungarees.

The dining room was already beginning to thin out when, still smiling but obviously done in, the two of them approached our table. Giulio was immediately on his feet, pulling out chairs for them and then bouncing off to replenish the table's supply of food and drink. They sat down heavily, plunked their elbows on the table, looked at each other for a long moment, and then, a bit self-consciously, looked at each of us in turn. It was as though they had at last reached safe haven and could be completely themselves.

They were famished, and so for a while the rest of us did most of the talking as they ate. Once their plates were pushed back, the conversation picked up considerably, especially among the ladies. But Giulio and I were having trouble eliciting much from Peter. We could understand that the groom had other things on his mind beside table talk, and, had Andie not shot a warning glance in my direction, we would have engaged in some discreet kidding. It was fortunate that we did not, because Peter's problem was not impatience. Rather, he was struggling to find the right words for what he had to say. Finally, deciding to let the words come as they would, he blurted out, in a voice that was much too loud, "I destroyed the inscription." And then he hid his face in his hands.

Everyone at the table suddenly fell silent. Even little Peter, a fork full of wedding cake half-way to his mouth, looked up nonplused. The topic of conversation had been Jackie's plans for the barber shop, and so it required some shifting of gears before we realized that we had just heard a confession. Giulio was first to speak. Gently, and without plying his staged accent, he asked, "But why, Pietro, why would you do such a thing?"

His question was not intended to condemn but to provide Peter with opportunity to make some sense of his action. Jackie shifted her chair closer to Peter's and put her arm around him as he sobbed quietly into his hands. All of us were well-acquainted with his strange periods of muteness, and so we simply waited for the response that we

knew would eventually come. Our only fear was that his all-too-public confession might have sparked some curiosity among the remaining wedding guests. A few of them had looked our way, but the music had muffled Peter's words, and the rest of us smiled back sweetly to veil the gravity of the situation. He came around more quickly than we had anticipated, perhaps because he realized what he was doing to Jackie on their wedding day. When he lifted his head to speak it was not to Giulio, but to Andie and me, that he addressed himself.

"I heard almost everything you said here in the dining room that night. It was a strain, but my ears are very good and you can understand why I was determined to use them. At the time, I hadn't the faintest idea who you were, but every ounce of me resented your presence. You had stumbled across the very thing that had eluded me for years, something that was priceless and very sacred to me. And there you were, stuffing yourselves and joking and laughing . . . like a couple of ugly Americans abroad, completely insensitive to what might be of importance to the locals . . . or so I thought at the time. "I don't know what came over me . . . I suppose the feeling could best be described as a kind of blind rage . . . but I was obsessed by the need to protect the inscription from outsiders . . . from the enemy, if you will . . . even at the cost of its destruction. I could see 'experts' pawing over it, making all sorts of erroneous conjectures about its origins and significance. Then would come the reporters, out for a sensational scoop, and, finally, a gawking, gullible public ready to gobble it all up. I could picture myself trying to set them straight without violating the confidentiality of intimate family records. How laughable! The whole scene was ghastly, and I could hardly wait to rush out into the night to head off the catastrophe.

"Greg . . . Andie, I hope you can forgive me, not only for what I did but for waiting until now to tell you. From the moment we met and began to trust each other, I've gone through all kinds of hell. I thought that surely the right moment to break the news would come, but I'm afraid I was fantasizing."

He turned to Jackie. "And can you forgive me, my dear? I know I couldn't have picked a lousier time for this, but having got it out means we'll have a lot less excess baggage on our honeymoon."

There was no question about our readiness to forgive. We had all had our moments of madness. But other than for Peter's need, we

wondered if forgiveness was the appropriate response. Acting intuitively, he may well have done us a greater favor than we realized. Besides, there was still Maria's diary for the record. There might even be a reference to the inscription in the Rotchev papers, waiting to be discovered somewhere in the labyrinth of Moscow archives.

I asked Peter about his current intentions concerning the disposition of what was pertinent in Maria's diaries. He was still of a mind to hold the evidence inviolate, at least until his mother's demise; but he suggested that I consider another way of informing others for whom the inscription might be of constructive, historical interest. Was I not a writer, and was I not familiar with the salient circumstances leading to its creation? Did we not trust one another, confident that neither of us would act in matters of mutual concern without consulting the other? His invitation to "write it up" was genuine and generous, and I told him that I would give it a try.

The last Andie and I saw of our friends for some time was as Jackie and Peter were climbing into the car to depart on their honeymoon. (We noticed that Giulio had deposited the picnic hamper on the back seat.) At the last instant before they pulled away, little Peter broke free from where he stood, between Giulio and Mother Castro, and ran to Peter's open window.

"When you and Mom get back, can we all crawl into that place where you saved the rock?"

"Only if you promise to take good care of Grandmother while your mother and I are away."

He promised, and the old Pontiac, trailing a dozen tin cans, moved slowly down the street.

Afterword

Distinguishing historical fact from fiction presents distressing difficulties for the most erudite scholar, let alone for those of us who possess but a passing acquaintance with some given period or theme in our human past. However, I hasten to assure the reader that the Russians did indeed establish Fort Ross on California's Sonoma Coast back in 1812; that there actually *was* a Chernykh ranch located somewhere near Freestone or Occidental; and that the names of the fort's commandants and their spouses mentioned herein are authentic. The Franciscan missions at San Rafael and Sonoma, together with their succession of padres, also constitute a very real part of California's sometimes heroic, often tragic, but always absorbing history. And even the casual history buff will have recognized the name Mariano Vallejo, although only a few will have chanced onto accounts of the scurrilous Don Ortega. *The Inscription*'s depictions of these historical personages are not limited to the written record, but they are reasonably faithful to it—insofar, that is to say, as I have been able to avail myself of reliable sources.

Problems inherent in penetrating the life and times and personalities of the Amerinds (here, in particular, of the Kashaya Pomo, Southern Pomo, and Coast Miwok) are more distressing still. The process is especially difficult if one's concern is to gain an authentic glimpse of Amerind lifestyles and world views in their pre-Hispanic and pre-Russian state—or, in view of Sir Francis Drake's brief touchdown on the Sonoma coast in the sixteenth century, their pre-New Albion state. The absence of written records necessitates a turning to the findings of cultural anthropologists or, if the diligent student insists on primary sources, to those rare living Amerinds who have themselves received unblemished (and remembered accurately) their people's oral traditions and are able and willing to pass them along to the stranger.

Still, despite problems in getting at the facts, the reader need not doubt that villages, or *rancherías*, such as Mettini, At the-south-water, Pakahuwe, and Olompali actually existed and survived into the nineteenth century. The ghost dancers, while spectral in appearance and intent, were nonetheless very much flesh and blood, and the Big Time is still celebrated here and there in Sonoma Coast country. It must also be noted that, tragically, the smallpox epidemic of 1837–39 *did* take a terrible toll on the northern frontier's Amerind population. Estimates of the number of victims range between sixty and seventy thousand, a near-annihilation from which the area's indigenous inhabitants never fully recovered.

I trust that the reader will be sympathetic if it was the sum of impressions gleaned from Pomo and Miwok oral tradition on which I was obliged to depend in constructing *The Inscription*'s principal Amerind characters. Maria and Grigory might also best be understood as composite figures. It is no coincidence, however, that the book's contemporary figures resemble some of the "living legends" in and about Occidental and Freestone.

All in all, perhaps, it is Chief Bromden in Ken Kesey's *One Flew Over the Cuckoo's Nest* who captures, most poignantly, my own sentiments concerning fact and fiction in the present work. "But please," Bromden pleads, "it's still hard for me to have a clear mind thinking on it. But it's the truth even if it didn't happen."